Entering Germany

Tony Vaccaro

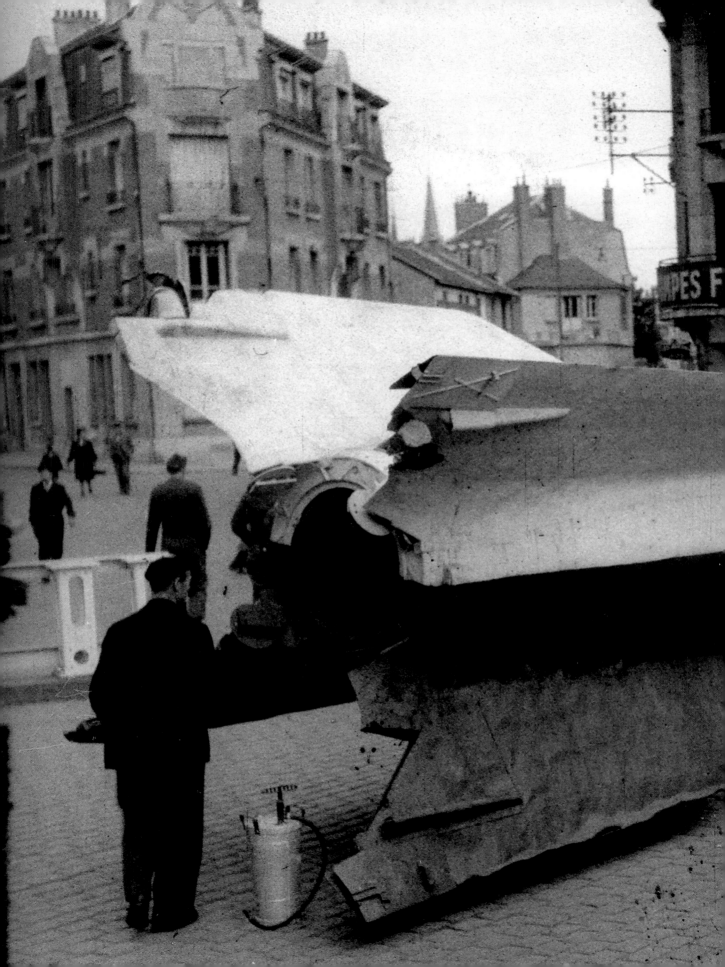

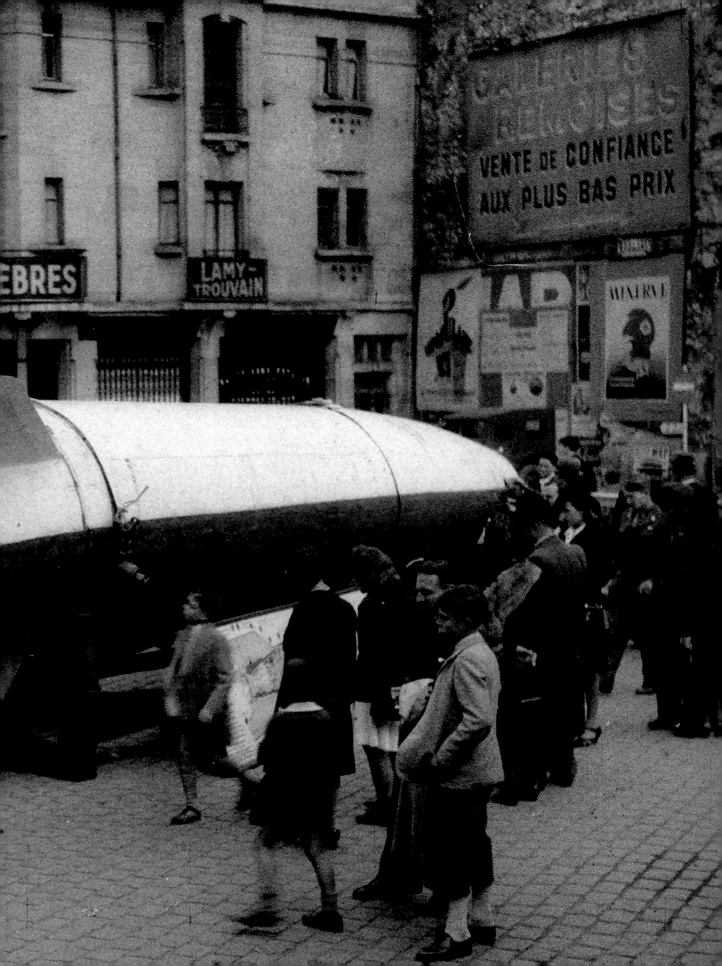

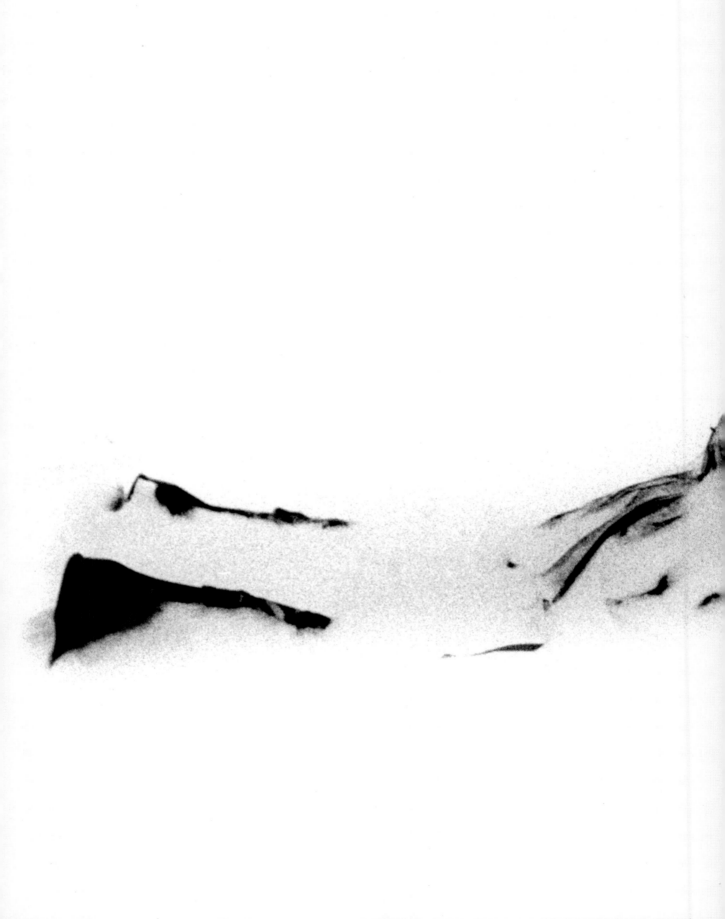

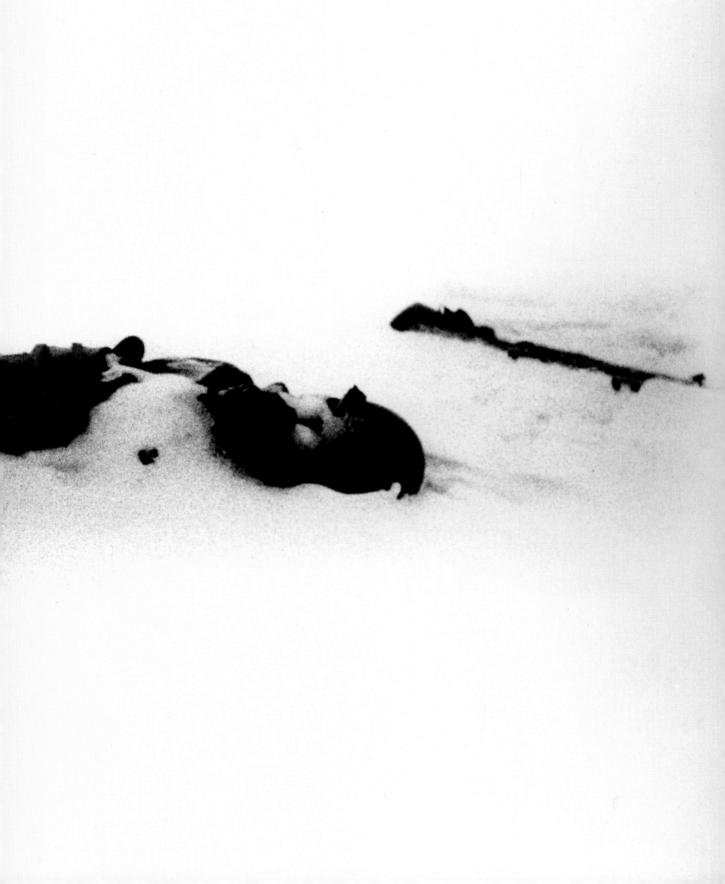

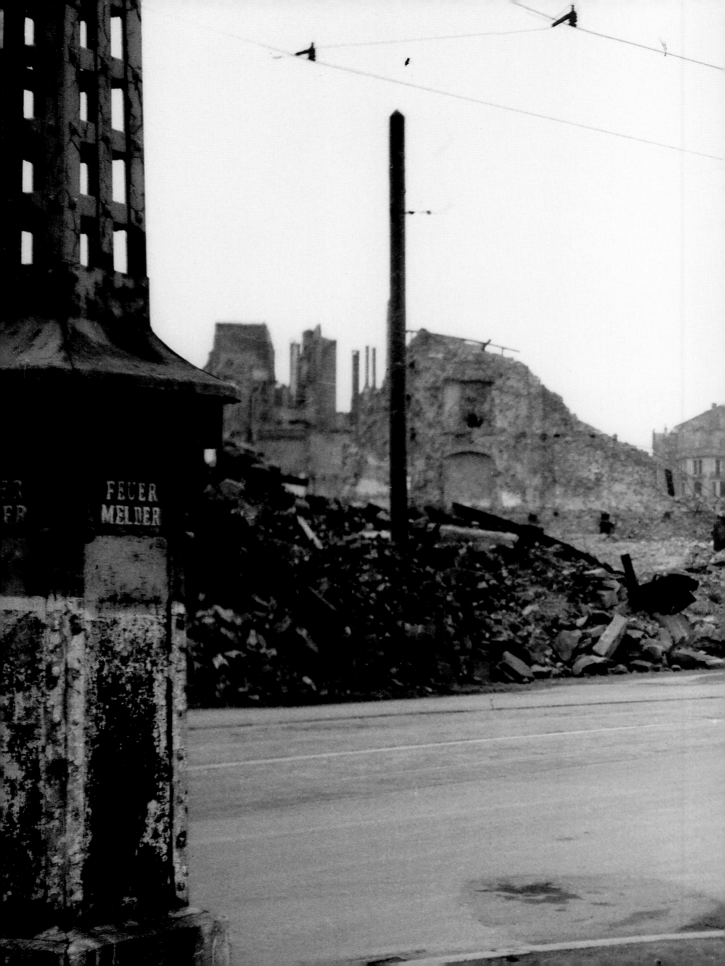

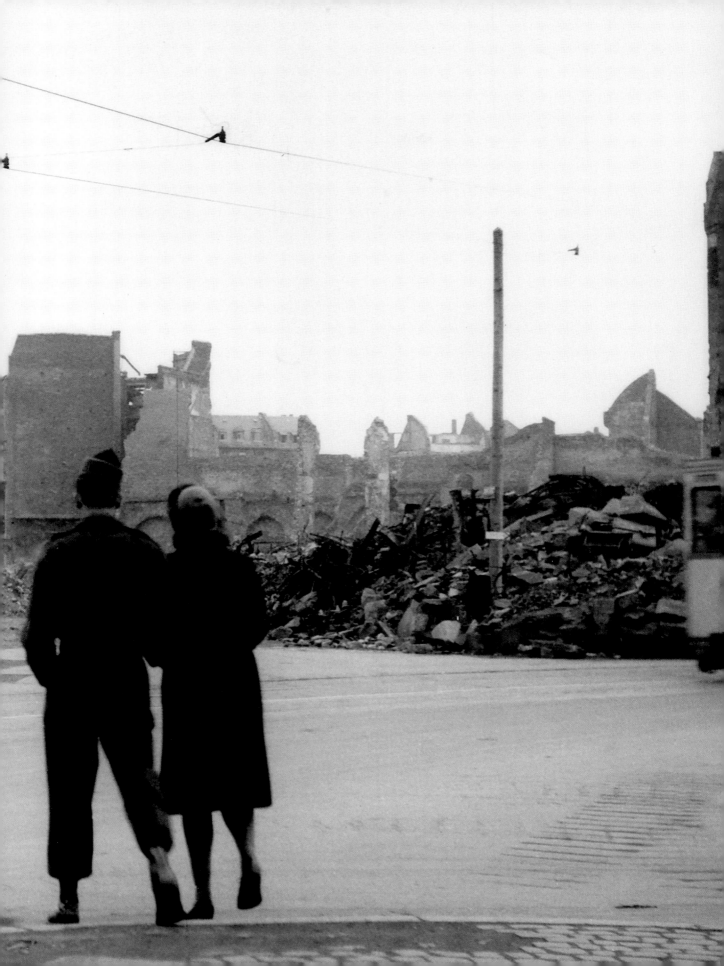

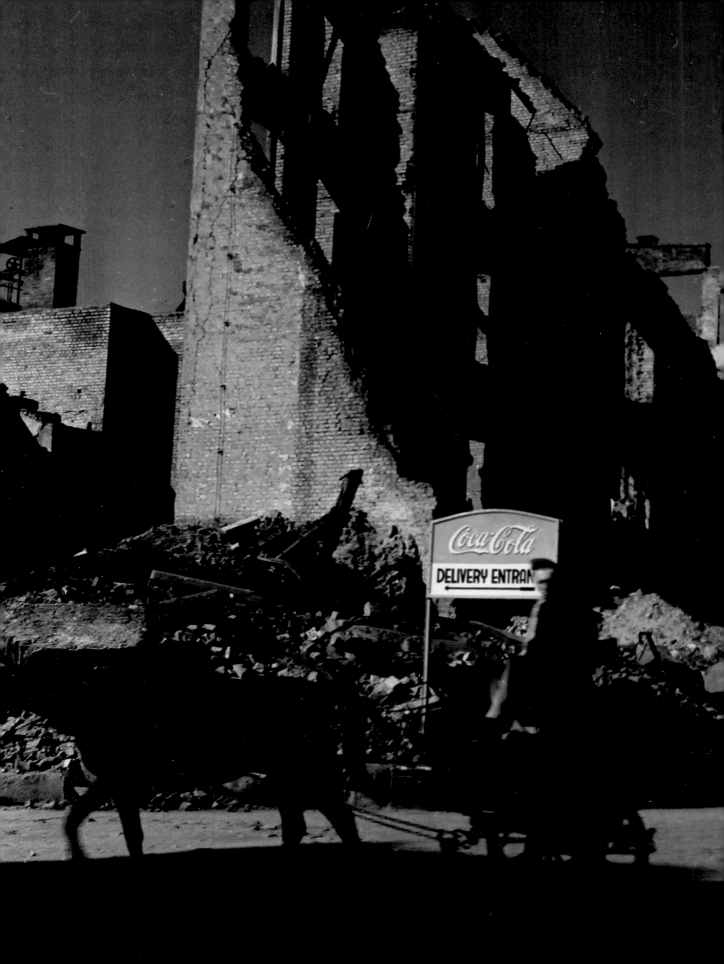

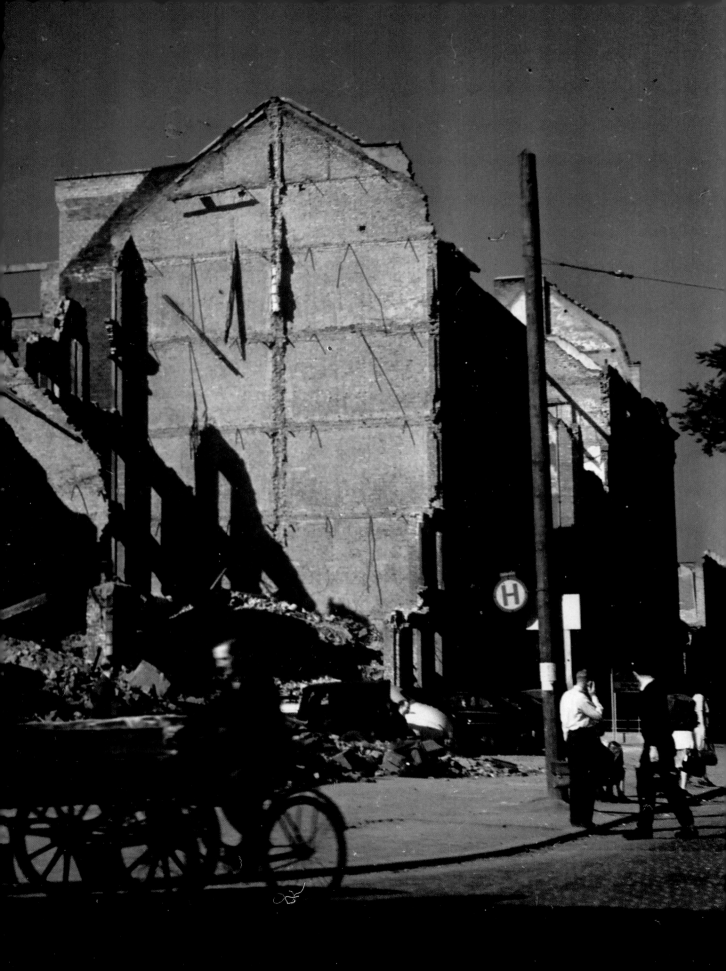

Entering Germany

1944–1949

Germany

Tony Vaccaro

TASCHEN

KÖLN LONDON MADRID NEW YORK PARIS TOKYO

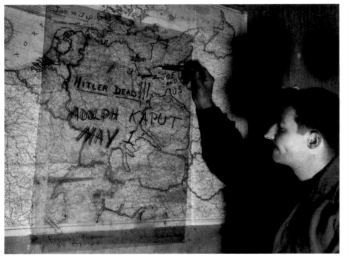

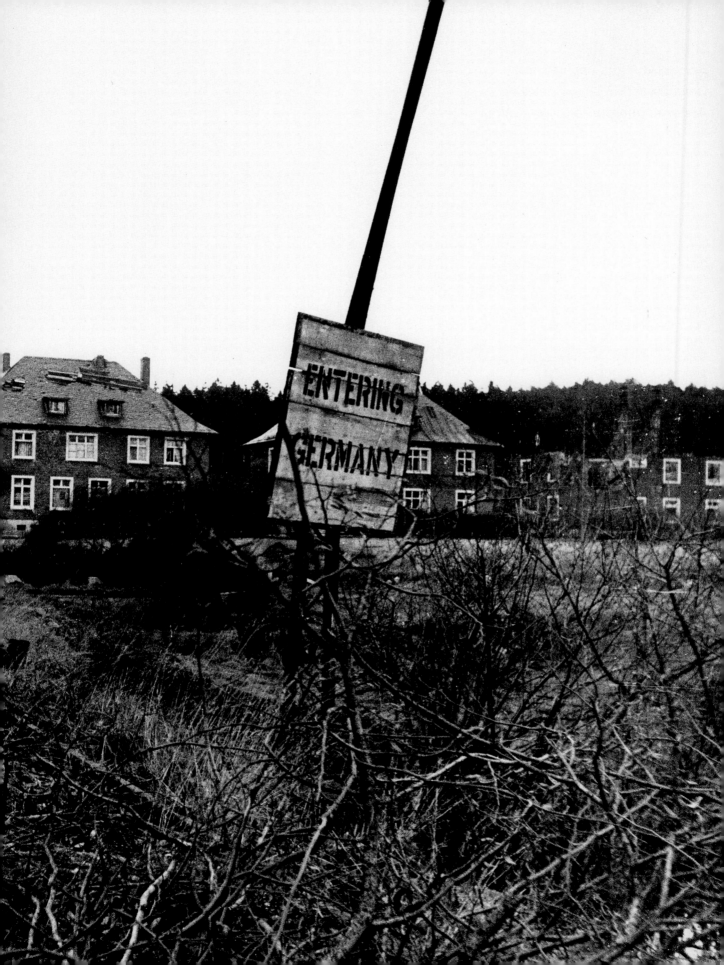

Armed with gun and camera
Bewaffnet mit Gewehr und Kamera
Appareil photo et arme au poing

The images in this book were selected from over 10,000 photographs, most of which I took in Germany between 1944 and 1949. For the last five months of the war I served as an infantryman, and during the Allied Occupation I continued to photograph as a civilian. This entire book is a picture story. Even my 'word stories' are descriptions of pictures.

I entered Germany at the cold and bitter battle for the Hürtgen Forest on December 6, 1944, in which about 68,000 soldiers, Americans and Germans, lost their lives.

I was a private first class in the Intelligence Platoon of the 2nd Battalion, 331st Regiment, 83rd Infantry Division, "Ohio", of the U.S. Army.

My assignment, usually with three other soldiers, was to go behind the enemy lines at night, make contact with the local inhabitants, gather information about enemy activity and return to Headquarters with whatever they told us.

Like the other GIs, I carried a rifle in my hands, but what set me apart was the Argus C-3 35mm camera hanging around my neck always ready for the next shot. By the end of the war I had taken nearly 7,000 photographs.

My night work left me more or less free dur-

Die hier veröffentlichten Fotografien wurden unter mehr als 10 000 Aufnahmen ausgewählt, die ich, zum überwiegenden Teil in Deutschland, in den Jahren 1944–1949 gemacht habe. Die letzten fünf Monate des Krieges war ich als Infanterist in der US-Army, während der Besatzungszeit fotografierte ich dann als Zivilist. Das ganze Buch ist eine Bildergeschichte, und selbst meine Texte sind nichts anderes als „erzählte Bilder".

Nach Deutschland kam ich am 6. Dezember 1944, während der grausamen Schlacht um den Hürtgenwald, in der etwa 68 000 amerikanische und deutsche Soldaten ihr Leben verloren. Als Obergefreiter eines Spähtrupps der „Ohio"-Division (2. Bataillon des 331. Regiments der 83. Infanteriedivision) hatte ich die Aufgabe, nachts hinter den feindlichen Linien mit der einheimischen Bevölkerung Kontakt aufzunehmen und mit den so gewonnenen Informationen über die Aktivitäten des Feindes ins Hauptquartier zurückzukehren. Wie alle GIs schleppte auch ich ein Gewehr mit mir herum. Was mich jedoch von den anderen unterschied, war die um meinen Hals hängende „schussbereite" Argus C-3, eine 35mm-Kamera. Bei Kriegsende hatte ich fast 7 000 Aufnahmen gemacht.

Da ich in der Regel nachts „arbeitete", konnte ich tagsüber mit meiner Kamera losziehen.

Les images de ce livre ont été sélectionnées dans un ensemble de plus de 10 000 clichés réalisés pour la plupart en Allemagne de 1944 à 1949. D'abord comme simple fantassin pendant les cinq derniers mois de guerre, puis, pendant les cinq ans qu'a duré l'occupation américaine, comme civil. Ce livre est une histoire en images. Même les textes ne font que décrire des images.

Je suis entré en Allemagne le 6 décembre 1944 par la forêt de Hürtgen lors de la sanglante bataille du même nom. Plus de 68 000 hommes, américains et allemands y ont trouvé la mort. J'étais caporal-chef au service de renseignements de la 83e division d'infanterie « Ohio », 331e régiment, 2e bataillon. Mon travail, généralement avec trois autres soldats, consistait à infiltrer les lignes ennemies de nuit, prendre contact avec les gens du cru, obtenir des informations sur les activités de l'ennemi et retourner au Q.G. américain muni des renseignements que j'avais recueillis. J'étais différent des autres GIs en ce sens que je brandissais un fusil dans la main droite et un appareil photo 35 mm Argus C-3 dans la gauche. A la fin de la guerre, j'avais pris près de 7 000 photographies. Travaillant de nuit, je jouissais d'une relative liberté durant la

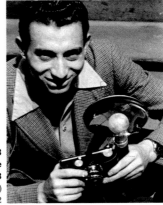

Tony Vaccaro. The day he bought the Argus C-3
Tony Vaccaro. Der Tag, an dem er seine Argus C-3 kaufte
Tony Vaccaro. Le jour où il a acheté son Argus C-3
Photograph by Randy Christensen. New Rochelle (NY)
August 29, 1942

Entering Germany
Belgium/Route N3. December 6, 1944

ing the day to take pictures of whatever I experienced. When I was not on a night mission, I processed my films in four army helmets and hung the wet negatives from tree branches to dry. Even in basic training at Camp Van Dorn, Mississippi, and Camp Breckinridge, Kentucky, in 1943, my superiors—from the company to the division level—allowed me to photograph. The idea—eventually realized—was to use the photographs for the histories of my regiment and division; in addition, my own dream was to become a magazine photographer and get a job on *LIFE* or a similar publication in America after the war. Whether I would ever realize this dream depended on surviving the war and becoming a good enough photographer by the end of the war to secure such a job.

From the Hürtgen Forest, we moved northeast along the Erft canal towards the bridge to Dusseldorf over the Rhine. During the night of March 2, 1945, Co. E of my 2nd Battalion became the first Allied troops to reach the mid-Rhine in that segment, but the Nazis blew up the bridge, preventing us from becoming the first American unit to cross. We spent most of March practicing river crossings on the Maas near Maastricht. On March 30, we crossed the Rhine at Wesel. Moving eastward through Hamm, Paderborn, Holzminden, Alfeld, Goslar, Wernigerode, Halberstadt, we reached Barby on the Elbe by the evening of April 12. During this drive, the 83rd Infantry Division covered 280 miles in 12 days, setting infantry speed records that surpassed those of the best Allied armor and capturing over 65,000 prisoners. Next morning at 6:30 a.m., I crossed the river with the first series of assault boats, heading in the direction of Zerbst.

When the war ended on May 8, I was in the

Hatte ich nachts dienstfrei, entwickelte ich die Filme in vier Soldatenhelmen. Die Negative hängte ich zum Trocknen an Zweige. Schon während meiner Grundausbildung 1943, in Camp Van Dorn, Mississippi, und in Camp Breckinridge, Kentucky, hatten mir sämtliche Vorgesetzte, ob Kompaniechef oder Divisionskommandeur, erlaubt zu fotografieren. Die Idee dahinter war nicht nur – wie später ja auch geschehen –, die Geschichte meines Regiments und meiner Division zu dokumentieren, sondern auch, meinen eigenen Traum zu realisieren: Nach dem Krieg wollte ich einen Job bei *LIFE* oder einem ähnlichen amerikanischen Magazin bekommen. Um diesen Traum zu verwirklichen, mußte ich allerdings erst einmal den Krieg überleben – und meine Fähigkeiten als Fotograf mussten den Qualitätsansprüchen einer solchen Zeitschrift genügen.

Vom Hürtgenwald aus zog unsere Einheit in nordöstlicher Richtung entlang des Erft-Kanals zur Rheinbrücke bei Düsseldorf. Als unser Bataillon in der Nacht zum 2. März 1945 als erstes diesen Rheinabschnitt erreichte, sprengten die Nazis die Brücke. Fast den ganzen März verbrachten wir in der Nähe von Maastricht und übten Flussüberquerungen. Am 30. März überquerten wir schließlich bei Wesel den Rhein. Von dort ging es über Hamm, Paderborn, Holzminden, Alfeld, Goslar, Wernigerode, Halberstadt weiter Richtung Osten. Am Abend des 12. April erreichten wir bei Barby die Elbe. Innerhalb von nur 12 Tagen hatte die 83. Infanteriedivision 450 km zurückgelegt und damit einen neuen Rekord aufgestellt; obendrein hatten wir mehr als 65 000 Gefangene gemacht. Am nächsten Morgen um halb sieben überquerte ich mit einem der ersten Sturmboote den Fluss und zog weiter nach Zerbst. Das Kriegsende erlebte ich in dem kleinen Dorf Hohenlepte. Hier wurde ich vom

journée. C'est ainsi que j'ai pu photographier la guerre. Quand je n'étais pas en mission, je développais mes films dans quatre casques militaires (développeur, eau de rinçage, fixateur, eau de rinçage). Je suspendais ensuite les négatifs à des branches pour qu'ils sèchent. Tous mes supérieurs hiérarchiques, du chef de compagnie au commandant de division, m'avaient autorisé à emporter mon appareil partout avec moi, depuis ma formation de base commencée en 1943 à Camp Van Dorn, Mississippi, et achevée à Camp Breckinridge, Kentucky. En prenant ces clichés, je ne voulais pas seulement graver sur la pellicule les faits d'armes du régiment et de la division, mais aussi – et avant tout – décrocher, après la guerre, un travail à *LIFE* ou dans d'autres magazines américains similaires. Pour réaliser ce rêve, je devais répondre à de nombreuses questions, toutes tributaires de ma bonne fortune: survivrais-je à la guerre? Serais-je un assez bon photographe pour me voir confier un tel travail une fois la guerre finie? De la forêt de Hürtgen nous avons fait mouvement vers le nord-est et le Rhin, en suivant le canal de l'Erft. Dans la nuit du 2 mars 1945, la Compagnie E du 2e bataillon, à laquelle j'appartenais, a été la première unité alliée à atteindre le Rhin entre Neuss et Düsseldorf. C'est à ce moment que les Nazis firent sauter le pont et nous dûmes passer presque tout le mois de mars près de Maastricht à nous exercer à traverser la rivière. Ma division a franchi le Rhin à Wesel, le 30 mars. Nous avons ensuite traversé Hamm, Paderborn, Holzminden, Alfeld, Goslar, Wernigerode, Halberstadt et atteint Barby, sur l'Elbe, dans la soirée du 12 avril. La 83e division d'infanterie avait couvert 450 kilomètres en 12 jours, battant tous les records de vitesse de

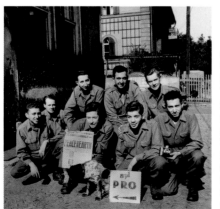

Staff of the *83rd Thunderbolt* newspaper: Top (l. to r.): Sgt. Bob Vierhile, Lt. Henry Herzfeld, Pfc. Carl Weber; front: Bob LaVine, Sgt. South, James Townsend, mascot Rompin, Morris Renek, Tony Vaccaro

Die Redaktion der Zeitschrift *83rd Thunderbolt:* Obere Reihe, v.l.n.r.: Unteroffizier Bob Vierhile, Leutnant Henry Herzfeld, Obergefreiter Carl Weber; vorne: Bob LaVine, Unteroffizier South, James Townsend, Maskottchen Rompin, Morris Renek, Tony Vaccaro

L'équipe de rédaction du *83rd Thunderbolt:* en haut, de gauche à droite: sgt. Bob Vierhile, lt. Henry Herzfeld, cal.-chef Carl Weber; en bas: Bob Lavine, sgt. South, James Townsend, Rompin, la mascotte, Morris Renek, Tony Vaccaro

Photograph by Tony Vaccaro. Vilshofen, Bavaria August 12, 1945

hamlet of Hohenlepte. Here my combat photography came to an end and my chronicle of the occupation of Germany began.
A few days after the end of the war we were pulled back west of the Elbe to the beautiful Harz Mountains. By now I had become one of the photographers for the division paper—*83rd Division Thunderbolt*. The cessation of hostilities in Germany brought about a new phase of operations: the occupation and governing of Germany. Nazi party members had to be replaced by non-Nazis in minor administrative jobs.

Becoming a photojournalist
Stationed at Anderbeck and later at Seesen, I covered the activities of our Division personnel as they interacted with the local population from Braunschweig to the Elbe. I determined to get to know the German people—and the ones I got to know first were those who had the same profession: photographers. Whenever I moved to a new town I contacted the local photographers, and they were only too happy to have me share their facilities in exchange for some favor which I gladly obliged.
A few headlines from our newspaper will give the reader an idea of the transition from war to peace and occupation:
May 5, 1945: "East of the Elbe. 83rd Meets Russians West of Berlin. Germans Turn Over 19,000 Allied PWs to the 83rd Infantry. Nazi Attack on Bridge Thrown Back. Russians Entertain Yanks At the May Day Meeting East of the Elbe."
May 12, 1945: "East of the Elbe. United Nations Celebrate V-E Day As Germany Signs Unconditional Surrender. Allied World Rejoices At End of Bitter Six-Year Struggle. Complete Capitulation Signed Monday at Reims. Two GIs Serve as Bürgermeister For Twelve Days."

Kriegsfotografen zum Bildchronisten des besetzten Deutschland.
Wenige Tage später wurden wir in den schönen Harz versetzt. Inzwischen war ich einer der Fotografen unserer Divisionszeitung *83rd Division Thunderbolt*. Das Ende des Krieges brachte neue Aufgaben: die Besetzung und Verwaltung Deutschlands. Die Parteigänger Hitlers mussten aus den öffentlichen Ämtern entfernt und durch unbelastete Personen ersetzt werden.

Die Anfänge als Bildjournalist
Zuerst in Anderbeck, später in Seesen stationiert, berichtete ich über das Gebiet zwischen Braunschweig und Elbe. Ich wollte die hiesige Bevölkerung kennen lernen und das konnte ich am besten, wenn ich Berufskollegen traf. Kam ich also zum ersten Mal in eine neue Stadt, suchte ich zuerst die dort ansässigen Fotografen auf. Nur zu gern stellten sie mir ihre Einrichtungen zur Verfügung, denn auch ich konnte ihnen den ein oder anderen Gefallen tun. Einen guten Eindruck von dieser bewegten Zeit vermittelt der Blick auf die damaligen Schlagzeilen unserer Zeitung:
5. Mai 1945: „Östlich der Elbe. Die 83. Infanteriedivision trifft sich westlich von Berlin mit den Russen. Die Deutschen übergeben der 83. Infanteriedivision 19 000 alliierte Kriegsgefangene. Angriff der Nazis auf die Brücke zurückgeschlagen. Die Russen laden die Yanks zum Maifeiertag östlich der Elbe ein."
12. Mai 1945: „Östlich der Elbe. Nach der bedingungslosen Kapitulation der Deutschen feiern die Siegermächte den V-E Day (den Tag des ‚Victory in Europe'). Die alliierte Welt bejubelt das Ende sechsjähriger Kriegsgräuel. Am Montag wurde in Reims die bedingungslose Kapitulation unterzeichnet. Zwei GIs amtieren zwölf Tage lang als Bürgermeister."

l'infanterie et surpassant les meilleures armées alliées ; de plus, elle avait capturé plus de 65 000 soldats. A six heures, le lendemain matin, j'ai franchi l'Elbe en direction de Zerbst. Quand la guerre a pris fin, le 8 mai, je me trouvais dans le hameau d'Hohenlepte. C'est là que s'est achevée ma carrière de photographe de guerre et que j'ai commencé ma chronique de l'occupation de l'Allemagne.
Quelques jours après la fin de la guerre, nous avons été transférés sur la rive ouest de l'Elbe dans le magnifique massif montagneux du Harz. J'étais à présent l'un des photographes du journal de division *83rd Division Thunderbolt.* La cessation des hostilités en Allemagne avait entraîné une nouvelle phase opérationnelle : l'occupation et l'administration du pays par l'armée américaine. Nous devions écarter les membres du parti nazi de tous les postes officiels et les remplacer par des non-nazis.

Les débuts d'un reporter photographe
J'ai d'abord été stationné à Anderbeck puis à Seesen où j'ai couvert les différentes activités des soldats de la division sous l'angle du rapport à la population entre Brunswick et l'Elbe. Je décidai de faire la connaissance des Allemands sur un pied d'égalité. Et je commençais par ceux qui avaient la même profession que moi. Chaque fois que j'arrivais dans une nouvelle ville, je contactais les photographes locaux qui acceptaient toujours très volontiers de partager leur chambre noire avec moi. Voici quelques titres de notre journal qui donneront au lecteur une idée de la transition entre la période de la guerre et l'occupation pacifique : 5 mai 1945 : « Est de l'Elbe. La 83ᵉ rencontre les Russes à l'ouest de Berlin. Les Allemands remettent à la 83ᵉ division d'infanterie 19 000 soldats alliés prison-

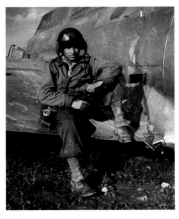

Pfc. Tony Vaccaro
sitting on the wing of a crashed B-17
Obergefreiter Tony Vaccaro
auf dem Flügel einer abgestürzten B-17
Le caporal-chef Tony Vaccaro assis
sur l'aile d'un B-17 abattu
Mondorf-les-Bains, Luxembourg.
September 25, 1944

May 19, 1945: "Bad Harzburg, Germany. 500 GIs A Day Enjoy Mountain Resort Life At Bad Harzburg Rest Camp. Superb Recreation Facilities Include Open-Air Casino With Nightly Floor Show, Theater, Swimming Pool, Tennis Courts and Stables. First 83rd High Point Men Return to the States. Athletic and Education Program for GIs. Baseball in the Harz Mountains."

May 26, 1945: "Bad Harzburg, Germany. 83rd Plans Impressive Ceremonies To Mark Memorial Day. 83rd Men Take Over Government of Braunschweig. Citizens of Bad Harzburg Give Our Military Police Little Trouble."

And a news item from the same issue: "Division men are now engaged in the task of bringing order out of chaos, of restoring to an approximation of normalcy the daily life of 750,000 people in the province of Braunschweig. There are 447 towns in the Division's area … [with] thousands of foreign workers and former PWs to be processed as soon as possible for repatriation … One captain is in charge of a zone in which 200 GIs are responsible for 15,000 people, including numerous foreign workers and refugees from heavily-bombed out industrial centers. It means playing nursemaid to all the nationalities of Europe, but the GIs realize the importance of the task and are giving all they have got, particularly those who speak Polish, Russian, French [or] German."

On June 9, 1945, the Division moved to the area around Passau by way of Erfurt, Bamberg, Nuremberg and Regensburg. In Passau, two unit histories of the war were published: *See It Through* by Jack Straus for my regiment and *Thunderbolt Across Europe,* edited by C. D. Philos, for the Division. My photographs were featured in them. For a month, I was stationed in the town of Pocking and later moved to the Divi-

19. Mai 1945: „Bad Harzburg, Deutschland. Pro Tag erholen sich 500 GIs in Bad Harzburg. Sie genießen ihre Freizeit im Kasino oder im Theater, beim Schwimmen, auf den Tennisplätzen oder beim Reiten. Die ersten Soldaten der 83. Infanteriedivision kehren in die Staaten zurück. Sport und Bildung für GIs. Baseball im Harz."

26. Mai 1945: „Bad Harzburg, Deutschland. Die 83. Infanteriedivision plant eindrucksvolle Feiern anlässlich des ‚Memorial Day' [des amerikanischen Volkstrauertags am 30. Mai]. Angehörige der 83. Infanteriedivision übernehmen die Verwaltung des Landes Braunschweig. In Bad Harzburg macht man unserer Militärpolizei kaum Ärger." In derselben Ausgabe heißt es u. a.: „Die Division hat jetzt die Aufgabe, Ordnung ins Chaos zu bringen. 750 000 Menschen hier im Land Braunschweig sollen zu einer gewissen Normalität zurückkehren können. Der Verwaltungsbereich der Division umfasst 447 Städte und Gemeinden. Abertausende von Fremdarbeitern und ehemaligen Kriegsgefangenen müssen so bald wie möglich repatriiert werden. Ein Hauptmann ist zuständig für einen Bereich, in dem 200 GIs für ca. 15 000 Menschen verantwortlich sind, darunter zahlreiche Fremdarbeiter und Flüchtlinge aus ausgebombten Industriezentren. Es müssen Menschen aller europäischen Nationen betreut werden, aber die GIs wissen um die Bedeutung ihrer Aufgabe, und alle geben ihr Bestes, insbesondere auch die, die Polnisch, Russisch, Französisch oder Deutsch sprechen."

Am 9. Juni 1945 wurde die Division in die Gegend um Passau verlegt. Hier publizierte die US-Army die Bücher *See It Through* von Jack Straus und *Thunderbolt Across Europe*, herausgegeben von C. D. Philos. In beiden erschienen meine Fotos. In dieser Zeit war ich zunächst in Pocking stationiert, danach

niers. Certains d'entre eux capturés à la tête de pont sur l'Elbe. Attaque nazie sur la tête de pont repoussée. Les Russes reçoivent les Américains aux festivités du 1er mai, à l'est de l'Elbe. »

12 mai 1945 : « Est de l'Elbe. Capitulation sans conditions de l'Allemagne : les vainqueurs célèbrent la Victoire en Europe. Les Nations unies opèrent leur jonction à la fin d'un terrible conflit de six ans. La capitulation totale signée lundi à Reims. Deux GIs maires pendant douze jours. »

19 mai 1945 : « Bad Harzburg, Allemagne. 500 GIs goûtent chaque jour les plaisirs de la détente dans la station de montagne de Bad Harzburg. Parmi les superbes équipements dont dispose la ville, citons le casino en plein air avec ses spectacles de variétés, le cinéma, la piscine, les courts de tennis et le centre équestre. Les premiers soldats américains, les plus éprouvés, de retour aux Etats-Unis. Programmes sportifs et éducatifs pour les GIs. Baseball dans les montagnes du Harz. »

26 mai 1945 : « Bad Harzburg, Allemagne. Impressionnantes cérémonies du souvenir à la 83e division. Les hommes de la division prennent en main l'administration de la province Brunswick. Les citoyens de Bad Harzburg ne causent que quelques problèmes à notre police militaire. » Voici un article extrait du même numéro : « Les hommes de la division sont désormais attelés à la tâche de substituer l'ordre au chaos et de rétablir une vie quotidienne à peu près normale pour les 750 000 habitants de Brunswick. Le secteur administratif dévolu à la division comporte 447 villes et communes. Dans ces villes, on dénombre des milliers de travailleurs étrangers et d'ex-prisonniers de guerre qui doivent être rapatriés dès que possible dans leurs pays respectifs. Sous les ordres d'un capitaine,

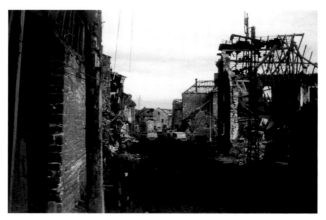

The ruins of Gey
Die Ruinen von Gey
Les ruines de Gey
Gey, near Düren. December 11, 1944

sion headquarters in Vilshofen as the only photographer on the staff of the newspaper, covering an area of 150 square kilometers. I now had a Jeep assigned to me and a driver. He was a sergeant and I was still a mere private first class. Often I originated the story, took the photos, processed the film, made the contact prints and enlargements, captioned them and delivered them to their respective editors—such as sports, entertainment or tourism. At the same time I was also busy writing a column for the paper called *Foto Facts.*

Groundwork for a career in the U.S.

Meanwhile, American soldiers were still fighting and dying in the South Pacific. It was rumored that soon we would be sent to Trieste, Italy, and shipped to Japan. The fear of getting killed or maimed in a war was still very much present with me. However, as the following headlines show, we were to remain in Germany:
August 12, 1945: "Passau, Germany: Japan Surrenders. Peace on Earth. The Atomic Bomb Presents New Problems for Future Wars."
Suddenly, on September 24, I was ordered to return immediately to the U.S. and civilian life. The U.S. Army had no further use for me. However, I had started various projects in Germany that I wanted to complete. I also felt that I had not yet mastered photography to the point of securing a good job on a magazine back in the States. I needed to learn more about my future profession and I felt that Germany would be the ideal place to do so. However, I could not remain without a civilian job with the Occupation Forces. By chance there was an opening for a photographer with the U.S. State Department at the Audio Visual Aids (AVA) section, based in the I.G. Farben

im Hauptquartier der Division in Vilshofen. Ich war der einzige Fotograf im Redaktionsstab der Zeitung, die ein Verbreitungsgebiet von ca. 150 Quadratkilometern hatte. Man teilte mir einen Jeep und einen Fahrer zu. Während ich nach wie vor nur Obergefreiter war, bekleidete mein Fahrer einen Unteroffiziersrang. Meist wählte ich die Themen aus, fotografierte, entwickelte die Filme und machte dann die Kontaktabzüge und Vergrößerungen. Anschließend versah ich die Fotos mit Bildunterschriften und gab sie weiter an den zuständigen Redakteur. Darüber hinaus schrieb ich regelmäßig für die Zeitschrift *Foto Facts.*

Grundlagen einer Karriere in den USA

Unterdessen dauerte der Krieg im Südpazifik unverändert an. Es hieß, wir würden bald über Triest nach Japan verschifft. Meine Angst, in diesem Krieg doch noch getötet oder verwundet zu werden, war also nach wie vor begründet. Wie die folgende Meldung zeigt, sollten wir jedoch in Deutschland bleiben:
12. August 1945: „Passau, Deutschland: Japan kapituliert. Friede auf Erden. Die Atombombe bringt neue Probleme für künftige Kriege."
Am 24. September erhielt ich unerwartet meinen Abschied, die US-Army hatte keine Verwendung mehr für mich. Zwischenzeitlich hatte ich allerdings verschiedene Projekte in Angriff genommen. Zudem fühlte ich mich noch nicht professionell genug, bei einer Zeitschrift in den USA als Fotograf zu arbeiten. Stattdessen waren Erfahrungen zu sammeln und die Kenntnisse zu vertiefen; Deutschland schien mir der ideale Ort dafür zu sein. Um bleiben zu können, brauchte ich jedoch eine Anstellung bei einer US-Behörde. Zum Glück fand sich gerade eine freie Stelle bei der Dokumentationsabteilung (Audio Visual Aids, AVA) des Außenministeriums in

200 GIs sont responsables d'une population de 15 000 personnes parmi lesquelles de nombreux travailleurs étrangers et des réfugiés. Leur rôle : prendre soin de toutes les nationalités européennes, mais les GIs donnent le meilleur d'eux-mêmes. »
Le 9 juin 1945, la division part pour la région de Passau. Ici, l'armée américaine publie entre autres les livres *See It Through* de Jack Straus et *Thunderbolt Across Europe,* édité par C. D. Philos, dans lesquels mes photographies jouent un rôle majeur. Pendant un mois, je suis posté à Pocking avant de rejoindre le Q.G. de la division à Vilshofen. Je suis alors le seul photographe du journal à couvrir un périmètre de 150 kilomètres. On m'alloue une Jeep et un chauffeur – lequel est sergent, alors que je suis toujours simple soldat. C'est à cette époque que j'effectue la plupart des reportages, prend les photos, développe les films, tire les planches contacts, réalise et légende les agrandissements que j'envoie aux différents chefs de rubrique. J'écris aussi régulièrement pour le magazine *Foto Facts.*

Les bases d'une carrière aux Etats-Unis

Mais, pendant ce temps, des soldats américains continuent à mourir dans la guerre du Pacifique. Selon les rumeurs, nous devons être envoyés sous peu à Trieste, en Italie, et, de là, embarquer pour le Japon. La peur d'être tué ou mutilé à vie reste donc toujours bien présente. Pourtant, nous restons en Allemagne comme le montre le gros titre suivant :
12 août 1945 : « Passau, Allemagne. Le Japon capitule. Paix sur la terre. La bombe atomique crée de nouveaux problèmes pour les guerres du futur. »
Le 24 septembre, je reçois mon ordre de démobilisation : je dois rentrer chez moi et

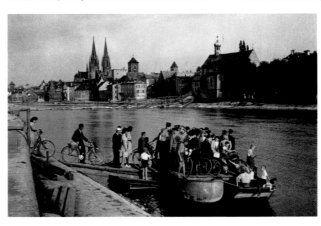

Ferry over the Danube
Donaufähre
Un bac sur le Danube
Regensburg. July, 1945

building in Höchst, near Frankfurt. Twenty photographers applied for the job, but I was the first one in line and got it. My war portfolio and pictures of the early occupation days in Germany helped my bid.

Most of my work at AVA was in the darkroom, and since I had no car the bulk of my photography was done in the Frankfurt area. However, in May 1946 I bought a Jeep, a new Leica C-III, and a Rolleiflex and spent the rest of that year traveling everywhere I could go in Germany in my spare time. I loved the German countryside with its castles, monuments, colorful mountains, valleys and lakes. Many stimulating things were going on in Germany at that time and I tried to cover them all: such as the first postwar motor race and even bicycle race. These events were photogenic because the participants were using old outdated vehicles and work outfits that needed, in order to function, a great deal of repair, ingenuity and prayer.

In the midst of this rebirth, I felt that children were very often left to fend for themselves. What was to become of these orphans of war? Boys may have suffered even more than girls, who had womenfolk to raise them, but many families had no man in the house to bring up the boys. Their fathers and other male relatives had been killed, maimed or were still being held prisoner in the Soviet Union. Often I saw children without shoes and poorly clothed. It was a perfect scenario for an entire schizophrenic or depressed state in the male line of future generations. I tried to capture with the camera what I saw of those children as in the picture: "Germany's new generation" (p. 141).

Roads, bridges, factories, houses and entire cities had to be cleared of rubble and rebuilt. When I was a child, before the war,

Frankfurt. Ich war von 20, die sich um den Job bewarben, der erste. Offensichtlich wirkte meine Mappe mit Fotos aus der letzten Phase des Krieges und der frühen Nachkriegszeit überzeugend und so bekam ich die Stelle. Anfangs verbrachte ich den Großteil meiner Arbeitszeit in der Dunkelkammer, und da ich kein Auto hatte, entstanden die meisten Aufnahmen im Großraum Frankfurt. Im Mai 1946 kaufte ich mir einen Jeep, eine neue Leica C-III und eine Rolleiflex. Den Rest des Jahres war ich in ganz Deutschland unterwegs. Ich liebte die deutschen Landschaften mit ihren Schlössern und Denkmälern, ihren Tälern und Seen. Es gab so viel Interessantes zu berichten, und ich bemühte mich, überall dabei zu sein, etwa bei den ersten Auto- oder Radrennen nach dem Krieg. Hier fanden sich immer dankbare Motive, nicht zuletzt, weil die Autos ebenso wie die Ausrüstungen völlig veraltet und ständig kaputt waren, so dass die Teilnehmer Improvisationstalent und Gottvertrauen beweisen mussten.

Inmitten des allgemeinen Neubeginns blieb allerdings ein großer Teil der Kinder auf sich allein gestellt. Was sollte aus den vielen Kriegswaisen werden? Die Jungen waren vielleicht noch schlimmer dran als die Mädchen, weil sie oft ohne männliche Bezugspersonen aufwuchsen. Ihre Angehörigen waren gefallen oder schwer verwundet aus dem Krieg zurückgekehrt. Andere hielt die Sowjetunion als Kriegsgefangene fest. Immer wieder begegnete ich barfüßigen, abgerissenen Kindern – das perfekte Szenario für eine zu einem traumatisierten Leben verurteilte Generation. In Bildern wie „Deutschlands neue Generation" (S. 141) versuchte ich festzuhalten, was ich in den Gesichtern dieser Kinder sah.

Straßen, Brücken, Fabriken, Häuser und ganze Städte mussten vom Schutt geräumt und wieder aufgebaut werden. Vor dem Krieg

reprendre la vie civile. L'armée américaine n'a plus besoin de moi. J'ai toutefois démarré plusieurs projets en Allemagne, dont ce livre, que je tiens à achever. A l'époque j'ai aussi le sentiment de ne pas suffisamment maîtriser mon métier pour être sûr de trouver un bon travail de retour aux Etats-Unis. J'ai besoin de poursuivre mon apprentissage et je pressens que l'Allemagne sera l'endroit idéal pour le faire. Il ne reste plus qu'un moyen de prolonger mon séjour : trouver un travail comme civil. Par chance, il y a un poste vacant à l'AVA, la section audiovisuelle du département d'Etat, logée dans le bâtiment de l'IG Farben à Höchst. Vingt photographes font la queue pour ce travail mais je suis arrivé le premier et c'est moi qui suis choisi. Mes photographies de la guerre et des premiers jours de l'Occupation font manifestement bonne impression. Je passe l'année 1946 à sillonner l'Allemagne dans ma Jeep avec mon tout nouveau Leica C-III et deux Rolleiflex. J'adore la campagne allemande. L'Allemagne de l'époque est le théâtre d'une foule d'événements captivants comme la première course automobile ou la première course cycliste depuis la guerre, et j'essaie de tous les couvrir. Ces événements sont intéressants parce que l'équipement et les tenues des participants, vieux et périmés, nécessitent d'incessants rafistolages et dépannages. Il n'y pas encore de nouvelles machines : on ne peut compter que sur ses prières et son ingéniosité !...

Dans cette ambiance de reconstruction, les enfants sont livrés à eux-mêmes. La plupart des pères et autres parents masculins ont été tués ou estropiés, d'autres sont encore prisonniers en Union Soviétique. Je croise souvent des gamins pieds nus dans des vêtements trop grands, sales et déguenillés, qui me semblent promis à un triste

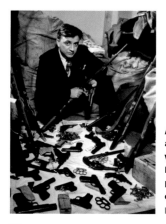

Arms confiscated from smugglers and other criminals

Von Schmugglern und anderen Kriminellen konfiszierte Waffen

Des armes confisquées à des contrebandiers et autres criminels

Mannheim. 1948

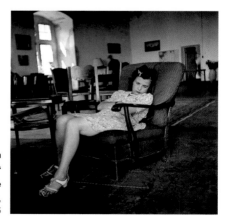

A tired, overworked fräulein

Ein müdes, überarbeitetes „Fräulein"

Une « Fräulein » surmenée

"Eagle's Nest" (Kehlsteinhaus), Bavaria. June, 1945

Germany had been the technological center of the world. It had just invented the stainless steel which made all its metal products shine while those of other countries eventually rusted away. Now, at the start of a new era, it was on its knees and I wanted to chronicle how it would rebuild itself from year zero.

As Nazi ideals faded, an affinity gradually grew up between the Germans and the Americans. Certainly our boys took home plenty of war brides. Far too often, enemies in war remain enemies after the peace accord has been signed. I tried to tell my German friends and acquaintances that they had not invented war: history tells us that our species has really never lived in peace. It has only alternated from periods of cold wars to hot ones in a never-ending cycle. My hope was that German and American friendship might set an example for other people in the world.

Golden Years at *Weekend*

At AVA we had plenty of parties which bored me. While there I had very little work published. On January 1, 1947, things changed: I started working for *Weekend* picture magazine, the Sunday supplement of the Army newspaper *The Stars and Stripes*, which was based in Pfungstadt, near Darmstadt. These were the golden years of my photography in Germany. For nearly three years, until 1949, *Weekend* kept me constantly on the road in West Germany doing photo picture stories on all manner of subjects. I was now being published every week. Unfortunately, a tragedy occurred at *Weekend*, while I was on assignment in Spain, nearly 4,000 of my negatives were destroyed in a flood in *Weekend*'s darkroom. It represented virtually all my work in Germany to that date.

war Deutschland das technologische Zentrum der Welt – der hier erfundene Edelstahl ließ die deutschen Produkte glänzen, während die der anderen Länder dahinrosteten. Jetzt lag das Land völlig zerstört am Boden. Ich wollte dokumentieren, wie es sich von dieser Stunde Null an neu entwickeln würde.

Je mehr die Gespenster des Nationalsozialismus aus den Köpfen verschwanden, desto deutlicher zeigte sich eine Affinität zwischen Deutschen und Amerikanern. Jeder weiß, dass unsere Jungs viele „Fräuleins" mit nach Hause nahmen. Aber oft bleiben Kriegsgegner auch nach einem Friedensschluss Feinde. Ich versuchte, meinen deutschen Freunden klar zu machen, dass sie den Krieg nicht erfunden hatten: Die Geschichte lehrt uns, dass die Menschheit tatsächlich niemals in Frieden gelebt hat, dass es lediglich einander abwechselnde Perioden von „kaltem" und „heißem" Krieg gegeben hat. Ich hoffte, die deutsch-amerikanische Freundschaft könne anderen Völkern als Vorbild dienen.

Goldene Jahre bei *Weekend*

Bei der AVA wurden zwar viele Partys gefeiert – aber ich langweilte mich. Bislang hatte ich viel zu wenig veröffentlicht. Das änderte sich schlagartig mit dem 1. Januar 1947. Jetzt publizierte ich auch in *Weekend*, der Wochenendbeilage der Armeezeitung *The Stars and Stripes*, die ihren Sitz in Pfungstadt bei Darmstadt hatte und bei der ich bis 1949 blieb. Fast drei Jahre lang war ich ständig auf den Straßen Westdeutschlands unterwegs und machte Fotoreportagen über alle erdenklichen Themen. Während dieser goldenen Jahre bei *Weekend* hatte ich allerdings das Pech, dass die Dunkelkammer des Magazins überflutet wurde. Leider hatte ich meine sämtlichen Negative dort aufbewahrt, fast 4 000 wurden zerstört.

avenir. J'essaie de rendre tout cela dans des images comme celle de « La nouvelle génération allemande » (p. 141).

Il faut déblayer et reconstruire un pays : routes, ponts, usines, maisons… parfois des villes entières. Quand j'étais enfant, avant la guerre, l'Allemagne était à la pointe de la technologie mondiale. Maintenant, le pays est à l'an zéro et je veux être le témoin de la reconstruction.

Tandis que l'idéologie nazie cède peu à peu du terrain, je remarque une affinité croissante entre Américains et Allemands. Tout le monde sait que nos gars apprécient beaucoup les « Fräuleins ». Souvent, les ennemis qui se sont affrontés restent ennemis une fois la guerre finie. L'histoire nous montre que notre espèce n'a jamais vraiment connu la paix : elle a simplement alterné les périodes de guerre froide et de conflit ouvert, dans un cycle sans fin. Je guette toutes les manifestations de cette affinité, pour voir si les deux peuples deviendront amis et mettront un terme à cette malédiction.

Années d'or au magazine *Weekend*

A l'AVA, la vie est belle, je n'ai jamais fait autant la fête, mais je me rends bien compte que je n'ai pas assez publié jusqu'ici. Pourtant, le 1er janvier 1947, les choses changent : je travaille désormais pour le magazine *Weekend*, le supplément dominical du quotidien de l'armée *The Stars and Stripes* (la bannière étoilée), à Pfungstadt, près de Darmstadt. J'y resterai jusqu'en 1949. Ce sont les plus belles années de mon séjour en Allemagne. *Weekend* m'envoie sans cesse en reportage. Malheureusement pour moi, la chambre noire de *Weekend* est inondée, et tous les négatifs que j'y avais stockés, près de 4 000, seront détruits.

Weekend
April 20, 1947

The Stars and Stripes
August 9, 1947

The Berlin Blockade

In 1948, the Soviet Union instituted the Berlin Blockade which resulted in the Allied airlift to supply the beleaguered city with food, fuel and other necessities. I and many others thought WW III could begin at any moment. Instead, it turned out to be the turning point in German-American relations. Until the airlift, I had never seen us working together with the former enemy with such *esprit de corps*. It was a great challenge. The Soviets wanted to starve out 2,100,000 Berliners and oust the British, French and Americans from West Berlin—a bastion of hope and freedom in the heart of the East Zone of Occupation. I was very busy on the airlift where the Allies and the Germans worked as one, 24 hours a day. The picture of German children embracing a GI at Tempelhof Airport in West Berlin (p. 188/189), shows that we were no longer the enemies of the Hürtgen Forest days. With that picture I knew I could go home. Germany was well on its way to recovery and for my part, I felt quite secure in my profession.

My photographs had won all the photo contests that had been held in Germany. Afterwards, I ceased participating, but became one of the judges until mid-1947. The bullets, shrapnels and the devastated streets of Germany filled with the display of raw feelings—uncertainty, fear, hate, arrogance, regret, hunger, pathos, shame, anguish, despair, delusion, corruption, but finally cooperation and friendship—had been my university course and basic training for civilian life in the U.S. The pictures in this book are those through which I learned photography. But, were my kind of images good enough for the New York savants of my profession? Could I compete with the best New York had to offer?

Die Blockade Berlins

Im Jahr 1948 blockierte die Sowjetunion die Versorgungswege nach Berlin. Die Alliierten reagierten darauf mit der Einrichtung einer Luftbrücke, um die eingeschlossene Stadt mit dem Nötigsten zu versorgen. Wie viele andere befürchtete auch ich den Beginn des Dritten Weltkrieges. Stattdessen stellte die Blockade einen Wendepunkt in den deutsch-amerikanischen Beziehungen dar. Bis zur Luftbrücke hatte ich es nicht für möglich gehalten, dass die ehemaligen Kriegsgegner so eng zusammenarbeiten würden. Es war eine große Herausforderung: Die Sowjets wollten ca. 2 100 000 Berliner aushungern und die Briten, Franzosen und Amerikaner aus Westberlin, dieser Bastion der Hoffnung und Freiheit im Herzen der Ostzone, vertreiben. Seite an Seite arbeiteten Alliierte und Deutsche, rund um die Uhr, und ich begleitete sie mit der Kamera. Das Bild des GIs, der bei seiner Ankunft auf dem Flughafen Tempelhof von deutschen Kindern umringt wird, zeigt, dass wir nicht länger die Feinde aus den Tagen des Hürtgenwaldes waren (S. 188/189). Jetzt wußte ich, dass ich nach Hause gehen konnte: Deutschland befand sich im Wiederaufbau, und ich brauchte mir um meine berufliche Zukunft keine Sorgen mehr zu machen. Meine Fotos hatten alle Fotowettbewerbe in Deutschland gewonnen, bis zum April 1947, als ich selbst Jurymitglied wurde und nicht mehr an Wettbewerben teilnahm. Die Grundlagen meiner beruflichen Zukunft in den USA hatte ich im Kugelhagel und unter Geschützfeuer erworben, aber auch auf den Straßen der zerstörten deutschen Städte, in denen die Menschen ihre Gefühle unverhohlen zum Ausdruck brachten: Zweifel, Angst, Hass, Stolz, Bedauern, Hunger, Leidenschaft, Scham, Schmerz, Verzweiflung, Korruption, aber auch Mitleid, Anteilnahme und Freundschaft. Durch die in diesem Buch gezeigten

Le blocus de Berlin

Et puis l'inéluctable arrive : en 1948, les Russes décrètent le blocus de Berlin et nous ripostons par le pont aérien. Comme bien d'autres, j'ai le sentiment que la Troisième Guerre mondiale est imminente. Pourtant cet événement va hâter la fraternisation des Allemands et des Américains. Jusque-là, je ne les avais pas vus faire bloc avec autant de conviction autour d'un défi commun. Les Soviétiques veulent affamer 2 100 000 Berlinois et chasser les Anglais, les Français et les Américains – un bastion d'espoir et de paix au cœur de la zone d'occupation soviétique – de Berlin-Ouest. Les Alliés et les Allemands travaillent côte à côte, 24 heures sur 24, jusqu'à l'épuisement et moi je fixe tout cela sur la pellicule. Il y a tout un monde entre l'image des enfants allemands et des GIs s'embrassant à l'aéroport de Tempelhof (p. 188/189) et celle de la bataille sanglante de Hürtgenwald. Avec cette image devant le yeux, je sais que je peux rentrer chez moi. L'Allemagne est sur la voie de la guérison et je suis rassuré sur mon avenir professionnel. J'ai gagné tous les concours photo organisés en Allemagne pendant mon séjour. Ensuite, j'ai cessé d'y participer, mais je suis devenu membre du jury en avril 1947. Les balles, les obus, les rues des villes allemandes encombrées de gravats, d'une part et d'autre part le spectacle brut des sentiments humains (la peur, la haine, l'arrogance, les regrets, la faim, la honte, l'angoisse, le désespoir, l'illusion de grandeur, la corruption et finalement la coopération et l'amitié) m'ont tout appris. C'est grâce aux photos présentées dans ce livre que j'ai appris l'art et la science de la photographie. Mais avec le genre d'images que je réalise alors pourrai-je rivaliser avec les virtuoses new-yorkais du métier, les meilleurs arti-

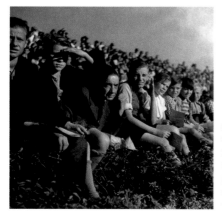

Spectators at the first big bicycle race in Germany after the war
Zuschauer beim ersten großen Radrennen im Nachkriegsdeutschland
Des spectateurs de la première grande course cycliste en Allemagne après la guerre
Wiesbaden. September, 1947

I had trained myself in the cauldron of battle and the streets of Germany, for such popular magazines as *Look* and *LIFE*, and for a while I worked for both of them. But, while photographing movie stars in Hollywood in August 1950, I happened upon a copy of *Flair* Magazine, which convinced me that after eight years of hard training, my tastes had changed. I no longer wanted to be incarcerated in the confines of *Look* or *LIFE* photojournalism.

Now, I had a new challenge. I felt I had to work for the most advanced and sophisticated magazine I had ever seen—*Flair*, where photography had no subject or creative boundaries. I wanted to take photography apart and begin anew. I wanted to make *Flair* more vigorous. I drove back to New York and went straight into the darkroom to print a special portfolio for *Flair*'s editor Fleur Cowles. It happened that *Flair* was looking for a photographer. When I delivered my portfolio to the picture editor, I saw on her desk the portfolios of many of the top photographers in the world. I thought I had no chance against them, but with great joy I learned that I had been selected as Chief Photographer of *Flair*—which I am convinced to this day is the most beautiful magazine ever published at any time, anywhere.

Tony Vaccaro,
New York City, September 2000

Aufnahmen lernte ich das Fotografieren. Aber würden sie von den New Yorker Koryphäen der Fotografie akzeptiert werden? Konnte ich mich mit den besten New Yorker Fotografen messen? Im Hexenkessel der Schlachten und auf den Straßen Deutschlands hatte ich mich auf meine spätere Karriere bei so populären Zeitschriften wie *Look* oder *LIFE* vorbereitet, und nach meiner Rückkehr in die Staaten war ich dann tatsächlich eine Zeit lang für diese beiden Magazine tätig. Doch eines Tages, im August des Jahres 1950 – ich war gerade in Hollywood, um einige Filmstars zu fotografieren – fiel mir ein Exemplar der Zeitschrift *Flair* in die Hände. Es überzeugte mich davon, das sich, nach acht Jahren harter Schulung, mein Geschmack geändert hatte. Ich wollte mich nicht länger den Beschränkungen unterwerfen, wie sie der Fotojournalismus à la *LIFE* und *Look* mit sich brachte. Für *Flair* zu arbeiten, war eine neue Herausforderung: das fortschrittlichste und anspruchsvollste Magazin, das mir bis dahin unter die Augen gekommen war, ein Magazin, das dem Fotografen weder thematische noch stilistische Vorgaben machte. Ich wollte einen grundlegenden Neuanfang in der Fotografie, und auch *Flair* sollte dynamischer werden. Ich fuhr zurück nach New York, um eine Mappe für die Herausgeberin Fleur Cowles zusammenzustellen. *Flair* suchte zu dieser Zeit tatsächlich gerade einen Fotografen. Als ich der Bildredakteurin meine Mappe überreichte, sah ich auf ihrem Schreibtisch die Bewerbungen der damals renommiertesten Fotografen. Das war es dann wohl, glaubte ich, gegen diese Leute hatte ich keine Chance. Aber ich hatte mich geirrt – und wurde zum Cheffotografen von *Flair*, für mich bis heute die schönste Zeitschrift, die es je gab.

Tony Vaccaro,
New York City, September 2000

sans de la capitale mondiale de la photo? Je m'étais formé dans les rues d'Allemagne en visant des magazines populaires comme *LIFE* ou *Look* et pendant quelque temps j'ai travaillé pour eux jusqu'à ce qu'un jour d'août 1950 – j'étais alors à Hollywood en train de photographier des stars du cinéma –, je tombe sur un numéro de *Flair*. Voilà un vrai défi, ai-je pensé. Je sentais qu'il me fallait travailler pour le magazine le plus novateur et le plus sophistiqué que j'aie jamais vu. L'idée que le photographe n'était pas soumis à des directives sur le plan du sujet ou du style me remplissait d'enthousiasme. J'avais envie de mettre la photographie en pièces et de tout reprendre à zéro. Je désirais donner de la vigueur à *Flair*. J'ai immédiatement bouclé ma valise, je suis retourné à New York et ai couru directement à la chambre noire préparer un portfolio à l'attention de l'éditrice Fleur Cowles. Il s'est trouvé que *Flair* cherchait un photographe. Quand j'ai apporté mon book au rédacteur en chef, j'ai vu sur son bureau ceux des plus grands photographes américains de l'époque. Je pensais que je n'avais pas la moindre chance contre eux, jusqu'à ce que je découvre que j'avais été choisi pour diriger le service photo de *Flair* – pour moi le plus beau magazine jamais publié au monde.

Tony Vaccaro,
New York City, septembre 2000

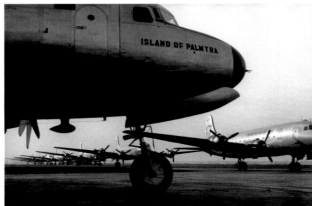

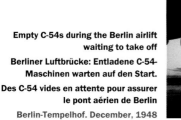

Empty C-54s during the Berlin airlift waiting to take off
Berliner Luftbrücke: Entladene C-54-Maschinen warten auf den Start.
Des C-54 vides en attente pour assurer le pont aérien de Berlin
Berlin-Tempelhof. December, 1948

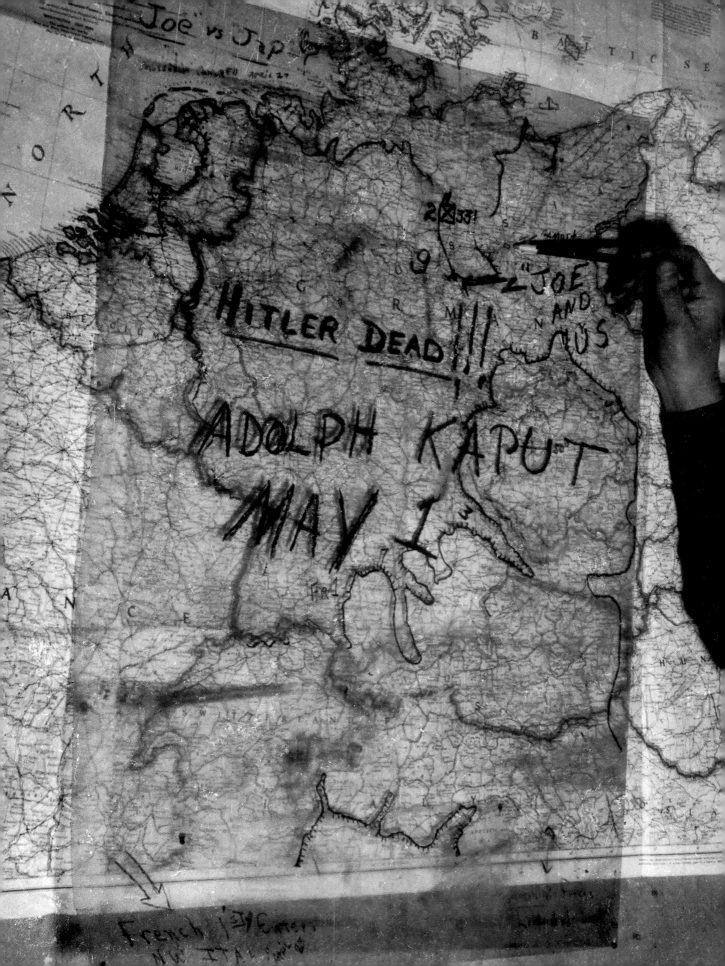

LIBERATION

Befreiung

Libération

On September 1, 1939, Hitler began a war of conquest and the world has never been the same since. The people in the countries the Nazis occupied lost their right to self-determination. From Agon, France, to Zarki, Poland, if citizens refused to comply with the Nazis, they were executed for crimes against the Third Reich. Our war, in contrast, was not one of conquest—it was one of liberation. Paradoxically, we also liberated the German people from the pathological ideas of a psychotic former corporal. These are thoughts that came to me while fighting in WW II: when one is squatting in a foxhole all alone, day after day, rain or shine, while bullets and shrapnel fly above, ideas keep coming about our species' most brutal activity. In war, a soldier close to the front line will have at least one memorable story to tell the folks back home for each day of the year—if he stays alive and takes notes. Stories like these help to illustrate the reality of war. For this reason, I have attached a few to my photographs.

Requiem for a dead soldier

The photo on pages 4/5 was taken during the Ardennes offensive. During the battle, I made two mental inventories of the combat actions and emotions I had recorded with my camera, and of those I was missing. One of the images I had not taken was a homage to a dead soldier. By then, I had taken photographs of many dead soldiers but none emoted the feelings one gets from a musical requiem. I needed a photographic requiem. "How can a photographer transpose the feelings from music to a photograph?" I thought. A composer takes months and even years to put his feelings into an opus. How can a photographer do the same in a photograph

Am 1. September 1939 begann Hitler seinen die Welt verändernden Eroberungs- und Vernichtungskrieg. Die Menschen in den von den Nazis besetzten Ländern verloren ihr Recht auf Selbstbestimmung. Wer sich weigerte, mit den Nazis zu kollaborieren, wurde des Verbrechens gegen das Dritte Reich beschuldigt und exekutiert – im französischen Agon ebenso wie im polnischen Zarki. Unser Krieg dagegen war kein Eroberungs-, sondern ein Befreiungskrieg. Und so befreiten wir schließlich auch das deutsche Volk von den Wahnideen eines ehemaligen Gefreiten. Wer Tag für Tag, bei welchem Wetter auch immer, mutterseelenallein im Kugelhagel in einem Erdloch hockt, macht sich zwangsläufig Gedanken über den Krieg. Und jeder Soldat, der den Einsatz an der Front überlebt, hat für jeden Tag des Jahres mindestens eine denkwürdige Geschichte zu erzählen. Vielleicht tragen diese Geschichten ja mit dazu bei, die Realität des Krieges deutlich zu machen. Aus diesem Grund habe ich einigen meiner Fotos entsprechende Texte beigefügt.

Requiem für einen toten Soldaten

Das Foto auf den Seiten 4/5 entstand während der Ardennenoffensive. Vor meinem inneren Auge ließ ich die Kriegsszenen Revue passieren, die ich bislang mit meiner Kamera festgehalten hatte. Was noch fehlte, war eine Hommage an einen toten Soldaten. Keines meiner bisherigen Fotos löste beispielsweise die gleichen Empfindungen aus wie ein Requiem. Ein „fotografisches" Requiem, das war es, was ich noch brauchte. „Wie lässt sich der emotionale Gehalt eines musikalischen Werks in einer Fotografie realisieren", fragte ich mich. Ein Komponist benötigt Monate oder gar Jahre, um seine Gefühle in ein Werk einzubringen. Wie kann ein Fotograf dies im Bruch-

Le 1er septembre 1939, Hitler commençait une guerre de conquêtes. Les peuples des pays occupés par les Nazis perdirent leurs droits : s'ils refusaient d'obéir, ils étaient exécutés pour crimes contre le troisième Reich, aussi bien, en France qu'en Pologne. Les habitants de ces pays n'avaient que faire du troisième Reich. Notre guerre à nous était une guerre de libération : paradoxalement, nous avons aussi libéré les Allemands des lubies pathologiques d'un ex-caporal psychotique. Quand on passe ses journées terré dans un abri de fortune, sans bouger, qu'il pleuve, vente ou neige, et qu'obus et balles sifflent autour de vous, on pense sans cesse à l'activité la plus brutale de notre espèce. Un soldat qui a combattu à proximité de la ligne de front aura au moins une histoire mémorable par jour de guerre à raconter aux siens à son retour – à condition de survivre. Comprendre ces histoires permet de saisir l'ambiance de la guerre. Afin que le lecteur puisse mieux apprécier les photos présentées dans ce livre, elles sont parfois accompagnées de courts récits qui les éclairent.

Requiem pour un soldat mort

La photo des pages 4/5 a été prise pendant l'offensive des Ardennes. Durant la bataille, j'ai fait l'inventaire mental des actions et émotions de guerre que j'avais photographiées et de celles qui me manquaient. Une des images que je n'avais pas était l'hommage à un soldat mort. J'avais photographié beaucoup de soldats morts, mais aucune de ces images n'avait l'ambiance d'un requiem musical. Je voulais réaliser un requiem photographique. Comment un photographe peut-il transposer des sentiments musicaux dans une photographie, me suis-je demandé ? Alors que je me trouvais aux

Previous double page: At 2nd Battalion headquarters. Sgt. Warren Foggle of Cambridge, Massachusetts, points to our location near Berlin on the day after Hitler died.

Vorhergehende Doppelseite: Im Hauptquartier des 2. Bataillons am Tag nach Hitlers Tod: Sergeant Warren Foggle aus Cambridge, Massachusetts, zeigt unsere Position auf unserem Vormarsch nach Berlin.

Double page précédente : Au Q.G. du 2e bataillon, le lendemain de la mort d'Hitler. Le sergent Warren Foggle, de Cambridge, Massachusetts désigne notre position, près de Berlin.

Hohenlepte. May 1, 1945

when in his profession he has to do it in hundredths of a second? I was in this quandary when our battle of the Ardennes began on Christmas Eve, 1944 and lasted till mid-January. On January 12, a sergeant came up and told me that the Nazis had massacred an entire platoon of our F Company. He took me to the scene where the bodies lay frozen and partially covered with snow. I walked up to them to find out who had been killed. As I approached one dead soldier, and was making footprints in the process, I said to myself, "Stop! This picture is your Photo-Requiem. Don't mess up the snow." I back-stepped to a spot from where I took one picture. He turned out to be my army buddy, Pvt. Henry I. Tannenbaum, of my hometown—New York City.

Fifty years later

In 1995 I met his son, Sam, and we became good friends. Last year I went back to Bihain, Belgium, to the exact spot where I had taken the picture. Sam wanted to place a stele in honor of his father on that spot. The field is now an evergreen forest. I asked the landowner if he knew what had taken place there during WW II. He did not know. I told him and showed him the photograph which the Austrian novelist Josef Haslinger had recently proclaimed "his photo of the century" in *ZEITmagazin*. He looked at the picture. Then I asked him why he had turned the wheat field into a forest. He explained that he was growing Christmas trees which he had been selling for many years now in Spain and Portugal. Then I asked him if he knew the meaning of the word "Tannenbaum" in German. He said "No," and when I told him that it meant Christmas tree he remained speechless.

teil einer Sekunde bewerkstelligen? Noch während ich nach einer Lösung des Problems suchte – zur Zeit der Ardennenoffensive –, berichtete mir ein Sergeant, die Nazis hätten einen ganzen Zug unserer Kompanie F massakriert. Er führte mich zum Schauplatz des Gemetzels. Es war der 12. Januar 1945, die Leichen waren zum Teil mit Schnee bedeckt. Ich trat näher darauf zu, um nachzusehen, ob ich einen der Toten gekannt hatte. Plötzlich hielt ich inne: Dieses Bild war mein Foto-Requiem, ich durfte es mir nicht durch Fußabdrücke im Schnee verderben. So ging ich zurück zu der Stelle, von der ich dann das Bild aufnahm. Wie sich später herausstellte, war der Tote ein alter Kriegskamerad, der Gefreite Henry I. Tannenbaum aus New York City.

50 Jahre später

1995 lernte ich seinen Sohn Sam kennen und wir wurden gute Freunde. Im letzten Jahr kehrte ich in den belgischen Ort Bihain zurück, genau zu der Stelle, an der ich damals das Foto aufgenommen hatte. Sam wollte dort zu Ehren seines Vaters eine Stele aufstellen. Wo früher nur Felder waren, stehen heute unzählige Nadelbäume. Ich kam mit dem Eigentümer ins Gespräch, der nichts von den Dingen wusste, die sich hier zugetragen hatten. Also berichtete ich und zeigte ihm die Aufnahme, die der österreichische Romancier Josef Haslinger kurz zuvor im *ZEITmagazin* als sein „Foto des Jahrhunderts" bezeichnet hatte. Ich fragte ihn, weshalb er das Feld in einen Wald umgewandelt habe, und er erklärte mir, dass er die Bäume als Weihnachtsbäume nach Spanien und Portugal exportiere. Als ich ihn fragte, ob er die Bedeutung des Wortes „Tannenbaum" kenne, verneinte er, und als ich es ihm übersetzte, verschlug es ihm die Sprache.

prises avec ce dilemme, un sergent m'apprit que les Nazis avaient anéanti un peloton entier de notre compagnie. Le 12 janvier, il m'emmena sur les lieux du carnage. Les corps des soldats étaient partiellement recouverts de neige. Je me suis avancé pour découvrir qui avait été tué et, en arrivant auprès d'un soldat mort, je me suis dit : « Stop, Tony, cette image est ton requiem photographique. N'abîme pas la neige. » J'ai reculé jusqu'à l'endroit d'où j'ai pris une seule photo. Le soldat était mon camarade de régiment Henry I. Tannenbaum, de New York City.

Cinquante ans plus tard

En 1995 j'ai rencontré son fils Sam et nous sommes devenus bons amis. L'année dernière, je me suis rendu à Bihain en Belgique à l'endroit même où j'ai pris la photo. Son fils voulait y ériger une stèle en l'honneur d'Henry. Le champ est devenu une forêt de sapins. J'ai demandé au propriétaire s'il savait ce qui s'était passé à cet endroit durant la guerre. Il n'était pas au courant. Je lui ai dit qu'à cet endroit même j'avais pris une photo qualifiée d' « une des meilleures images du siècle » par le romancier autrichien Josef Haslinger dans le *ZEITmagazin* allemand. Il a regardé la photo que j'avais sur moi. Ensuite, je lui ai demandé pourquoi il avait transformé ce champ de céréales en forêt. Il m'a répondu que ce n'était pas une forêt mais qu'il faisait pousser sur ce terrain, depuis des années, des sapins qu'il revendait à Noël en Espagne et au Portugal. Je lui ai ensuite demandé s'il connaissait la signification du mot allemand *Tannenbaum*. Il m'a répondu par la négative. Quand je lui ai dit que le mot voulait dire sapin, il est resté sans voix.

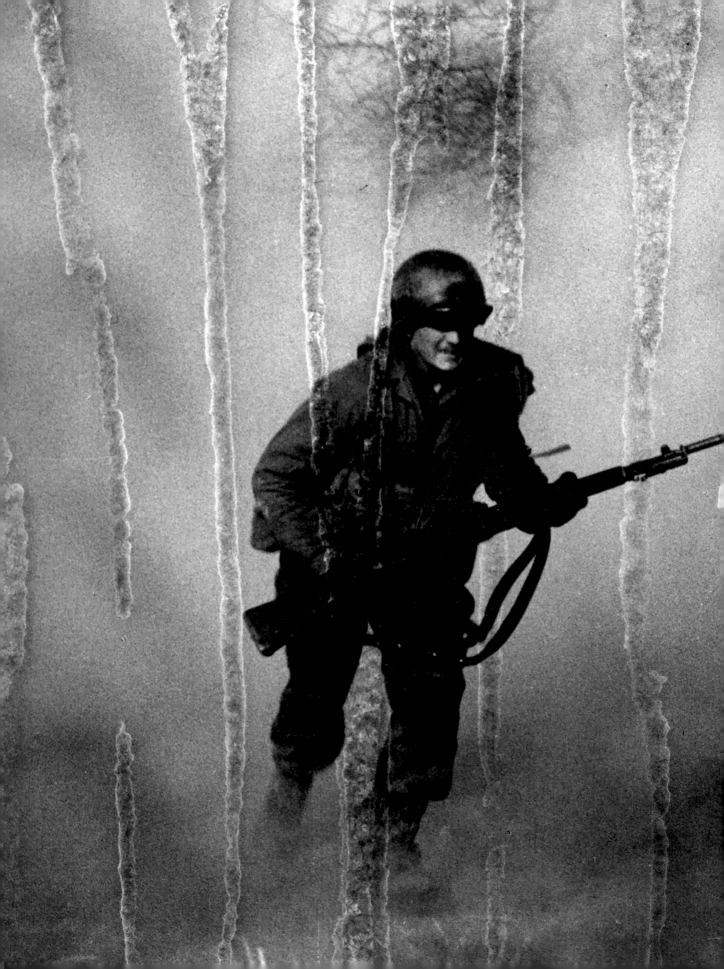

In no-man's-land. Private Ivan Parrott of Deckerville, Michigan, during the Battle for the Rhine

Im Niemandsland. Der Gefreite Ivan Parrott aus Deckerville, Michigan, während der Schlacht am Rhein

Dans le no man's land : le caporal Ivan Parrott de Deckerville, Michigan, pendant la bataille du Rhin

Neuss. March 1, 1945

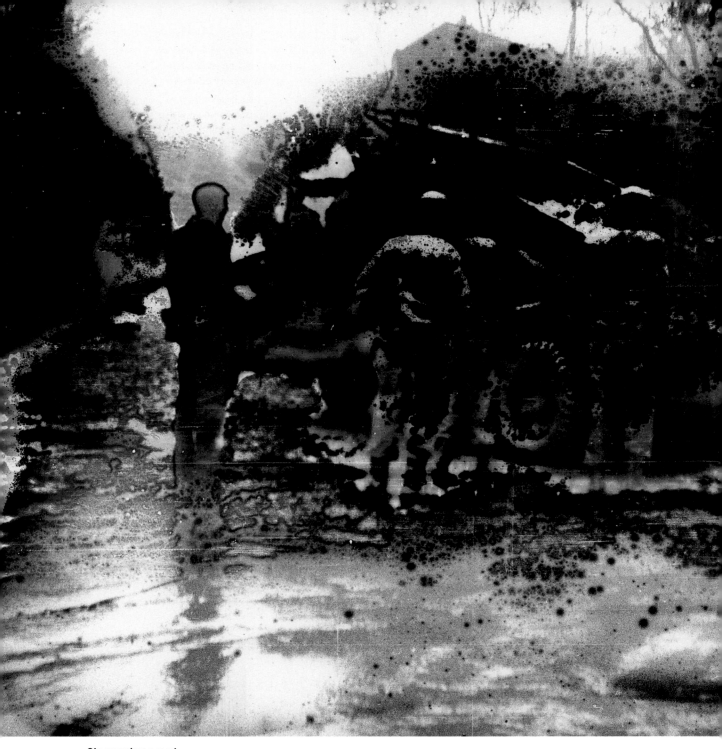

GIs repaving a road

GIs bei Straßenarbeiten

GIs réparant une route

Hürtgen Forest. December 13, 1944

In August 1947, while I was on an assignment in Spain, there was a flood in the Pfungstadt cellar darkroom, where I had a footlocker containing all my negatives. I lost about 4,000 negatives. Some, like these, were marred by the water; others were completely destroyed.

Im August 1947 — ich war einiger Aufträge wegen in Spanien unterwegs – verlor ich durch eine Überschwemmung der im Keller eingerichteten Dunkelkammer in Pfungstadt etwa 4 000 Negative. Einige, wie die hier gezeigten, wiesen Wasserschäden auf, andere wurden ganz zerstört.

J'étais parti faire des photos en Espagne, au mois d'août 1947, quand la chambre noire que j'avais aménagée dans la cave de Pfungstadt a été inondée. J'ai ainsi perdu environ 4 000 négatifs. Voici quelques exemples des photos plus ou moins détruites.

Drenched GIs of the 329th Regiment entering Germany
Durchnässte GIs des 329. Regiments beim Einmarsch in Deutschland
GIs trempés du 329ᵉ régiment entrant en Allemagne
Hof Hardt, near Düren. December 7, 1944

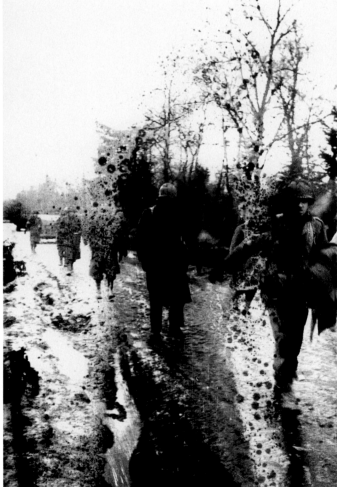

During WW II we wore boots with rubber bottoms while the German soldiers had boots with metal nails. At night we heard them a mile away, but they could not hear us until we were on top of them.

Während die deutschen Soldaten Metallbeschläge unter ihren Stiefeln hatten, trugen wir Stiefel mit Gummisohlen. Nachts konnten wir die Deutschen kilometerweit hören, sie uns jedoch nicht, bis wir im wahrsten Sinnes des Wortes über sie herfielen.

Nous portions des bottes à semelles de caoutchouc alors que celles des soldats allemands avaient des semelles cloutées. La nuit, nous les entendions à des kilomètres, mais eux ne nous remarquaient que lorsque nous tombions sur eux, dans le meilleur sens du terme.

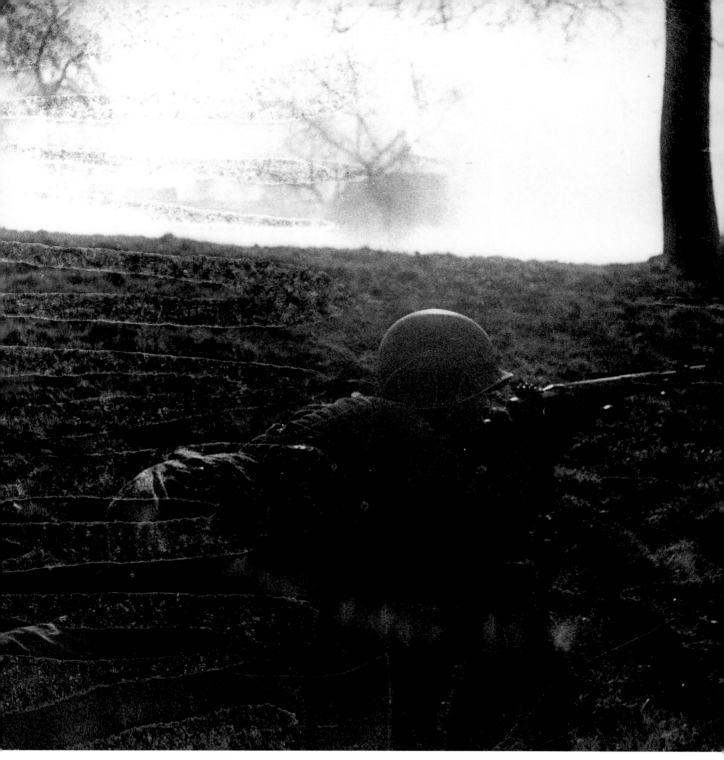

Pvt. Ivan Parrott aiming his M-1 at a German soldier

Der Gefreite Ivan Parrot nimmt mit seinem M-1-Gewehr einen deutschen Soldaten ins Visier.

Le caporal Ivan Parrot pointe son M-1 sur un soldat allemand.

Neuss. March 1, 1945

The most traumatic experience of my life: aiming my rifle at a human being

Die traumatischste Erfahrung meines Lebens: mit meinem Gewehr auf einen Menschen zielen

L'expérience la plus traumatisante de ma vie: pointer mon fusil sur un être humain

Taking a direct hit from a P-47 airplane, this Tiger tank burst into flame. The turret opened and a German soldier with his uniform on fire clambered out and fell in front of the tank. When I took the picture, German soldiers shot at me and I hit the ground from where I could read on his buckle: "Gott mit uns" (God with us).

Dieser Tiger-Panzer wurde von einer P-47 beschossen und ging in Flammen auf. Die Luke öffnete sich und ein brennender Soldat stürzte ins Freie. Als ich diese Aufnahme machte, wurde auf mich geschossen. Ich warf mich auf den Boden; auf dem Koppelschloss des vor mir liegenden Toten konnte ich die Worte „Gott mit uns" lesen.

Un P-47 abattu a touché un char Tigre, causant une explosion. La tourelle s'est ouverte et un soldat allemand en flammes s'est précipité dehors. On a tiré sur moi quand j'ai pris cette photo, je me suis jeté sur le sol et je pouvais lire sur la boucle de son ceinturon : « Gott mit uns » (Dieu avec nous).

Hemmerden, near Grevenbroich. February, 1945

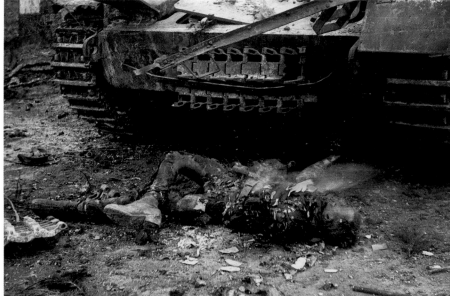

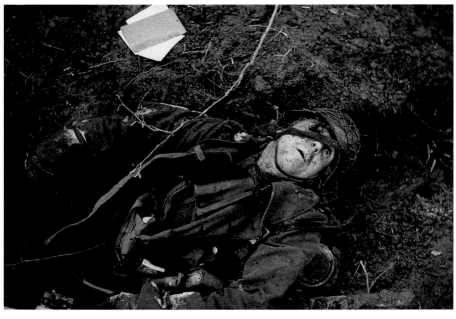

The dead soldier and the Christmas card from his family

Der tote Soldat und die Weihnachtskarte von seiner Familie

Le soldat mort et la carte de Noël de sa famille

Hürtgen Forest. December, 1944

A wounded GI found himself stuck in the middle of no-man's-land. For over half an hour he screamed for help. No one dared to go over to him except for an officer who could no longer stand the cries of the dying soldier in the forest clearing. The officer, with a white handkerchief in one hand and a first aid kit in the other started to crawl towards the wounded American. When he was almost there, a single shot was heard, reverberating throughout the forest. Eventually the wounded GI bled to death. The single shot from an M-1 rifle had killed the officer who had tried to help him, Lt. Friedrich Lengfeld of the Wehrmacht.

Ein verwundeter GI, einsam und verlassen, mitten im Niemandsland. Über eine halbe Stunde schreit er um Hilfe. Niemand wagt es, zu ihm zu gehen, bis schließlich einer der Offiziere die Schreie des Sterbenden nicht länger mit anhören kann. Ein weißes Taschentuch in der einen, einen Verbandskasten in der anderen Hand, kriecht er zu dem Verwundeten hinüber. Als er ihn fast erreicht hat, hallt plötzlich ein einzelner Schuss durch den Wald. Der verletzte GI verblutet. Der Schuss aus seiner M-1 hatte den Offizier, der versucht hatte, ihm zu helfen, getötet – es war ein Offizier der Wehrmacht, Leutnant Friedrich Lengfeld.

Un GI est blessé au beau milieu du no man's land qui sépare les premières lignes. Pendant plus d'une demi-heure, il appelle à l'aide. Personne n'ose s'approcher de lui, à l'exception d'un officier qui ne peut plus supporter les cris du soldat mourant. Cet officier, brandissant un mouchoir blanc dans une main et une trousse de première urgence dans l'autre, commence à ramper vers le soldat américain. Il se rapproche et le GI blessé le voit. Au moment où il le rejoint, on entend tirer une balle. Le coup de feu se répercute dans toute la forêt. Finalement, le GI blessé cesse d'appeler. Il est mort d'hémorragie. Son coup de feu a tué l'officier qui voulait l'aider le lieutenant Friedrich Lengfeld de la Wehrmacht.

Lost in the Hürtgen Forest, this German soldier ran into a booby trap, set by the Nazis in a tree. It exploded in his face, charring his skin and destroying his eyes. One of our medics, who gave him first aid and understood the seriousness of the wound, had nothing but compassion for the unfortunate twenty-year-old.

Das Gesicht dieses deutschen Soldaten wurde völlig verbrannt. Der Mann verlor sein Augenlicht, als eine in einem Baum versteckte Bombe direkt vor ihm explodierte. Einer unserer Ärzte, der ihm Erste Hilfe leistete, hatte gleich erkannt, wie schwer die Verletzungen waren – doch mehr als tiefes Mitgefühl konnte er dem gerade Zwanzigjährigen nicht geben.

Une bombe dissimulée dans un arbre par les Nazis a explosé juste à côté de ce soldat allemand âgé de vingt ans. Son visage et ses yeux ont été gravement brûlés. Nos médecins ont fait tout leur possible, mais le jeune homme était trop gravement touché. Ils n'avaient que leur compassion à lui offrir.

Hürtgen Forest. December, 1944

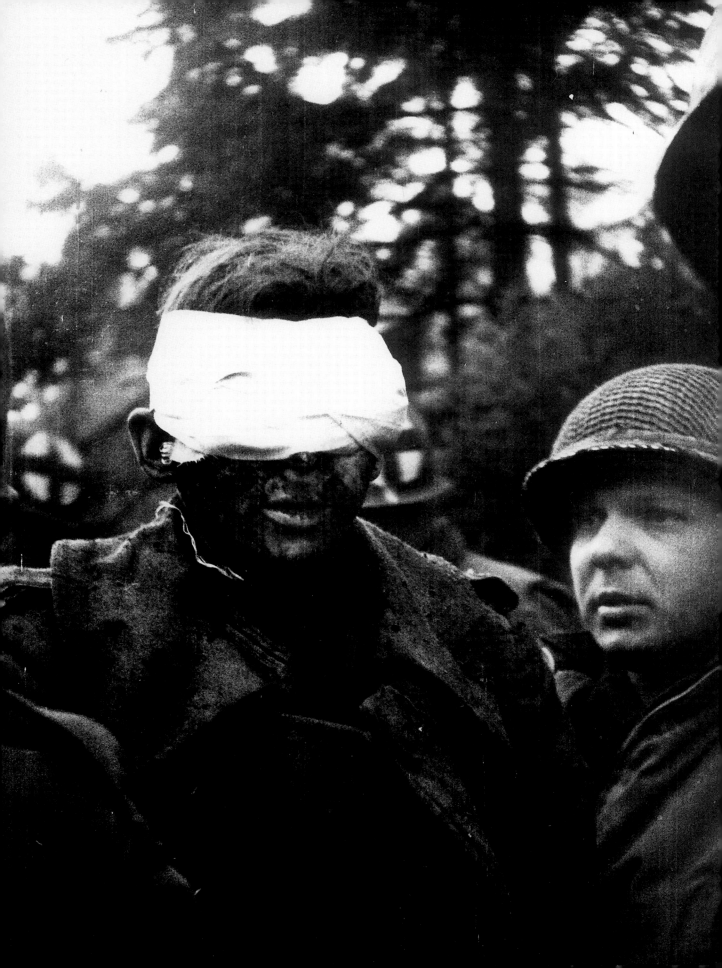

Christmas gift packages. The packages on the right were not delivered: most of the addressees had been killed.

Weihnachtspäckchen von zu Hause. Die Päckchen, die auf der rechten Seite des Bildes zu sehen sind, waren „unzustellbar". Die meisten Adressaten waren tot.

Les cadeaux de Noël envoyés par la famille. Les paquets que l'on voit à droite n'ont pas pu être délivrés. La plupart des destinataires étaient morts.

Hürtgen Forest. December 20, 1944

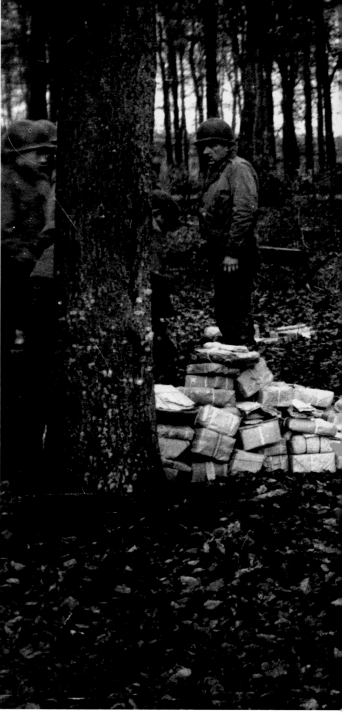

Disposing of the Dead. The frozen corpses were thrown upon the trailer of a Jeep and taken to a cemetery.

Die gefrorenen Leichen dieser Gefallenen wurden auf den Anhänger eines Jeeps geworfen und dann zum Friedhof gebracht.

Les corps gelés des soldats morts sont chargés sur la remorque d'une Jeep et emportés au cimetière.

Hürtgen Forest. December 23, 1944

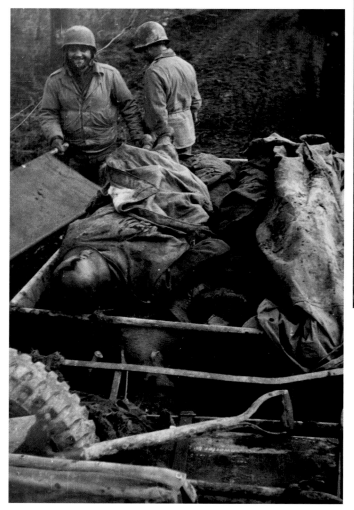

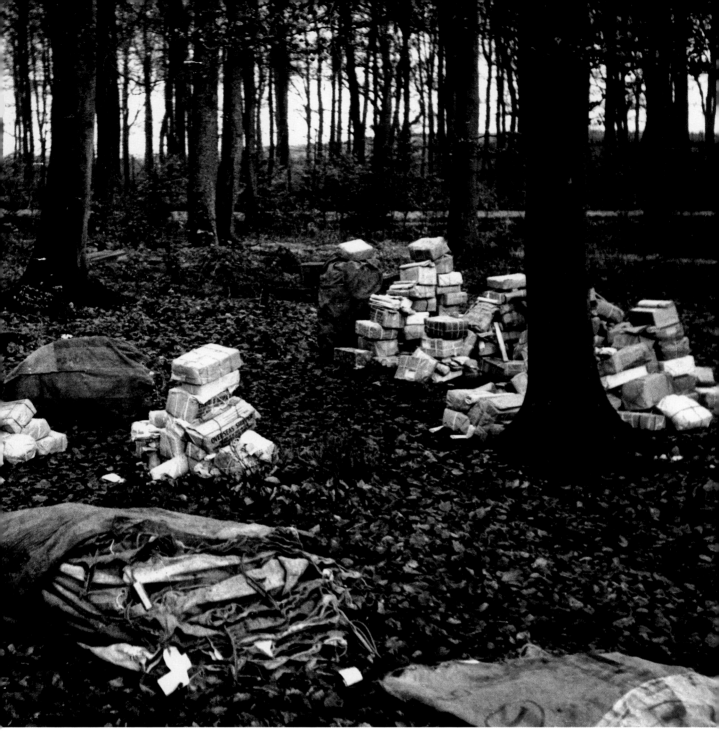

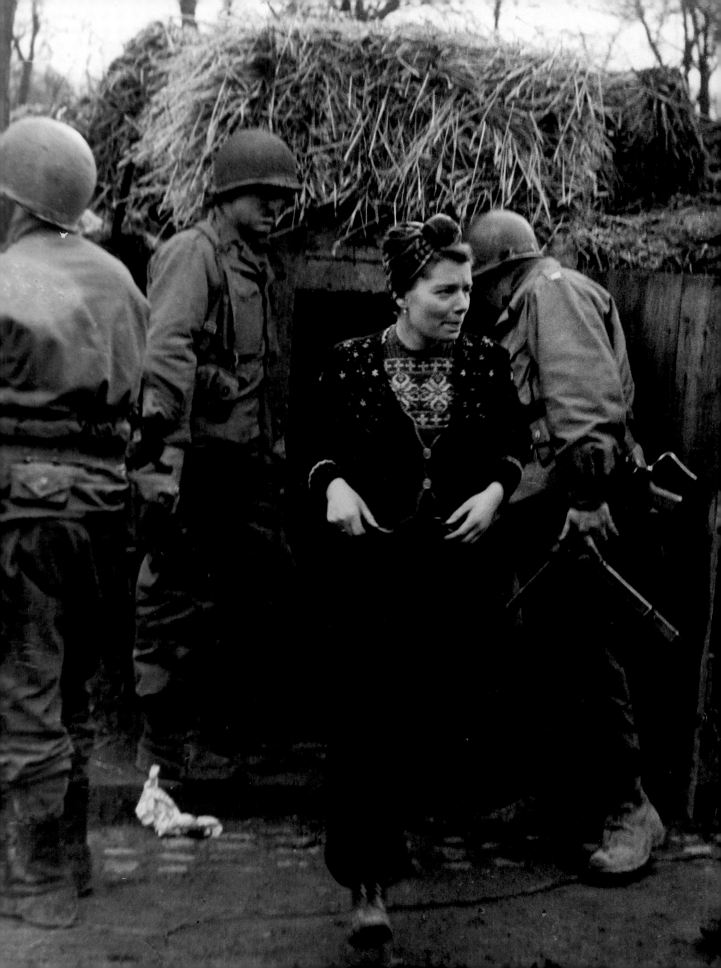

After the battle, inhabitants of a town are evacuated from the shelter.

Nach der Schlacht werden die Einwohner aus ihren Schutzräumen herausgetrieben.

Après la bataille, les soldats font sortir les habitants des abris.

Near Grevenbroich. February, 1945

German prisoners behind barbed wire
Deutsche Kriegsgefange hinter Stacheldraht
Prisonniers allemands derrière les barbelés
Near Neuss. March, 1945

Whatever became of those prisoners?

From the closing days of the war and for weeks afterwards, German soldiers from the eastern front made their way over to the American lines to avoid being captured by the Russians. At the beginning of June 1945, about a month after the end of the war, men of Co. A, 803rd TD BN, appeared in a motley procession numbering more than 650 German vehicles of every shape and size. They transported 10,000 of those prisoners, without telling them their destination, from their homeland, lovely Bavaria, nearly 200 km to the Russian lines in Czechoslovakia. As the convoy entered that country, the prisoners discovered where they were being taken. One of them turned to a group of GIs and in clear English said: "I never thought you Americans would do this to us."

Was wurde aus diesen Gefangenen?

In den letzten Kriegstagen und den ersten Nachkriegswochen versuchten viele deutsche Soldaten von der Ostfront die amerikanischen Linien zu erreichen, um russischer Gefangenschaft zu entgehen. Anfang Juni 1945 wurden 10 000 deutsche Gefangene den Russen überstellt, ohne dass sie gewusst hätten, was sie erwartete. In einem Zug von mehr als 650 Fahrzeugen brachte man die Männer aus ihrer Heimat in Bayern über eine Strecke von fast 200 km in die Tschechoslowakei. Erst als der von Soldaten des 803. Jagdbataillons eskortierte Konvoi die Grenze erreichte, wurde den Gefangenen klar, welches Schicksal auf sie zukam. Einer von ihnen wandte sich an eine Gruppe von GIs und sagte in klarem Englisch: „Ich hätte nie geglaubt, dass ihr Amerikaner uns das antun würdet."

Que sont devenus ces prisonniers ?

Les derniers jours de la guerre et pendant des semaines ensuite, des soldats allemands du front Est gagnèrent la zone américaine pour éviter d'être capturés par les Russes. Au début de juin 1945 des hommes de la Compagnie A, appartenant à la 803e division blindée, dans une procession bigarrée comptant plus de 650 véhicules en tout genre, transférèrent à leur insu 10 000 de ces prisonniers, de la riante Bavière, leur pays natal, en Tchécoslovaquie. Or celle-ci, située à deux cents kilomètres de là, se trouvait à l'époque en secteur russe. Comme le convoi pénétrait dans ce pays, les prisonniers découvrirent où on les emmenait. L'un d'eux se tourna vers un groupe de GIs et l'interpella en bon anglais : « Je n'aurais jamais pensé que vous autres Américains nous feriez ça. »

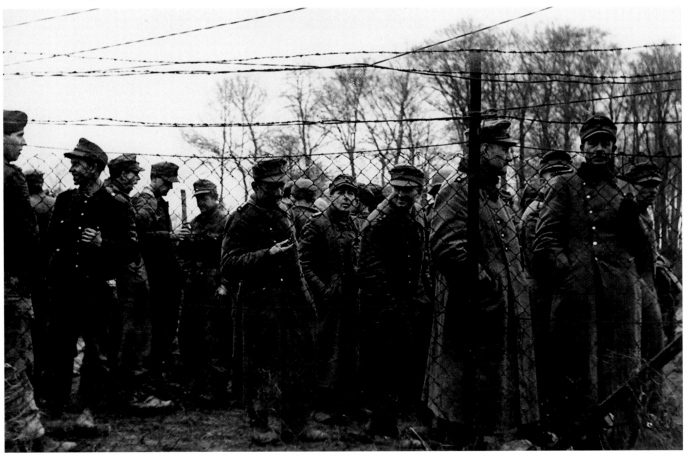

The German "soldier" of Hohenlepte

When the war ended I was in the hamlet of Hohenlepte, some 50 miles southwest of Berlin. As soon as I heard the news, I went for a walk in the forest. During the war I thought I had seen all the cruellest scenes imaginable. I was hoping the quietude of the unspoiled woods would begin to help me forget all that.

But, I was wrong—the worst war scene possible was yet to come. In the gutter I saw the bloodied body of a woman dressed in a German Army uniform with her machine gun and bazooka nearby. She was lying on her back with her skirt pulled above her waist, panties torn, knees apart and a knife stuck in her body.

Der deutsche „Soldat" von Hohenlepte

Bei Kriegsende befand ich mich in dem kleinen Dorf Hohenlepte, etwa 90 km südwestlich von Berlin. Nachdem ich von der deutschen Kapitulation erfahren hatte, machte ich einen Waldspaziergang. Ich glaubte, während des Krieges die grausamsten Szenen gesehen zu haben, die man sich nur vorstellen kann, und hoffte, in der Ruhe des unberührten Waldes Abstand von diesen Bildern zu gewinnen.

Doch ich hatte mich geirrt – die schlimmste Kriegsszene stand mir noch bevor. Am Wegrand sah ich den blutigen Körper einer Frau, die eine deutsche Armeeuniform trug, neben ihr ein Maschinengewehr und eine Panzerfaust. Sie lag auf dem Rücken, mit hochgezogenem Rock, zerrissenem Schlüpfer und gespreizten Beinen. In ihrem Körper steckte ein Messer.

Le « soldat » allemand de Hohenlepte

Quand la guerre a pris fin, je me trouvais dans le hameau de Hohenlepte, à 90 km au sud-ouest de Berlin. Dès que j'ai appris la nouvelle, je suis parti me promener dans la forêt. Je croyais avoir assisté aux scènes les plus cruelles possibles et j'espérais que la quiétude des bois m'aiderait à commencer d'oublier tout cela.

Mais je me trompais. La pire de toutes les scènes était encore à venir. Dans un caniveau, j'ai vu le corps ensanglanté d'une femme revêtue d'un uniforme allemand. Sa mitraillette et son arme portative antichar gisaient non loin d'elle. Elle était étendue sur le dos, la jupe remontée au-dessus de la taille, la culotte déchirée et un couteau planté dans sa chair.

The "soldier" with the red earrings

After the brutal battle of the Hürtgen Forest, my Battalion was given the task of capturing the town of Gey. We attacked the town at dawn on December 10, 1944. As we approached, we were pinned down by a lot of fire coming from a house with a red roof. We concentrated our attack on that house. When the battle was over, I entered the house. On the right side, the table was set with a breakfast for one person, but the food had not been touched. On the right side of the wall there was a picture of the Holy Virgin, and on the left, there was one of Hitler. I looked at the dead soldier on the floor and noticed something red under "his" helmet. I removed the helmet and there was the face of a beautiful young woman wearing red earrings.

Der „Soldat" mit den roten Ohrringen

Nach der grausamen Schlacht im Hürtgenwald bekam unser Bataillon den Befehl, den Ort Gey einzunehmen. Am 10. Dezember 1944 griffen wir bei Tagesanbruch an. Als wir näherrückten, wurden wir aus einem Haus mit rotem Dach unter heftigen Beschuss genommen. Wir konzentrierten unseren Angriff auf dieses Haus. Als die Schlacht vorbei war, ging ich hinein. Auf einem Tisch an der rechten Wand stand ein Frühstück für eine Person. Es war nicht angerührt worden. Rechts an der Wand hing ein Bild der Jungfrau Maria, links eins von Hitler. Auf dem Fußboden lag ein toter Soldat. Unter dem Helm lugte etwas Rotes hervor. Als ich „ihm" den Helm vom Kopf nahm, sah ich in das Gesicht einer schönen jungen Frau, die rote Ohrringe trug.

Le « soldat » aux boucles d'oreilles rouges

Après la sanglante bataille de la forêt de Hürtgen, mon bataillon avait pour mission de prendre la ville de Gey. Nous avons attaqué Gey à l'aube du 10 décembre 1944. En approchant de la ville, nous avons été stoppés net par un feu nourri provenant d'une maison au toit rouge. Nous avons concentré notre attaque sur cette maison. Une fois l'escarmouche finie, je suis entré. A droite le couvert était mis pour le petit déjeuner, pour une personne, mais on n'avait pas touché à la nourriture. Sur le côté droit du mur, était accrochée une image de la Vierge et sur le côté gauche, une photo de Hitler. J'ai regardé le soldat mort étendu par terre et j'ai remarqué quelque chose de rouge sous son casque. En l'ôtant j'ai découvert le visage d'une belle jeune femme qui portait des boucles d'oreilles rouges.

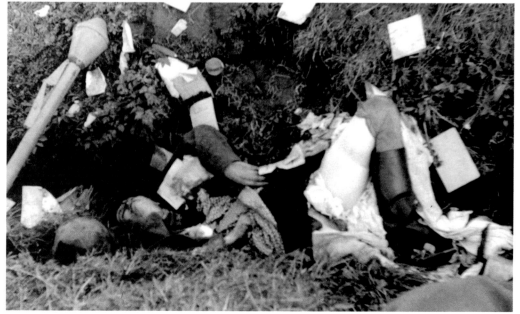

The "soldier" with the bazooka
Der „Soldat" mit der Panzerfaust
Le « soldat » au bazooka
Hohenlepte. May 8, 1945

**The "soldier" with the
red earrings**
**Der „Soldat" mit den
roten Ohrringen**
**Le « soldat » aux boucles
d'oreilles rouges**
**Gey, near Düren
December 10, 1944**

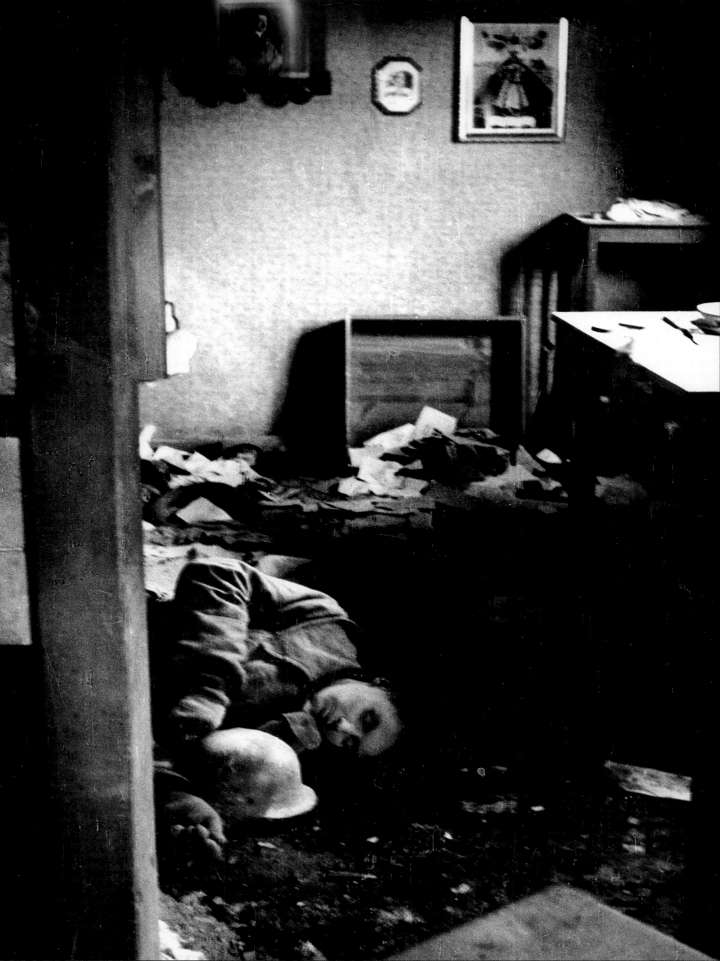

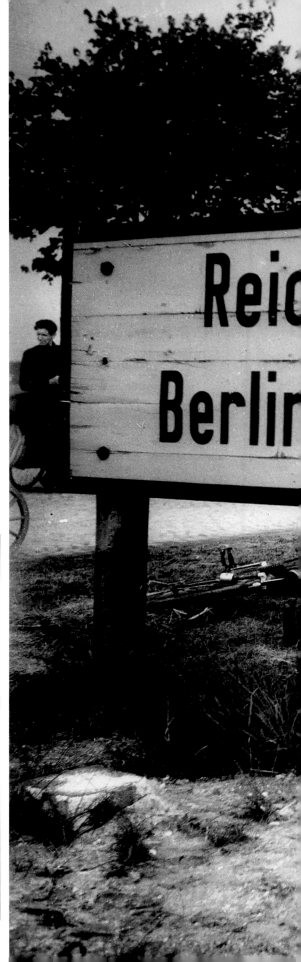

Meeting the Red Army

Das Zusammentreffen mit der Roten Armee

Rencontre avec l'Armée rouge

Near Coswig. May, 1945

The Americans at the Elbe. Maj. Lawrence A. Laliberte,
2nd Battalion executive officer, at the Truman Bridge

Die Amerikaner an der Elbe. Major Lawrence A. Laliberte,
Erster Offizier des 2. Bataillons, an der Truman-Brücke

Les Américains sur l'Elbe. Le major Lawrence A. Laliberte,
officier supérieur du 2ᵉ bataillon, devant le pont Truman

Walternienburg, near Barby. April 15, 1945

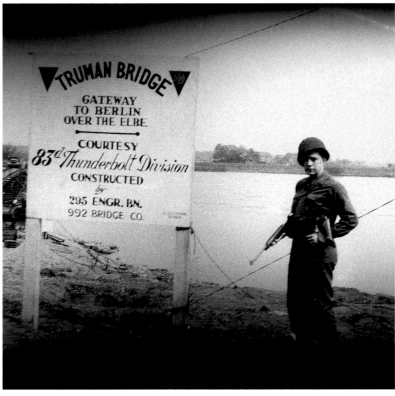

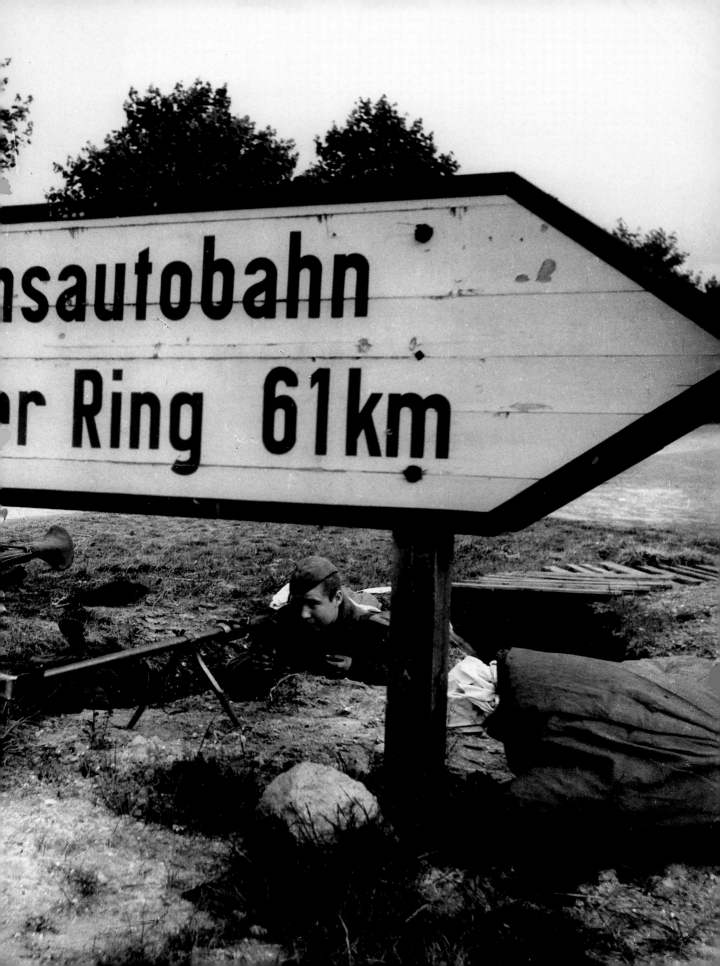

Capturing a German town en route
to the Elbe

**Einnahme einer deutschen Stadt
beim Vormarsch Richtung Elbe**

Prise d'une ville allemande
pendant la marche sur l'Elbe

Near Paderborn. April 5, 1945

Germans watching GIs taking their town

Die deutschen Einwohner beobachten, wie GIs ihre Stadt einnehmen.

Les Allemands regardent les GIs prendre leur ville.

Calbe, near Magdeburg. April 12, 1945

**Interrogating German officers. On
the right, my friend Lieutenant
Candler Wiselogle**

**Vernehmung deutscher Offiziere.
Rechts mein Freund Leutnant
Candler Wiselogle**

**L'interrogatoire d'officiers
allemands. A droite, mon ami,
le lieutenant Candler Wiselogle**

**Vahlbruch, near Bad Pyrmont
April, 1945**

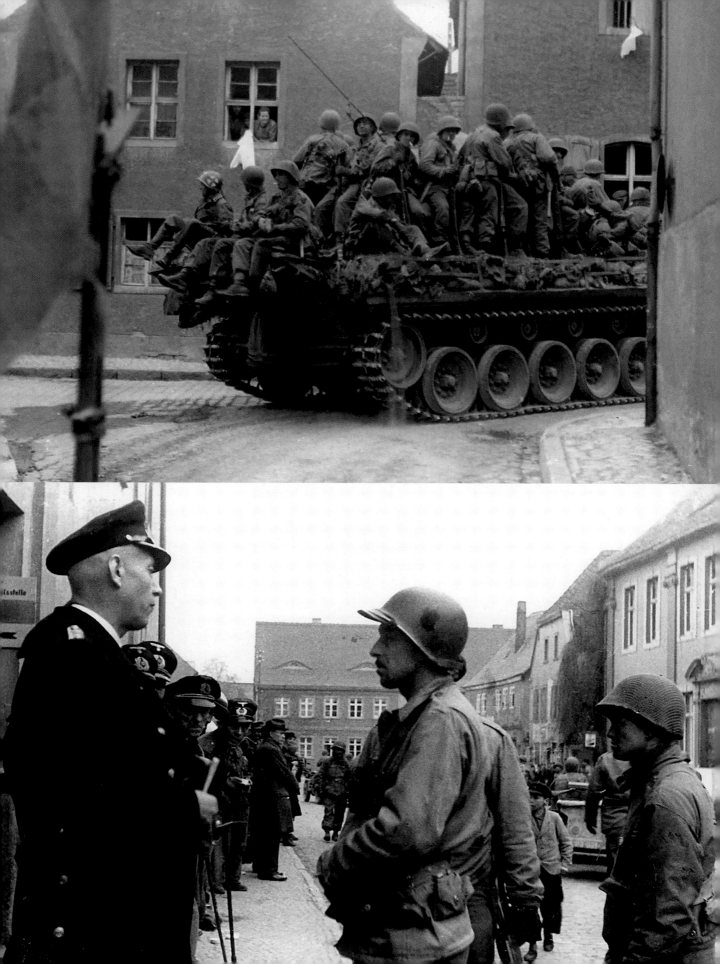

Friday the 13th

In April 1945, I stood alone on the west bank of the Elbe at Barby, trying out seven Luger pistols. I tested six and then took a few steps south and found a child's pair of white-rimmed sunglasses. I put them on as a joke. Oddly, the last pistol had two holes from where a projectile could exit. I pulled the trigger and my face was suddenly engulfed in a cloud of hot smoke and small particles. The sunglasses were almost pierced by the powder. I was lucky. Without those glasses, I could have blinded myself. The pistol was for track events and had a blank cartridge. It was 5:45 a.m. War is absurd.

I returned to my unit and exchanged the pistols for a tennis racket, which another GI had been carrying throughout the war. Then I went to a room at the top of a clinic for the elderly to take a panoramic picture of the Elbe. Lying in a bed in the room was a frail old woman. Suddenly an 88mm shell hit the corner of the ceiling, burying her under a heap of debris and me in a cloud of dust. The shell missed me by three yards. Once again I washed my face. It was 6:00 a.m. War is a tragedy.

Outside, trucks had arrived with boats we were to use for crossing the river. Halfway across the Elbe, the strangest noise began to come from the overcast sky above us. It was a propeller-less plane that dove directly for my boat. Luckily it did not fire. (Later I learned it was a prototype of an ME 262 jet sent by Hitler to locate the American advance.) It heralded the Jet Age. It was 6:35 a.m. War is an illusion.

On the east side of the river we took a rest. A stray bullet hit the support of the road sign I was leaning against. The battle east of the Elbe had begun, resulting in the total destruction of once lovely Zerbst, which had been visited by Catherine the Great. It was 7:54 a.m. War is a scourge. In the first few hours of that morning, I had used up all my luck. I was glad to be alive on that day east of the Elbe—to make it through to nighttime, calmness and caution were called for, because, as my Belgian calendar kept reminding me, it was "Vendredi 13". War is unpredictable.

Freitag der 13.

Im April 1945 stand ich allein am Westufer der Elbe bei Barby. Ich hatte sieben Luger-Pistolen und testete, wie sich mit ihnen schießen ließ. Bevor ich die siebte in die Hand nahm, fand ich in der Nähe eine Kindersonnenbrille, die ich mir spaßeshalber aufsetzte. Die letzte Pistole hatte merkwürdigerweise zwei Geschossausgänge. Ich drückte ab – mein Gesicht war in eine Wolke aus heißem Rauch und kleinen Partikeln gehüllt. Das Pulver hätte die Gläser der Sonnenbrille fast durchdrungen. Ich hatte Glück gehabt. Ohne diese Sonnenbrille wäre ich womöglich erblindet. Es war eine Wettkampfpistole mit einer Platzpatrone. Ich schaute auf die Uhr, 5.45 Uhr. Der Krieg ist absurd.

Ich kehrte zu meiner Einheit zurück und tauschte die Pistolen gegen einen Tennisschläger, den ein anderer GI während des ganzen Krieges mit sich herum geschleppt hatte. Anschließend wollte ich von einem Zimmer im obersten Stock eines Altenheims eine Panoramaansicht der Elbe aufnehmen. In dem Zimmer lag eine gebrechliche alte Frau in ihrem Bett. Plötzlich schlug ein 88-mm-Geschoss in die Zimmerdecke ein und begrub die alte Frau unter einem Haufen Schutt. Das Geschoss hatte mich knapp verfehlt. Schon wieder musste ich mir das Gesicht waschen. 6.00 Uhr morgens. Der Krieg ist eine Tragödie.

Draußen wurden uns auf Lastwagen die Boote gebracht, mit denen wir die Elbe überqueren sollten. Wir befanden uns mitten auf dem Fluss, als wir über uns ein seltsames Geräusch hörten, ein propellerloses Flugzeug, das direkt auf uns zu flog. Glücklicherweise wurde nicht geschossen. (Später erfuhr ich, dass es sich um einen Prototyp des Düsenjets ME 262 handelte, der die Vorhut der Amerikaner orten sollte.) Ein Vorbote des Düsenzeitalters. 6.35 Uhr. Der Krieg ist eine Illusion.

Am Ostufer der Elbe machten wir eine Pause. Eine verirrte Kugel traf den Pfosten des Verkehrsschildes, an das ich mich angelehnt hatte. Hier begann die Schlacht östlich der Elbe. Die schöne, alte Residenzstadt Zerbst, die Katharina die Große einst besucht hatte, wurde völlig zerstört. 7.54 Uhr. Der Krieg ist eine Heimsuchung. In den frühen Morgenstunden dieses Tages war ich mehr als einmal dem Tod entronnen. Ich war froh, noch einmal davon gekommen zu sein. Jetzt galt es, diesen Tag zu überstehen, Gelassenheit und Vorsicht walten zu lassen. Ein Blick in meinen belgischen Kalender mahnte mich: es war "Vendredi 13". Der Krieg ist unberechenbar.

Vendredi 13

Un jour d'avril 1945, j'essayais des pistolets, sept Luger, à Barby, sur la rive ouest de l'Elbe. J'en avais testé six quand, en faisant quelques pas, j'ai découvert une paire de lunettes de soleil d'enfant à monture blanche. Je les ai chaussées pour plaisanter. Bizarrement, le dernier pistolet avait deux canons. J'ai appuyé sur la détente et j'ai été enveloppé d'un nuage de fumée brûlante et de minuscules particules. Les verres des lunettes ont failli éclater : j'ai eu de la chance. Sans ces lunettes, je serais peut-être devenu aveugle. Le pistolet était un starter de courses chargé à blanc. Il était cinq heures quarante-cinq du matin. La guerre est une absurdité.

Je suis retourné à mon unité et j'ai échangé mes pistolets contre une raquette de tennis avec un GI qui l'avait transportée avec lui durant toute la guerre. Ensuite, je suis monté au dernier étage d'un hospice de vieillards pour prendre une photo panoramique de l'Elbe. J'ai aperçu une femme âgée et chétive allongée dans un lit. Soudain, un obus de 88 mm a explosé contre un coin du plafond, ensevelissant la petite vieille sous un monceau de gravats. L'obus m'avait manqué de trois mètres. Une fois encore, je me suis débarbouillé la figure. Il était six heures du matin. La guerre est une tragédie.

Dehors des camions venaient d'arriver, chargés d'embarcations sur lesquelles nous devions traverser l'Elbe. Arrivés au milieu du fleuve, nous avons entendu un bruit très étrange dans le ciel couvert. C'était un avion sans hélice qui plongeait droit sur nous. Heureusement, il n'a pas explosé. (Plus tard, j'ai appris, que c'était un prototype d'avion à réaction ME 262, envoyé par Hitler pour jauger l'avance des Américains.) Il annonçait l'ère de l'avion à réaction. La guerre est une illusion.

Une fois sur la rive est du fleuve, nous nous sommes reposés. Une balle perdue a percuté le panneau de signalisation contre lequel j'étais adossé. Ce fut le signal du début de la bataille de la rive est de l'Elbe qui devait aboutir à la destruction complète de la ravissante ville résidentielle de Zerbst où Catherine la Grande avait passé son enfance. Il était sept heures cinquante-quatre. La guerre est un fléau. Durant les premières heures de cette matinée, j'avais épuisé mon capital de chance. Pour tenir jusqu'au soir, il allait falloir faire preuve de calme et de prudence, parce que mon calendrier belge ne cessait de me rappeler qu'on était un vendredi 13. La guerre est imprévisible.

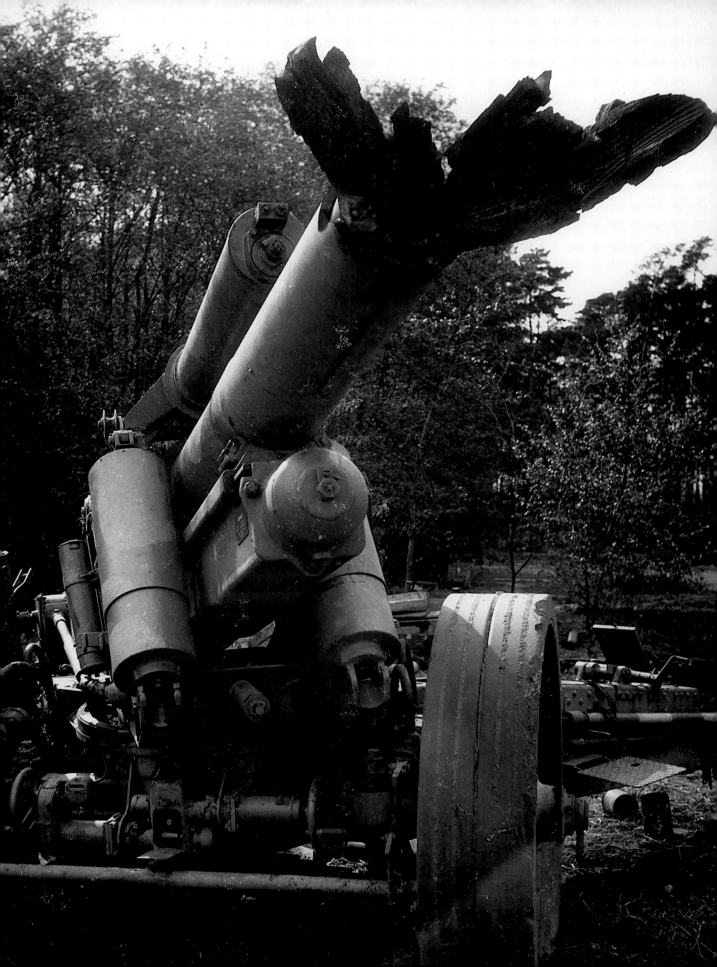

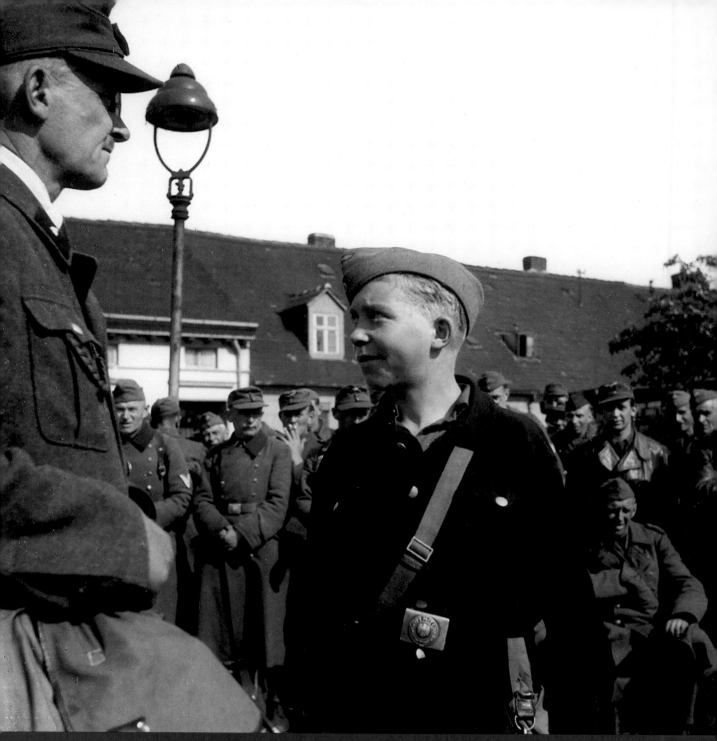

The End of the Wehrmacht
Das Ende der Wehrmacht
La fin de la Wehrmacht
Roßlau. May 8, 1945

German P.W.s
Deutsche Kriegsgefangene
Prisonniers de guerre allemands
Roßlau. May 8, 1945

A just-freed slave laborer

Ein soeben befreiter Zwangsarbeiter

Un travailleur forcé qui vient d'être libéré

Wegeleben, near Halberstadt. April, 1945

Liberated Polish slave laborers waiting for transportation to take them home

Befreite polnische Zwangsarbeiter warten darauf, nach Hause zurückkehren zu können.

Des travailleurs forcés polonais libérés attendent de pouvoir rentrer chez eux.

Calbe, near Magdeburg. April 12, 1945

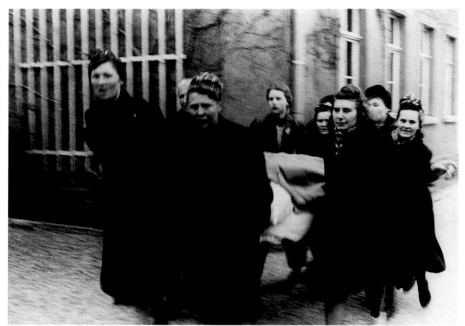

Women carrying a wounded comrade to the clinic

Frauen bringen eine Verwundete ins Krankenhaus.

Des femmes emportent une blessée à l'hôpital.

Vahlbruch, near Bad Pyrmont. April, 1945

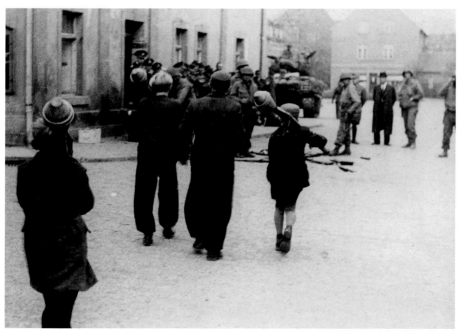

Kids and adults surrendering all kinds of arms

Kinder und Erwachsene übergeben Waffen aller Art.

Des enfants et des adultes rendent des armes de toutes sortes.

Vahlbruch, near Bad Pyrmont. April, 1945

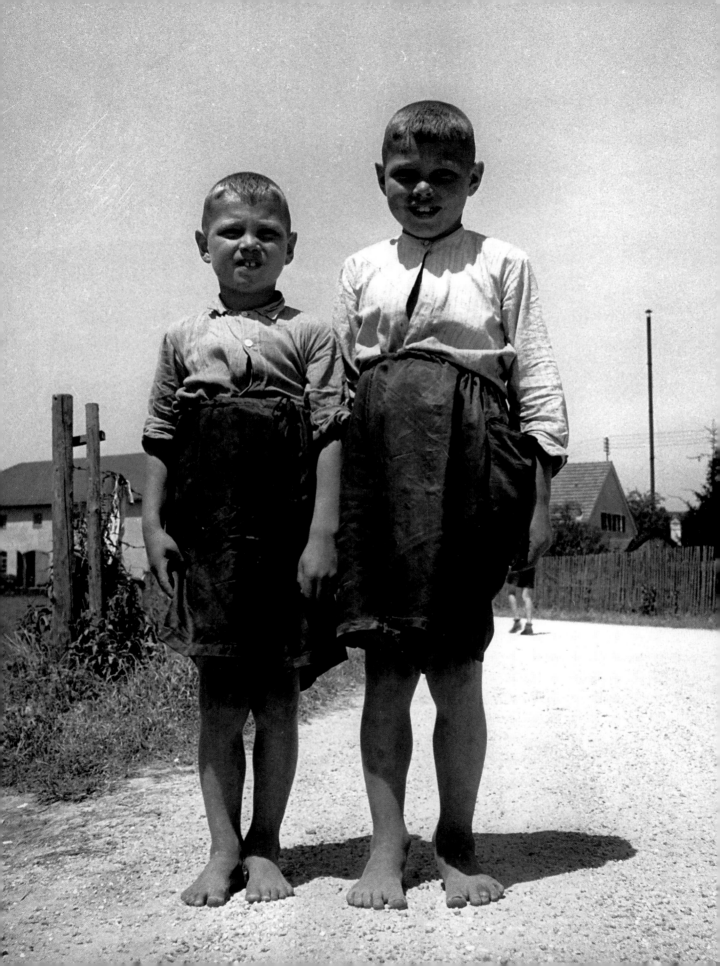

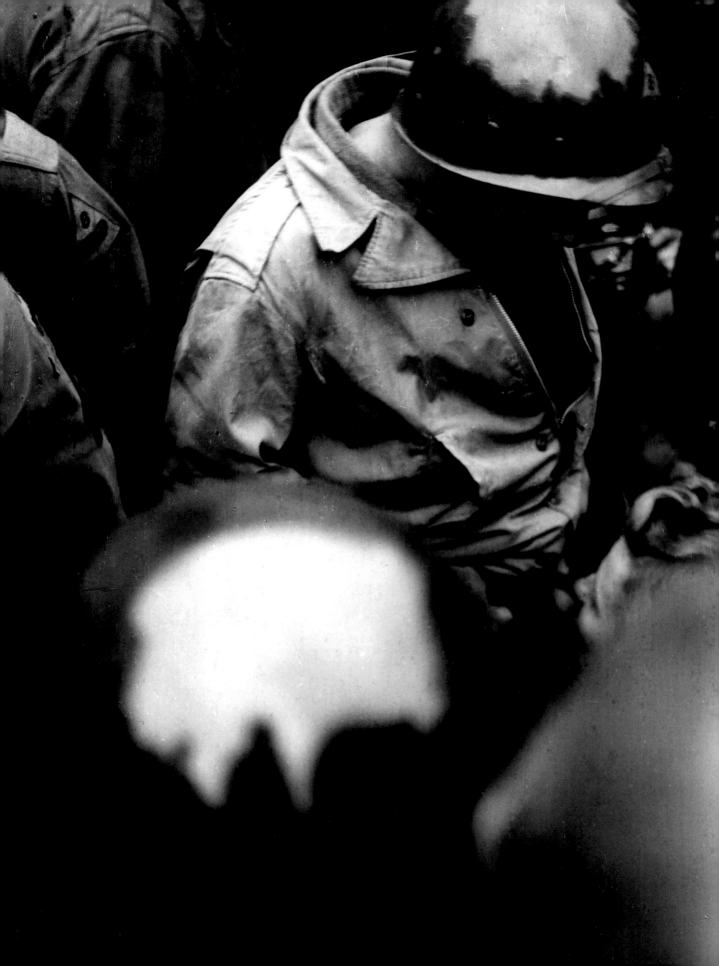

OCCUPATION

Besatzungszeit
Le temps d'occupation

A landscape of ruins

From May 9, 1945, to July 4, 1949, I lived in occupied Germany. When the Occupation began I had my trepidations: Would we succeed, or would the Germans turn into guerrillas and ambush us at every dark corner?

My regiment, the 83rd Infantry Division, was pulled out from the Russian Zone and relocated west of the Elbe. It took over the military government of the province and city of Braunschweig. (I was happy about this move because the manufacturer of Rolleiflex cameras, based in this city gave me one as a gift). During the war, I had been too busy saving my skin to take a look at the bombed-out German cities. But now, with plenty of time on my hands – and a Rolleiflex in them – I began to view and photograph the remains of the city. Braunschweig was now a landscape of ruins, which at first appealed to me because of the interesting photographic motifs it offered. But later some surprising statistics changed my mind.

The city had a prewar population of about 200,000. Those people had lived in about 16,000 houses which made up a beautiful city. But, during the war the British Royal Air Force and the U.S. Eighth Air Force had reduced it to dust. After the bombing, only about 3,000 of those houses remained standing. The bodies of a great number of innocent people, many children included, were no doubt still under those ruins. This awareness made me feel that I was not taking pictures of photogenic ruins but those of an immense, unsightly cemetery with standing ruins as steles. On my assignments, I eventually traveled to most of the major cities of Germany: they had all been reduced to cemeteries. What I saw led me to believe that our bombing of the

Eine einzige Ruinenlandschaft

In der Zeit vom 9. Mai 1945 bis zum 4. Juli 1949 lebte ich im besetzten Deutschland. Zu Beginn der Besatzungszeit beschäftigte mich vor allem die Frage, ob wir erfolgreich sein würden; ich hatte Angst, dass die Deutschen in den Untergrund gehen und uns aus dem Hinterhalt überfallen würden. Meine Einheit, die 83. Infanteriedivision, war aus der sowjetischen Besatzungszone in ein Gebiet westlich der Elbe zurückverlegt worden und übernahm die Verwaltung des Landes und der Stadt Braunschweig. (Für mich war das ein Glücksfall, denn Braunschweig war der Sitz der Rollei-Werke, und tatsächlich bekam ich eine Rolleiflex-Kamera geschenkt.) Im Krieg war ich so sehr damit beschäftigt gewesen, meine Haut zu retten, dass ich die ausgebombten deutschen Städte gar nicht richtig wahrgenommen hatte. Jetzt aber hatte ich eine Kamera und jede Menge Zeit. So begann ich, die zerstörte Stadt zu fotografieren. Braunschweig war eine einzige Ruinenlandschaft, die sich für mich zunächst lediglich dadurch auszeichnete, dass sie eine Unzahl interessanter Motive bot. Doch kam ich im Laufe der Zeit immer mehr ins Grübeln. Vor dem Krieg hatten hier etwa 200 000 Menschen gelebt, in einer schönen, alten Stadt mit etwa 16 000 Häusern, die von Touristen aus aller Welt besucht wurde. Die Royal Air Force und unsere Eighth Air Force hatten sie jedoch nahezu dem Erdboden gleichgemacht, nur etwa 3 000 Häuser hatten die Bombardierungen überstanden. Viele unschuldige Menschen verloren unter diesen Ruinen ihr Leben. Mir wurde mit einem Mal bewusst, dass ich keine pittoresken Ruinen fotografierte, sondern einen gewaltigen, häßlichen Friedhof, mit Trümmern als Grabsteinen.

Un paysage en ruines

J'ai « occupé » l'Allemagne du 9 mai 1945 au 4 juillet 1949. Ma division, la 83e d'infanterie a été assignée à l'arrière, à l'ouest de l'Elbe. Elle a pris en charge le commandement militaire de la province et de la ville de Brunswick (un transfert particulièrement avantageux pour moi car Brunswick était le siège de Rolleiflex et son patron m'a fait cadeau d'un appareil photo). Durant la guerre, beaucoup trop occupé à sauver ma peau, je n'avais pas réalisé la gravité du bombardement des villes allemandes par les Alliés. Dans ce secteur, disposant de beaucoup de temps libre et de mon Rolleiflex, j'ai commencé à sillonner la ville et à photographier les immeubles effondrés. Au début, je pensais que ces ruines feraient des images splendides. Et Brunswick avait beaucoup souffert des bombardements. Mais plus tard j'ai découvert des statistiques surprenantes qui m'ont fait changer d'avis. Avant la guerre, la ville comptait 200 000 habitants. Ces gens habitaient dans 16 000 maisons qui composaient une belle ville que visitaient des millions de touristes accourus du monde entier. Mais pendant la guerre, la RAF et la huitième armée de l'air américaine l'avait réduite en poussière. Après les bombardements, il ne restait plus que 3 000 immeubles debout. Un grand nombre d'innocents, parmi lesquels beaucoup d'enfants, avaient dû périr sous ces gravats. En réalisant cela j'ai compris que je ne photographiais pas des décombres photogéniques mais un immense cimetière invisible dont les ruines encore debout étaient les stèles.

Au cours de mes missions, j'ai visité la plupart des grandes villes Allemandes et toutes avaient été réduites à l'état de

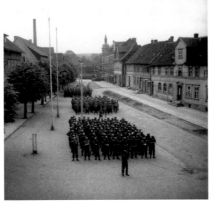

Previous double page: For one cigarette
Vorhergehende Doppelseite: Für eine Zigarette
Double page précédente : Pour une cigarette
Passau. September, 1945

Mother's day parade. At the beginning of the Occupation, townspeople shunned the Americans.

Truppenparade am Muttertag. Zu Beginn der Besatzungszeit wahrte man Distanz zu den Amerikanern.

La parade de la fête des Mères. Au début de l'Occupation, la population garde ses distances.

Seesen, near Goslar. May 13, 1945

German cities was a highly disproportionate retaliation. The Germans knew this and they hated us for it. I too felt quite ashamed of it until many years later when a German-American, of all people, convinced me otherwise.

You reap what you sow

On my return to America, a German-American who had been a student at the University of Göttingen before the war, sat at the same table I was assigned to in the ship's dining room. He had been drafted into the German Army and had been unable to get back to the States any earlier. Just to start a conversation, I told him of my feelings about the Allied destruction of German cities. He said bluntly: "Don't worry about the Germans. They will rebuild their cities even better than they were before the war. As for all that destruction, it was their fault." "What a waste," I said. Like many Germans I met, he went on as if he had not heard me. (We were now on deck taking pictures of the Statue of Liberty.) "Remember, never feel sorry for the Germans. In life you reap what you sow. It was they who invented the air bombing of cities and elevated it to an art form with their Heinkels and Junkers on April 26, 1937, at Guernica."

Als Fotoreporter kam ich in den ersten Nachkriegsjahren in die meisten größeren deutschen Städte, und alle lagen in Schutt und Asche. Ich gelangte mehr und mehr zu der Überzeugung, dass man in völlig unverhältnismäßiger Weise Vergeltung geübt hatte. Die Deutschen wussten das und viele hassten uns deswegen. Und auch ich schämte mich für die Alliierten, bis mich Jahre später ausgerechnet ein Deutsch-Amerikaner eines Besseren belehrte.

Wer Wind sät, wird Sturm ernten

Auf meiner Rückfahrt in die Vereinigten Staaten an Bord eines Transatlantikdampfers gehörte zu meiner Tischgesellschaft auch ein Deutsch-Amerikaner aus Wisconsin. Er hatte vor dem Krieg in Göttingen studiert. Man hatte ihn in die deutsche Armee eingezogen und jetzt erst konnte er in die Staaten zurückkehren. Als ich einmal von diesem Schamgefühl sprach, sagte er geradeheraus: „Machen Sie sich über die Deutschen keine Gedanken. Die bauen ihre Städte wieder auf, schöner als vor dem Krieg. Und überhaupt, diese ganzen Zerstörungen haben sie sich selbst zuzuschreiben." „Aber welch eine Vergeudung", erwiderte ich. Wie viele Deutsche, die ich kennen gelernt hatte, redete er weiter, als habe er mich nicht gehört. (Wir standen jetzt auf dem Deck des Schiffes und fotografierten die Freiheitsstatue.) „Kein Mitleid mit den Deutschen! Wer Wind sät, wird Sturm ernten. Sie waren es doch, die den Luftangriff auf Städte erfunden und ihn mit ihren Heinkel- und Junkers-Maschinen gleichsam zu einer Kunstform erhoben haben. Am 26. April 1937, in Guernica."

cimetières. Selon mes constatations de l'époque, la riposte alliée, totalement disproportionnée, était dans un rapport de un à mille. Les Allemands le savaient et ils nous haïssaient pour cette démesure. J'éprouvais encore de la honte sur ce point lorsque un Germano-américain a réussi à me convaincre que j'avais tort.

Qui sème le vent récolte la tempête

Quand je suis rentré aux Etats-Unis, mon voisin de table dans la salle à manger du paquebot était un Germano-américain qui avait fait ses études à l'université de Göttingen avant la guerre. Incorporé dans l'armée allemande il n'avait pu rentrer chez lui, dans le Wisconsin. Un jour, je lui ai confié mes sentiments concernant la destruction alliée des villes allemandes. Il m'a répondu abruptement : « Ne vous faites pas de soucis pour les Allemands. Ils reconstruiront leurs villes et elles seront encore plus belles qu'avant la guerre. Ils sont responsables de toute cette dévastation. » « Quel désastre », ai-je répondu. Nous nous trouvions à ce moment sur le pont du bateau en train de photographier la statue de la Liberté. Comme beaucoup d'Allemands que j'ai rencontrés, il a fait comme s'il ne m'avait pas entendu. « Rappelez-vous, a-t-il poursuivi, dans la vie, on récolte ce qu'on a semé. C'est eux qui ont inventé le bombardement aérien des villes et l'ont élevé à la dimension d'un art avec leurs Henkel et leurs Junker le 26 avril 1937, à Guernica. »

A German boy recieves first aid.

Einem deutschen Jungen wird Erste Hilfe geleistet.

Premiers soins à un jeune Allemand

Near Seeheim-Jugenheim/Pfungstadt
November, 1947

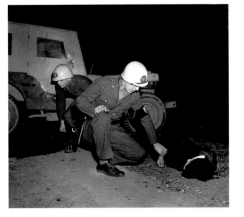

Germans reading the first occupation orders by the Allies

Deutsche lesen die ersten Anordnungen der Alliierten.

Allemands lisant les premières directives des Alliés

Anderbeck, near Halberstadt
May 13, 1945

No Love. The combat men were bored with the Occupation and wanted to return home.

No Love. Die Soldaten, die im Krieg gekämpft hatten, langweilten sich und wollten nach Hause zurück.

No Love. Les combats ont cessé, les soldats s'ennuient et veulent rentrer chez eux.

Near Halle. June, 1945

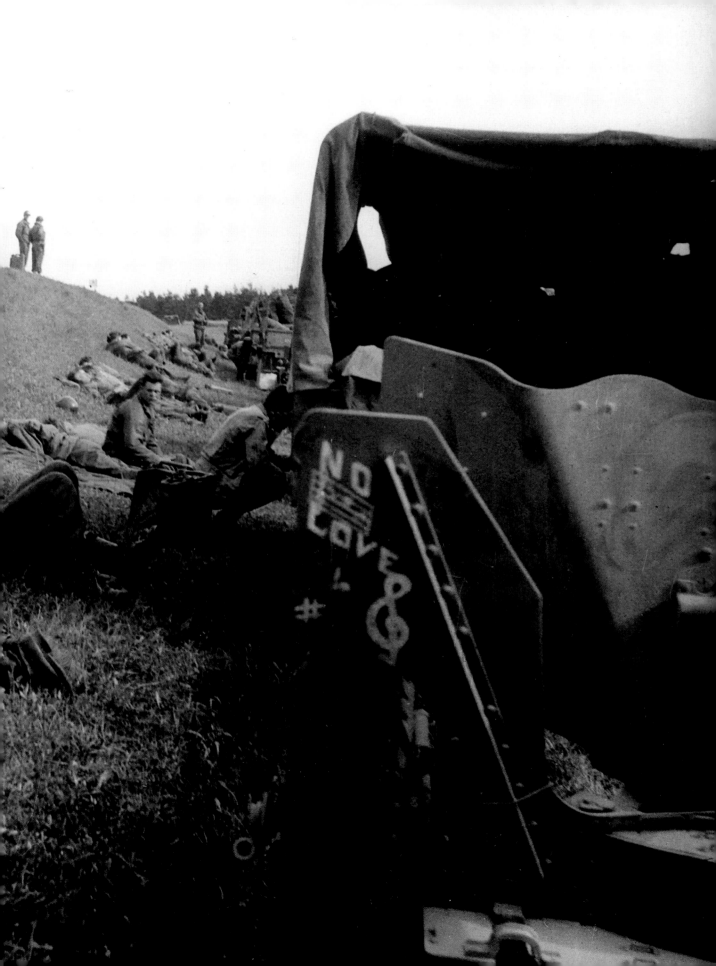

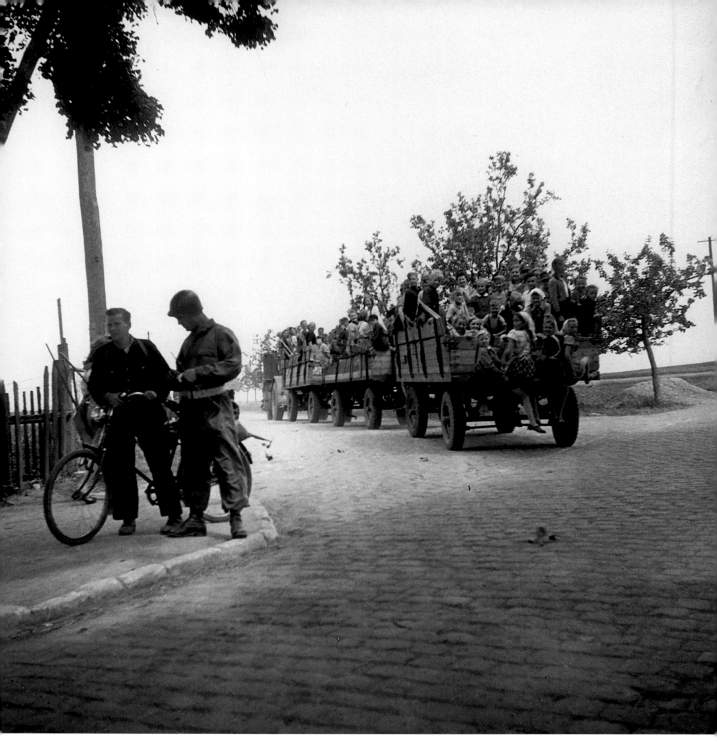

A GI checking the identification papers of a civilian

Ein GI prüft die Ausweispapiere eines Zivilisten.

Un GI vérifiant les papiers d'identité d'un civil

Zerbst. May, 1945

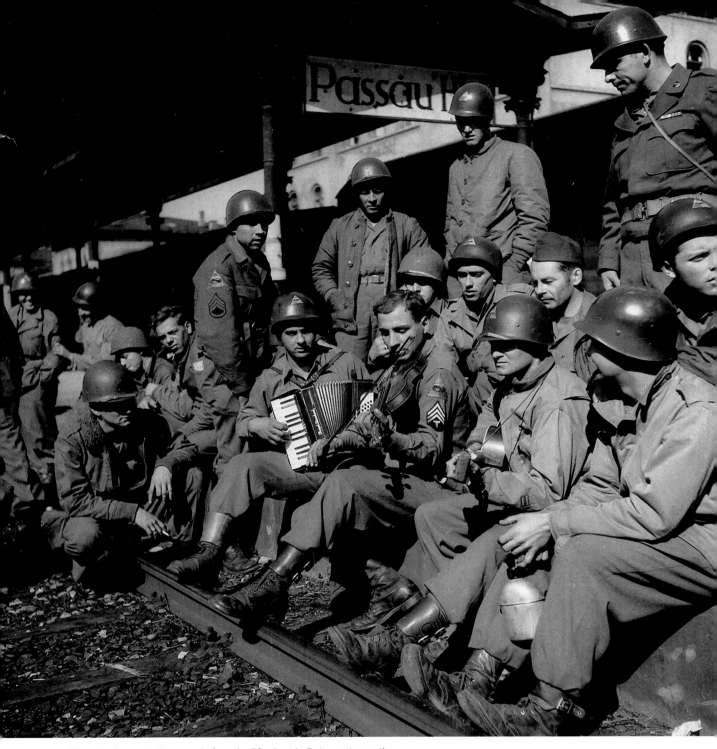

GIs going home to the sound of music. Pfc. Angelo Paternostro on the accordion, Sgt. Dominic Alimonti on the violin, and Sgt. Donald Green on guitar

Aufbruch in die Heimat, mit Musikbegleitung. Der Obergefreite Angelo Paternostro am Akkordeon, Sergeant Dominic Alimonti an der Violine und Sergeant Donald Green an der Gitarre

Retour à la maison des GIs, en musique. Le caporal-chef Angelo Paternostro à l'accordéon, le sergent Dominic Alimonti au violon et le sergent Donald Green à la guitare

Passau. September, 1945

The birthplace of Nazism
A GI guards the entrance to the "Bürgerbräukeller."

Die Geburtsstätte des Nationalsozialismus
Der Bürgerbräukeller wird von einem GI bewacht.

Le berceau du national-socialisme
Un GI garde l'entrée de la « Bürgerbräukeller ».

Munich. June, 1945

The interior of the "Bürgerbräukeller"
Das Innere des Bürgerbräukellers
L'intérieur de la « Bürgerbräukeller »
Munich. June, 1945

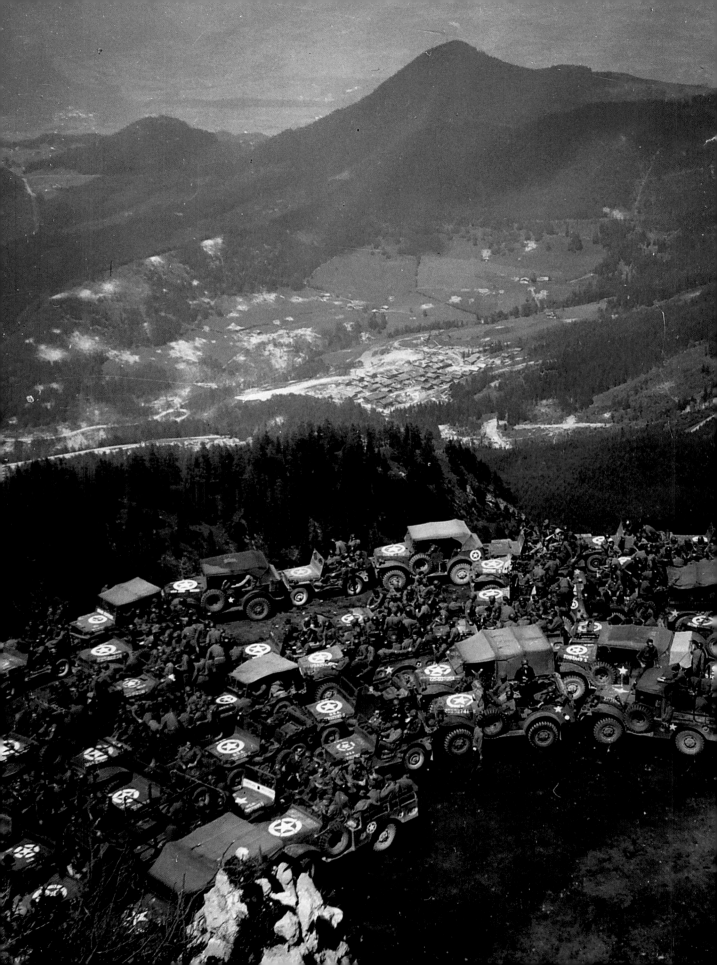

The parking area of the "Eagle's Nest" (Kehlsteinhaus)
Der Parkplatz des „Adlerhorst" (Kehlsteinhaus)
Le parking du « nid d'aigle » (Kehlsteinhaus)
Kehlstein mountain, near Berchtesgaden. June, 1945

Following double page:
GIs at the window of the "Berghof", Hitler's retreat in Bavaria
Folgende Doppelseite:
GIs am Fenster des Berghofs, Hitlers Rückzugsort in Bayern
Double page suivante:
GIs depuis la fenêtre du refuge d'Hitler au « Berghof »
Obersalzberg, near Berchtesgaden. June, 1945

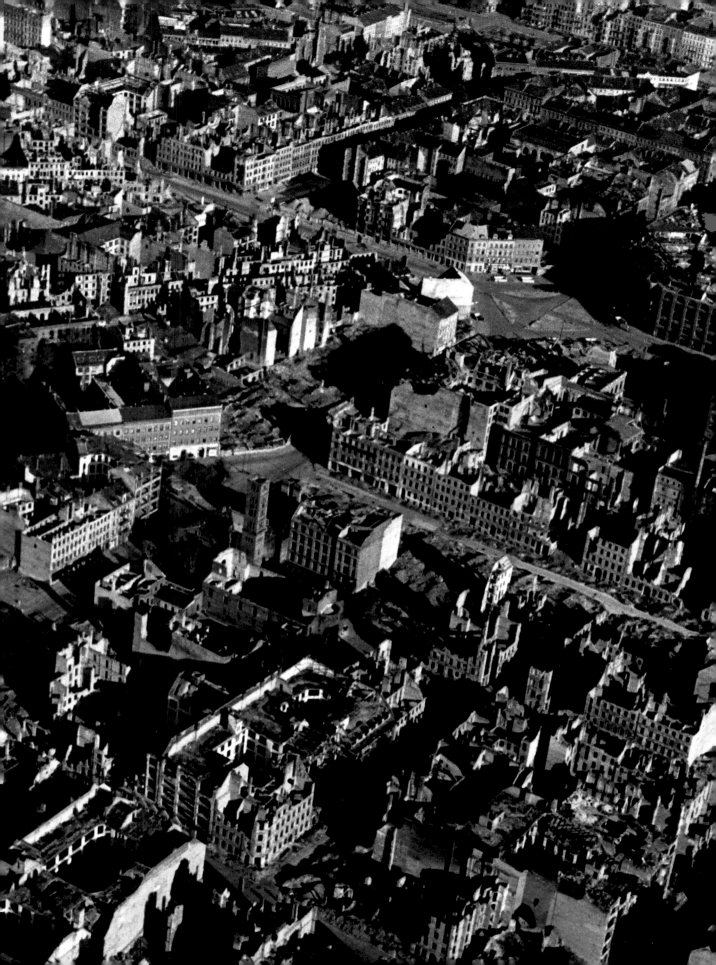

The ruins of Berlin
Die Ruinen von Berlin
Les ruines de Berlin
Berlin-Kreuzberg. December, 1945

Following double page:
Folgende Doppelseite:
Double page suivante:
Reichstag
Berlin. December, 1948

Gedächtniskirche
Berlin. December, 1948

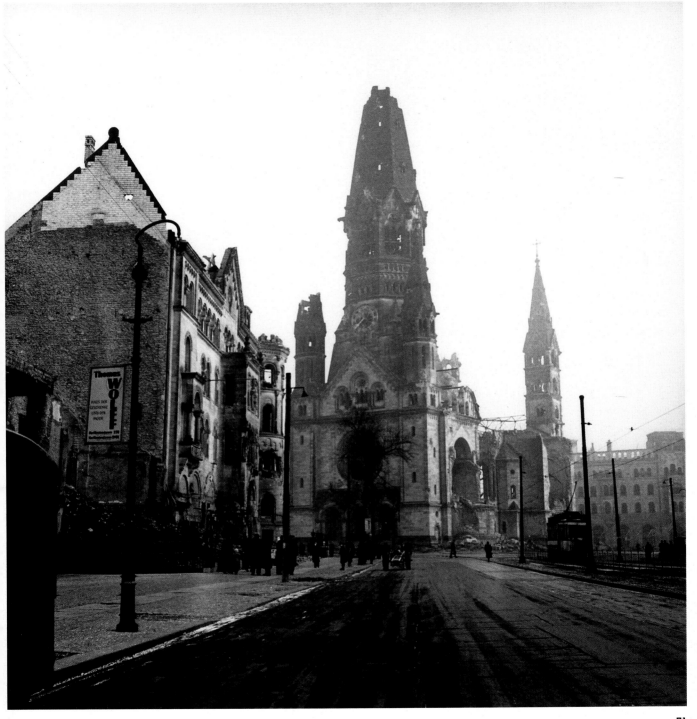

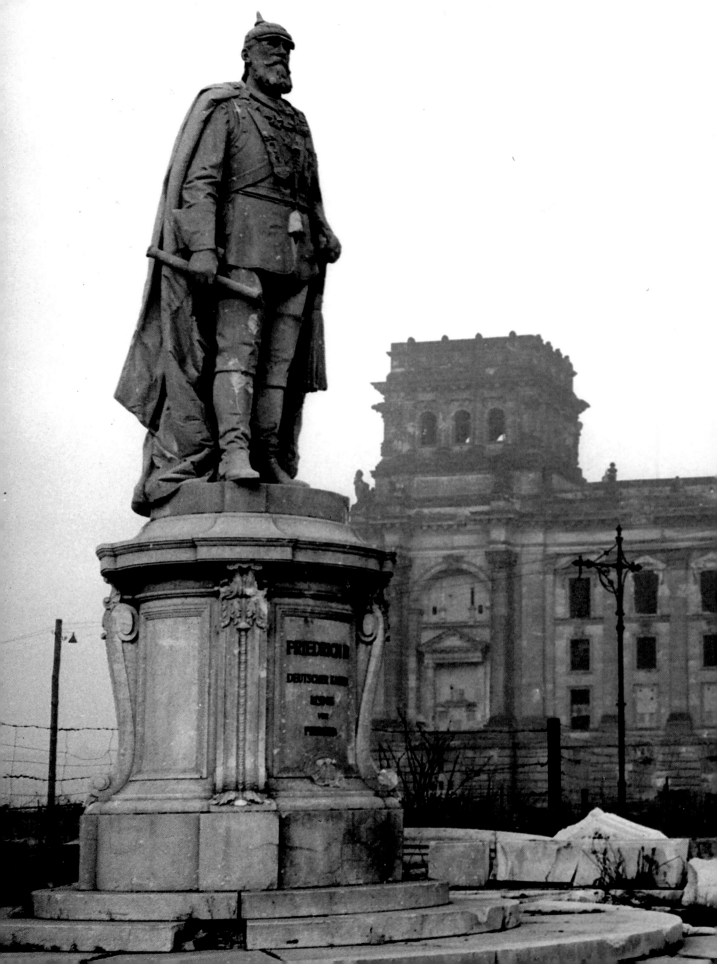

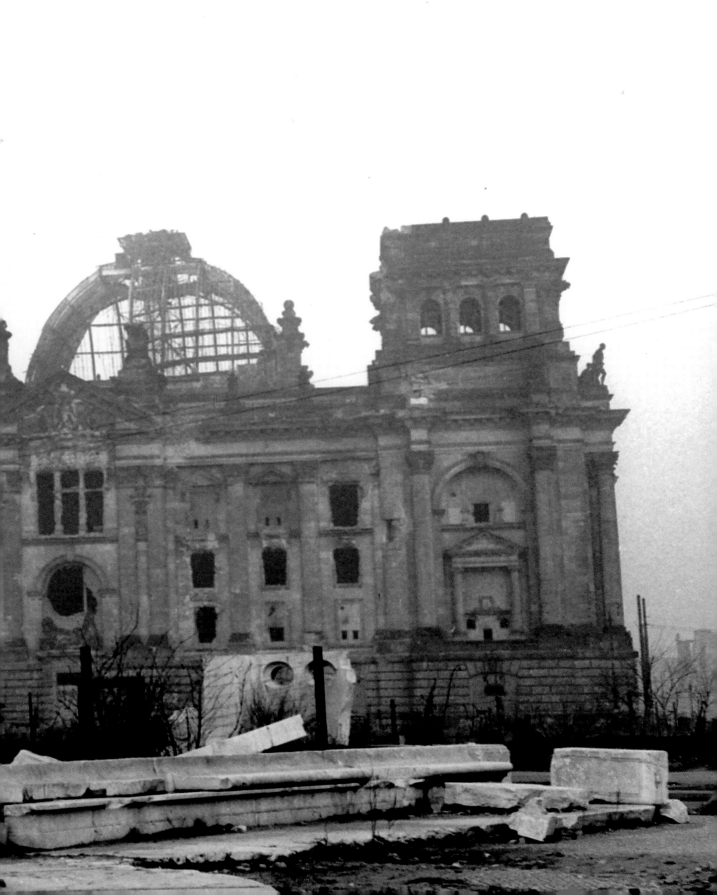

Ode to Joy? Monument to Friedrich Schiller, whose ode
inspired Beethoven to write his 9th symphony

Ode an die Freude? Das Denkmal Friedrich Schillers,
dessen Ode Beethoven zur 9. Sinfonie inspirierte

Hymne à la joie ? Le monument à Schiller dont un poème
a inspiré à Beethoven la 9e symphonie

Frankfurt. February, 1946

Death of a chestnut tree

Ein abgestorbener Kastanienbaum

La mort d'un châtaignier

Frankfurt. February, 1946

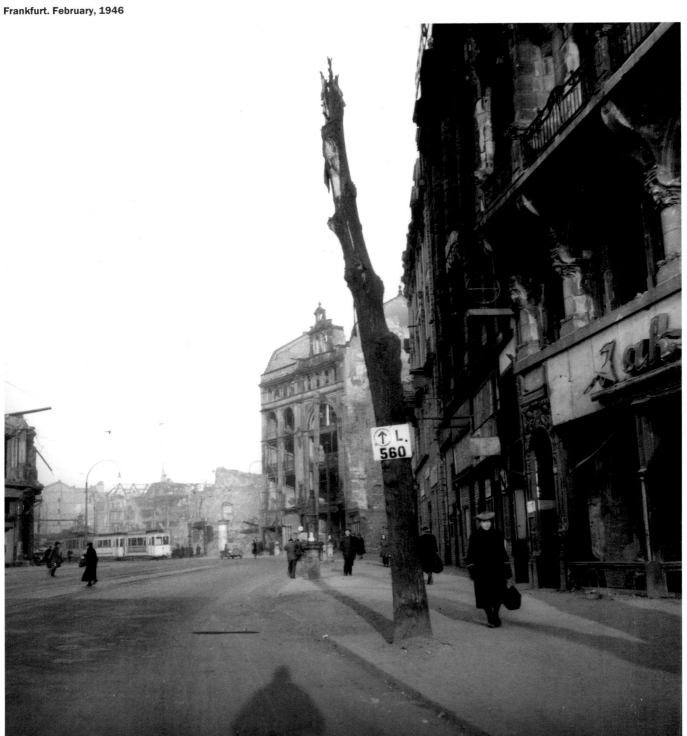

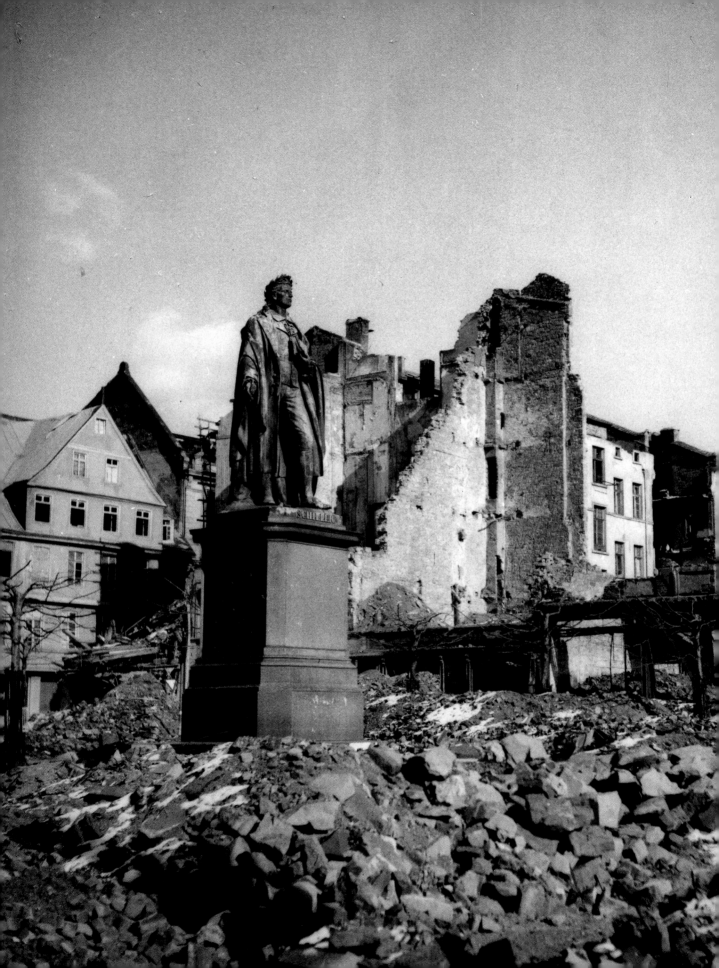

Cross above the ruins of Stuttgart
Ein Kreuz über den Ruinen von Stuttgart
Une croix au-dessus des ruines de Stuttgart
December, 1947

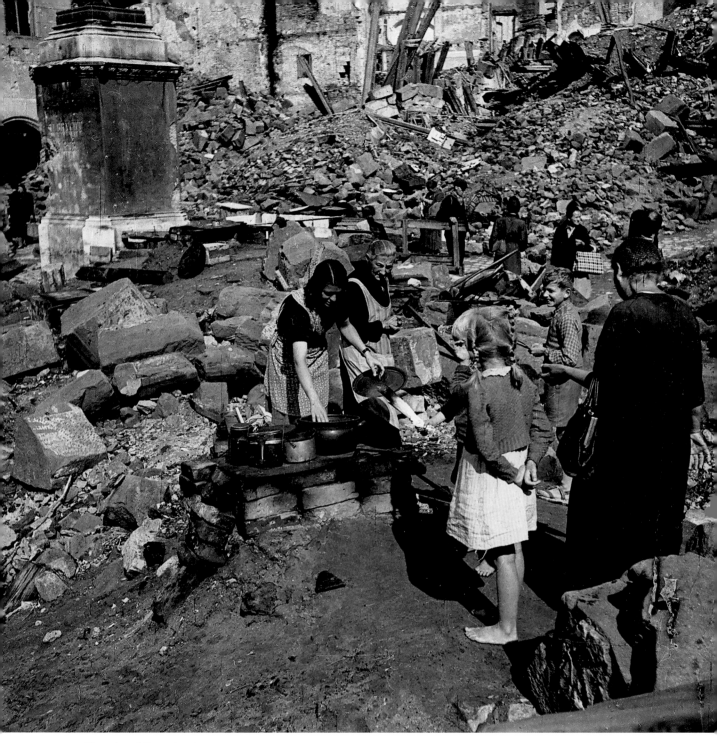

The ruins of Nuremberg
Die Ruinen von Nürnberg
Les ruines de Nuremberg
June, 1945

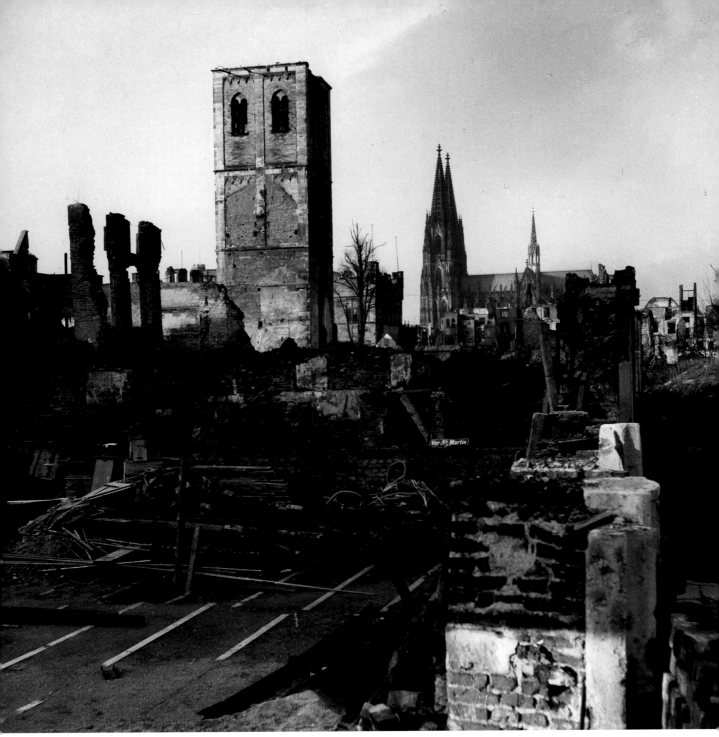

The ruins of Cologne
Die Ruinen von Köln
Les ruines de Cologne
March 6, 1947

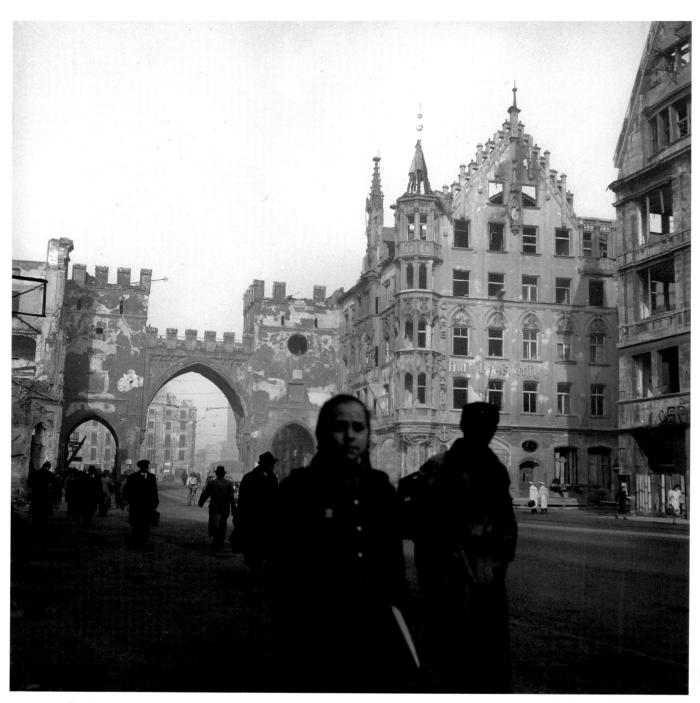

Street scene
Straßenszene
Scène de rue
Munich. March, 1946

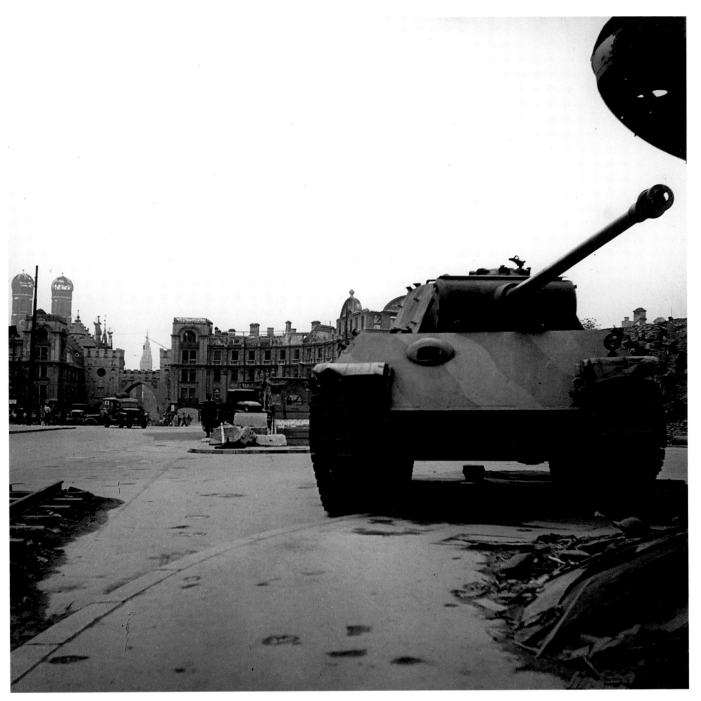

German tank on Stachus Square
Deutscher Panzer auf dem Stachus
Char allemand sur le Stachus
Munich. March, 1945

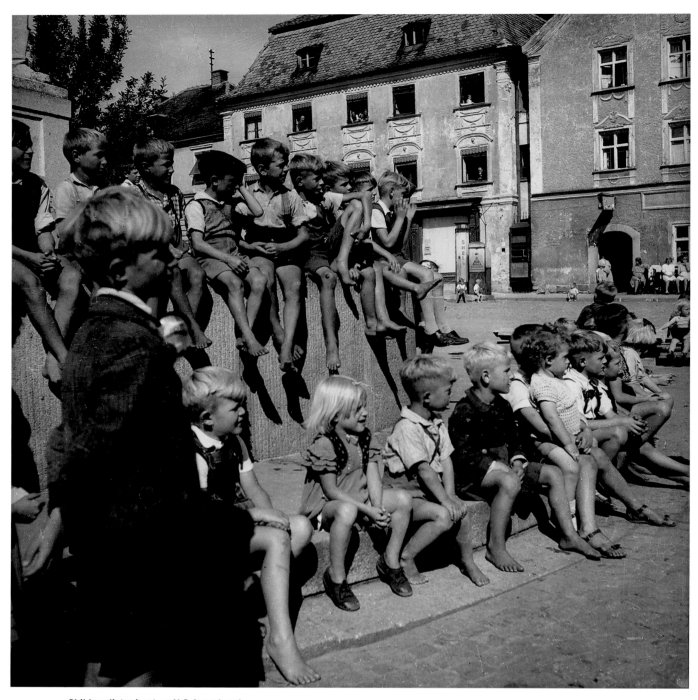

Children listening to a U.S.Army band
Kinder lauschen einer amerikanischen Militärkapelle.
Enfants écoutant l'orchestre de l'armée américaine
Hengersberg, near Passau. July, 1945

Boy walking a dog

Ein Junge geht mit seinem Hund spazieren.

Jeune garçon promenant son chien

Frankfurt. April 1946

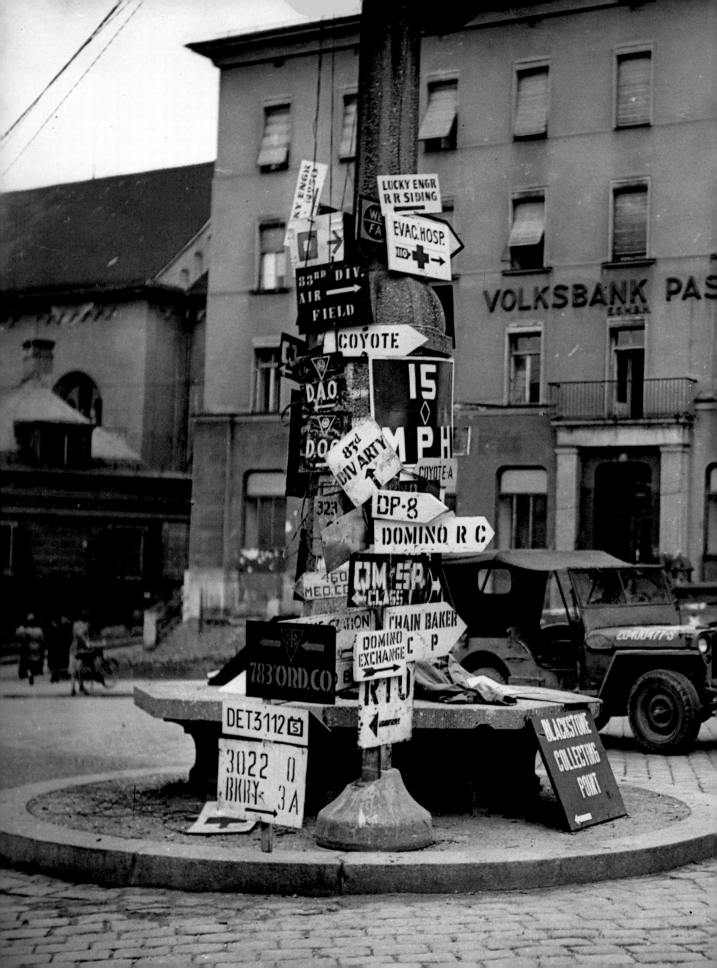

An MP directing traffic
Ein Militärpolizist regelt den Verkehr.
Un policier de l'armée réglant la circulation
Passau. September, 1945

Road signs in the French Sector
Wegweiser in der französischen Zone
Panneaux de signalisation dans le secteur français
Baden-Baden. October, 1948

The "roundup" streetcar for GIs
Die „Sammelstraßenbahn" für GIs
Le tram de ramassage des GIs
Frankfurt. February, 1946

Children stealing coal. The bitter winter of 1947 led children to steal coal off American railroad cars at night, while MPs looked the other way.

Kinder beim Kohlenklau. In dem bitterkalten Winter des Jahres 1947 wussten sich viele Deutsche nicht anders zu helfen. Die amerikanischen Militärpolizisten hatten Verständnis und schauten weg.

Enfants volant du charbon. Le froid hiver de 1947 poussait les Allemands à voler du charbon. Nos policiers militaires regardaient ailleurs.

Frankfurt. December, 1947

Coal dropped by a passing American truck is picked up by eager Germans and stuffed into pockets or suitcases.

Ein mit Kohle beladener amerikanischer Laster war vorbeigekommen. Die Passanten steckten die heruntergefallenen Kohlen in ihre Taschen und Beutel.

Un camion de charbon a été suivi par des Allemands qui bourrent avidement leurs poches et leurs sacs des morceaux qui sont tombés.

Frankfurt-Höchst. December, 1947

Ice-skating on the Neckar
Schlittschuhlaufen auf dem Neckar
Patineurs sur le Neckar
Heidelberg. December, 1947

Teacher explaining the meaning of "GI"
(Government Issue; informal term
for a soldier in the U.S. Army)

Eine Lehrerin erklärt die Bedeutung der Abkürzung „GI"
(Government Issue; informelle Bezeichnung
für einen Soldaten der US-Armee).

Un professeur expliquant le sens de « GI »
(Government Issue ; désignation courante
pour un soldat américain)

Frankfurt. November 1948

German children watching a fun movie

Deutsche Kinder schauen sich eine Filmkomödie an.

Enfants allemands à la projection d'un film comique

Amerika Haus, Frankfurt. December, 1947

German girls inquiring about dating GIs

Deutsche Mädchen möchten wissen, wie man
mit GIs ein Rendezvous vereinbart.

De jeunes Allemandes posent des questions
sur d'éventuels rendez-vous avec des GIs.

Frankfurt. November, 1947

German children playing baseball
Deutsche Kinder beim Baseballspielen
Des enfants allemands jouant au base-ball
Pocking, near Passau. June, 1945

GIs in the 100-yard dash at the
"Army Olympics"
GIs beim Start zum 100-Yards-Lauf bei der
„Armee-Olympiade"
GIs au départ du 100 yards aux
« Jeux Olympiques » de l'armée
Regensburg. August, 1945

Teaching baseball to German teenagers

Baseballunterricht für junge Deutsche

**Apprentissage du base-ball
à de jeunes Allemands**

Kelkheim, near Frankfurt. September, 1946

**Teaching American football
to German youngsters**

**Unterweisung in die Grundregeln
des American Football**

**Un GI enseigne à des enfants allemands
les rudiments du football américain.**

Kelkheim, near Frankfurt. September, 1946

Previous double page: German children waiting
to taste Coca-Cola

Vorhergehende Doppelseite: Deutsche Kinder
möchten Coca-Cola probieren.

Double page précédente: Des enfants allemands
découvrent Coca-Cola.

Near Darmstadt. October, 1948

Two German boys playing U.S. Navy men
Zwei Jungen spielen US-Marinesoldat.
Deux jeunes garçons jouant aux marins américains
Wiesbaden. March, 1946

The German boy and the GI
Der deutsche Junge und der GI
Le gamin allemand et le GI
Near Darmstadt. October, 1948

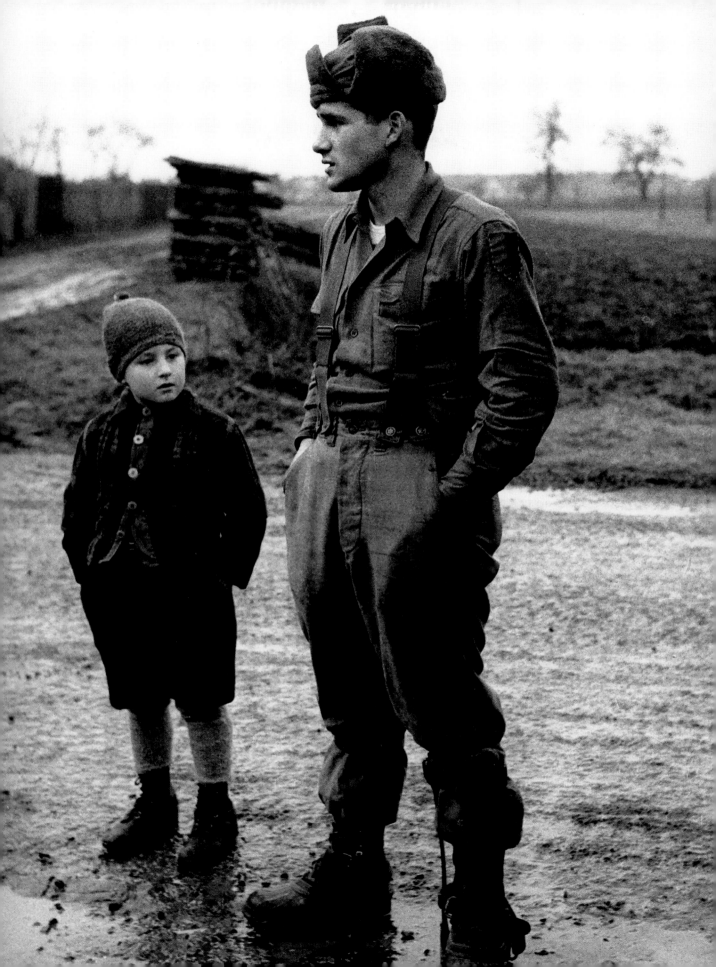

Helping a drunk
Hilfe für einen Betrunkenen
Aide à un homme ivre
Frankfurt. April, 1946

Following double page: Street scene
Folgende Doppelseite: Straßenszene
Double page suivante : Scène de rue
Frankfurt-Höchst. June, 1946

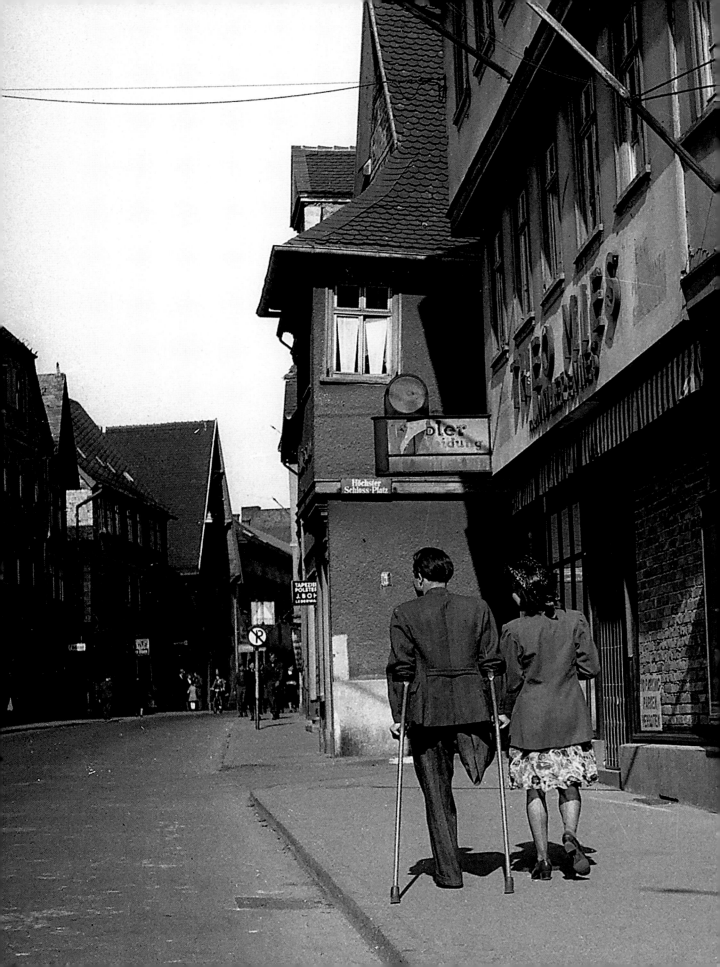

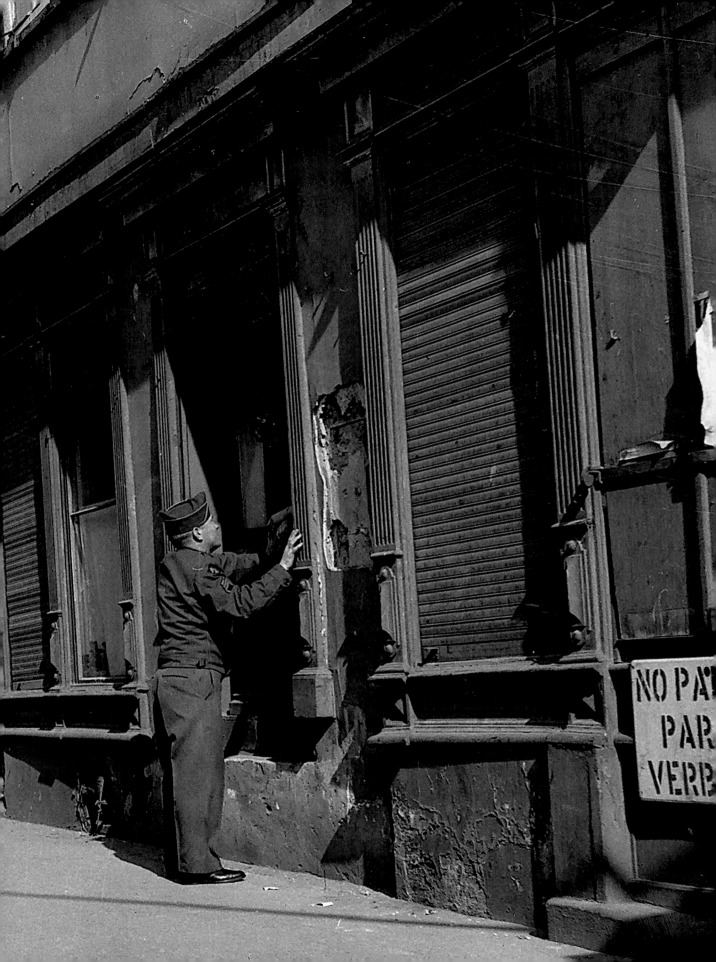

A GI flirts with a fräulein
Ein GI flirtet mit einem „Fräulein"
GI flirtant avec une « Fräulein »
Vilshofen, near Passau. July, 1945

German beauties selling "Oktoberfest"
souvenirs to a GI
Hübsche junge Frauen verkaufen einem GI
Souvenirs vom Oktoberfest.
De jolies Allemandes vendant des souvenirs
de l'« Oktoberfest » à un GI
Munich. October, 1948

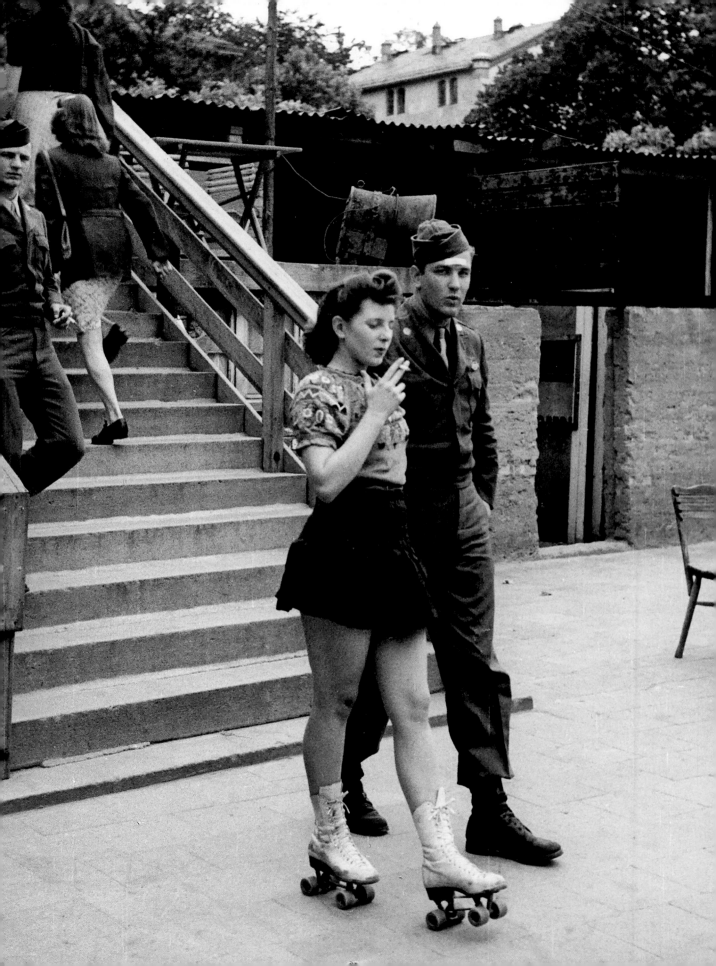

The magic of white sheets

At the beginning of the German Occupation, Americans were not permitted to fraternize with the Germans. But, it turned out to be the time when we really got to know each other: Forbid something and everybody wants it. German girls and American boys were no different. They wanted each other. An American War Department civilian shared one of his idiosyncrasies with me—whenever he broke up with a woman, he gave her a nice gift. He fell madly in love with a German waitress, Hilda, who was the most beautiful girl working for the Casino Mess Hall in Höchst. Like me he worked with the AVA Art Section which was located in the I.G. Farben building across the street from the Casino. He accompanied her secretly every night to the bombed-out cellar she shared with her mother, who worked nights in a bakery. For a year, he left every night about ten minutes before she got home, but Hilda never once allowed him to make love to her. They just talked and kissed... He tried but failed to find out the reasons for her frigidity. One day he went to visit a GI friend who was returning to the States. Earlier, this GI had written home asking his family to please mail him some white sheets. He got them, but now that he was leaving for home he gave the unused sheets to my friend. By then, my friend had had enough of unrequited love and decided to end the relationship with Hilda. The next Sunday he presented himself at the cellar, gave Hilda the wrapped gift, coldly shook her hand and left for what he thought would be the last time. Next day in the Casino Mess Hall, Hilda whispered in his ear her desire to see him after work. He took her home and within seconds they where in bed. It was the first time for both of them. They married and he took her home to Memphis, Tennessee, where they raised two daughters.
On his 75th birthday, she told him why it had taken so long for her to make love to him. She did not want to have her man between itchy old blankets: since she was a little girl she had dreamed of offering up her virginity to her man only between clean white sheets.

Der Zauber weisser Laken

In den Anfängen der Besatzungszeit war es den Amerikanern nicht erlaubt, Freundschaft mit Deutschen zu schließen. Aber die verbotenen Früchte schmecken bekanntlich am besten, und das galt für die deutschen Mädchen ebenso wie für die amerikanischen Boys.
In dieser Zeit lernte ich einen Zivilbeschäftigten des amerikanischen Kriegsministeriums kennen, der die gleiche Marotte hatte wie ich: Machte er mit einer Frau Schluss, erhielt sie zum Abschied ein hübsches Geschenk. Irgendwann verliebte er sich bis über beide Ohren in eine deutsche Kellnerin, Hilda, das schönste Mädchen, das im Kasino in Höchst arbeitete. Genau wie ich arbeitete er im Dokumentationszentrum des US-Außenministeriums, das im I.G.-Farben-Gebäude gegenüber des Kasinos untergebracht war. Immer auf der Hut vor der Militärpolizei, verbrachten die beiden ihre Zeit zumeist in einem ausgebombten Keller unter den Ruinen von Frankfurt. Dort wohnte Hilda zusammen mit ihrer Mutter, die bis zwei Uhr morgens in einer Bäckerei arbeitete. Nacht für Nacht verließ er den Keller zehn Minuten, ehe sie nach Hause kam. So ging die Geschichte fast ein ganzes Jahr lang, ohne dass er und Hilda auch nur ein einziges Mal miteinander geschlafen hätten.
Während dieser Zeit besuchte er eines Tages einen Freund, der im Begriff war, in die Staaten zurückzukehren. Im Jahr zuvor hatten die Eltern dieses GIs ihrem Sohn auf dessen Bitte hin weiße Bettlaken geschickt. Er hatte diese Laken allerdings niemals benutzt, und jetzt vor seiner Heimreise überließ er sie meinem Freund. Der hatte inzwischen genug von Hildas Hinhaltetaktik und wollte einen Schlussstrich ziehen. Am folgenden Sonntag tauchte er aus heiterem Himmel in dem Keller auf. Im Beisein ihrer Mutter überreichte er Hilda das verpackte Geschenk, verabschiedete sich kühl und verschwand, wie er glaubte, auf Nimmerwiedersehen. Die beiden Frauen rissen das Paket sogleich auf. Zum ersten Mal seit vielen Jahren hielten sie neue, saubere, weiße Laken in ihren Händen. Als Hilda ihm am nächsten Tag im Kasino das Essen servierte, verabredete sie sich wider Erwarten mit ihm. Gleich nach ihrer Arbeit brachte er sie nach Hause, und im Nu lagen sie miteinander im Bett. Für beide war es das erste Mal. Hilda wurde eine Kriegsbraut. Er nahm sie mit nach Memphis, Tennessee, und sie gründeten eine Familie. Jahrzehnte später, an seinem 75. Geburtstag, erzählte sie zum ersten Mal, weshalb sie ihn damals so lange hingehalten hatte: Hilda hatte nicht zwischen alten, kratzigen Decken mit ihm schlafen wollen. Schon als Mädchen hatte sie immer davon geträumt, sich ihrer ersten großen Liebe zwischen sauberen, weißen Laken hinzugeben.

La magie des draps blancs

Au début de l'Occupation, les Américains n'étaient pas autorisés à fraterniser avec les Allemands. Pourtant, c'est à cette époque que nous avons vraiment appris à nous connaître. Il suffit d'interdire quelque chose pour que tout le monde en ait envie. Cette règle valait pour les rapports des Allemandes avec les Américains. C'est à cette époque que j'ai rencontré un fonctionnaire civil du ministère de la Défense américain d'accord avec moi sur un point : quand on rompt avec une femme, il faut lui offrir un joli cadeau. Il était tombé amoureux fou d'une serveuse allemande, Hilda, la plus belle des serveuses du Casino de Höchst. Tous les Américains voulaient coucher avec Hilda, mais elle avait jeté son dévolu sur mon ami. Il la rencontrait en cachette tous les soirs. Il s'assurait que la police militaire ne le voit pas rejoindre en sa compagnie la cave qu'elle partageait avec sa mère sous une maison en ruine de Francfort. Cette dernière travaillait dans une boulangerie jusqu'à deux heures du matin et mon camarade s'éclipsait tous les soirs dix minutes avant son retour. Ces rendez-vous ont duré presque un an sans qu'Hilda accepte de faire l'amour avec lui.
Un jour, il a rendu visite à un copain qui rentrait aux Etats-Unis. L'année précédente, ce dernier avait écrit chez lui pour se plaindre des draps militaires couleur kaki fournis par l'armée, qu'il avait pris en grippe, et demandé à ses parents de lui envoyer des draps blancs. Il les avait reçus, mais, je ne sais pourquoi, ne s'en était jamais servi. A la veille de son départ, il a donné ces draps à mon ami. A cette époque, ce dernier, lassé de la résistance de Hilda, souhaitait rompre. Le dimanche suivant, il se présenta à la cave, sans avoir pris rendez-vous. Hilda et sa mère étaient là. Sa visite fut brève : il offrit le paquet contenant les draps à Hilda, lui serra froidement la main et partit en se disant que c'était la dernière fois qu'il mettait les pieds dans ce lieu. Le lendemain, pendant qu'elle lui servait son dîner dans la salle à manger du Casino, Hilda lui murmura à l'oreille qu'elle désirait le voir après son travail. Il la raccompagna chez elle et quelques secondes plus tard, ils étaient au lit. C'était la première fois pour eux deux. A partir de ce jour, ils ont fait l'amour chaque soir. Il l'a épousée et emmenée à Memphis, Tennessee et ils ont eu deux filles.
Le jour de son 75e anniversaire, elle lui a confié la raison pour laquelle elle avait repoussé si longtemps le moment de faire l'amour avec lui : elle ne voulait pas s'offrir à son fiancé dans de vieilles couvertures rêches. Depuis qu'elle était toute petite, elle avait rêvé de se donner à l'homme de sa vie dans des draps blancs et propres.

A GI and a fräulein on roller skates
Ein GI und ein „Fräulein" auf Rollschuhen
Un GI et une « Fräulein » en patins à roulettes
Frankfurt. June, 1946

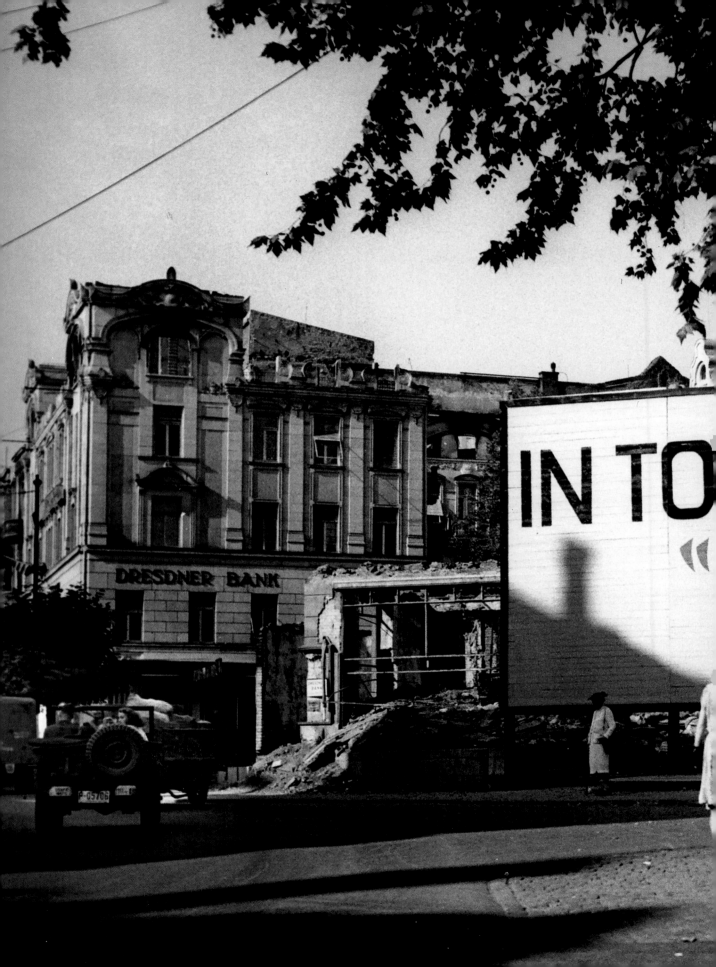

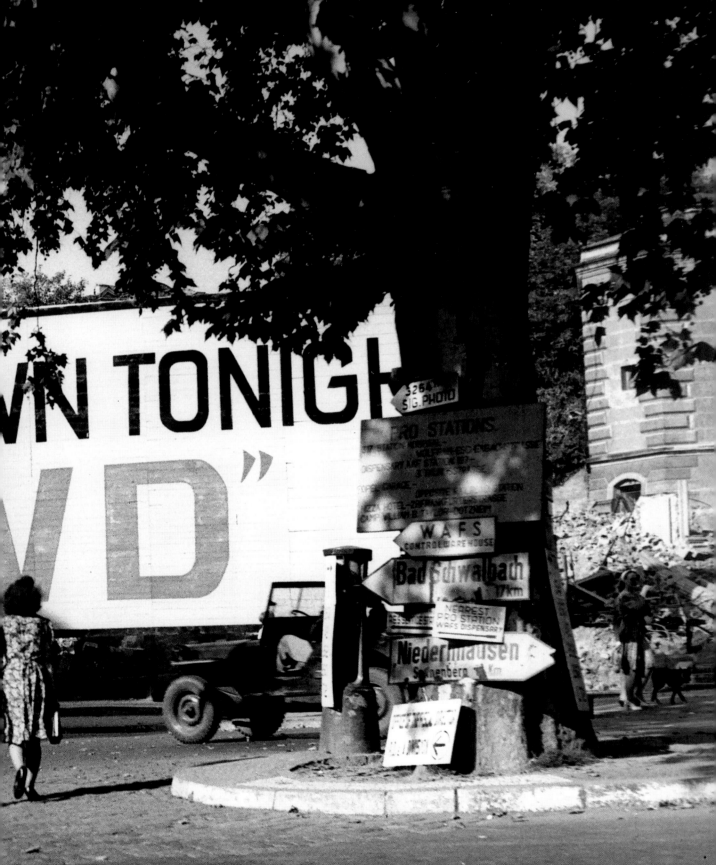

Previous double page: A sign warning of venereal disease
Vorhergehende Doppelseite: Ein Plakat warnt vor Geschlechtskrankheiten.
Double page précédente : Une affiche mettant en garde contre les maladies vénériennes
Wiesbaden. June, 1946

Venereal disease was rampant during the Occupation. The American authorities in the U.S. Zone had many posters like this one reminding GIs that any woman or man could be carrying the disease. The authorities created a symbolic German prostitute with the fictional name of Veronika Dankeschoen, after the letters V.D. One night a girl I was with saw the sign and asked me, "Is Veronika an entertainer in some club?"

Geschlechtskrankheiten waren während der Besatzung an der Tagesordnung. In der amerikanischen Zone warnten viele Plakate wie das auf diesem Foto die GIs vor der großen Ansteckungsgefahr. Die amerikanischen Behörden hatten sich eine symbolische deutsche Prostituierte mit dem fiktiven Namen Veronika Dankeschön ausgedacht – die Anfangsbuchstaben standen für „Venereal Disease". Eines Abends sah ein Mädchen, das ich kennengelernt hatte, ein solches Plakat und fragte mich: „Ist Veronika eine Entertainerin in einem Club?"

Les maladies vénériennes sévissaient sous l'occupation américaine. Dans la zone américaine, les autorités avaient placardé des affiches avertissant les GIs que tout un chacun, homme ou femme, pouvait transmettre ces maladies. Les autorités avaient inventé une prostituée allemande symbolique baptisée Veronika Dankeschoen (Veronika Merci bien), d'après les initiales de Venereal Disease (maladie vénérienne). Un soir, une fille qui m'accompagnait a vu cette affiche et m'a demandé : « Cette Veronika, c'est une entraîneuse dans un club ? »

GIs playing the doughnut game
GIs beim „Krapfenessenspiel"
GIs au jeu de « manger le beignet »
Wiesbaden. March, 1947

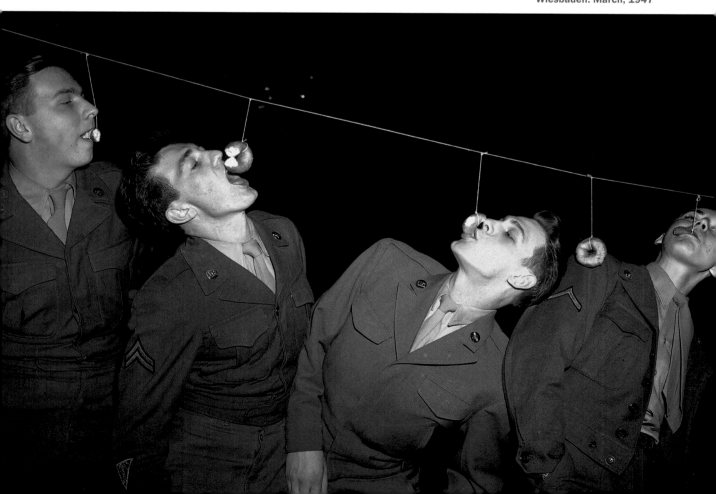

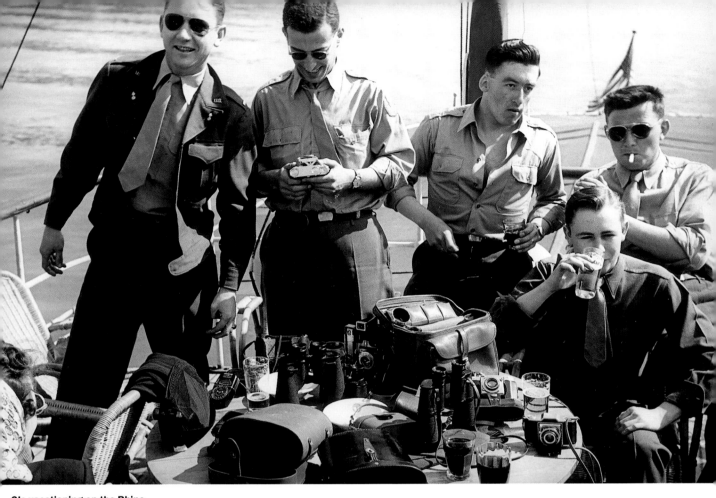

GIs vacationing on the Rhine
GIs beim Ausflug auf dem Rhein
GIs en vacances sur le Rhin
Near Assmannshausen. June, 1947

Following double page: Beautiful scenery on the Rhine.
The city of Dusseldorf donated the yacht to Hitler;
now it took GIs up and down the river

Folgende Doppelseite: Blick auf die wunderschöne Rhein-
landschaft. Die Stadt Düsseldorf hatte die Yacht Hitler
geschenkt; jetzt diente sie den GIs als Ausflugsdampfer.

Double page suivante : Les magnifiques rives du Rhin.
Le yacht offert à Hitler par la ville de Düsseldorf
emmène les GIs en excursion.

Near Assmannshausen. June, 1947

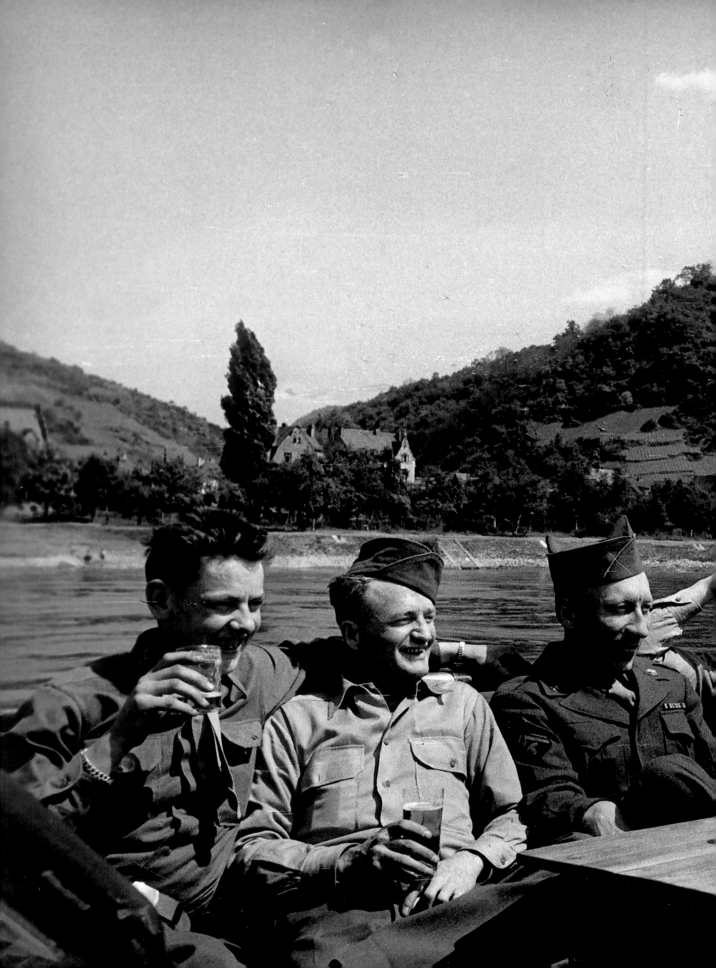

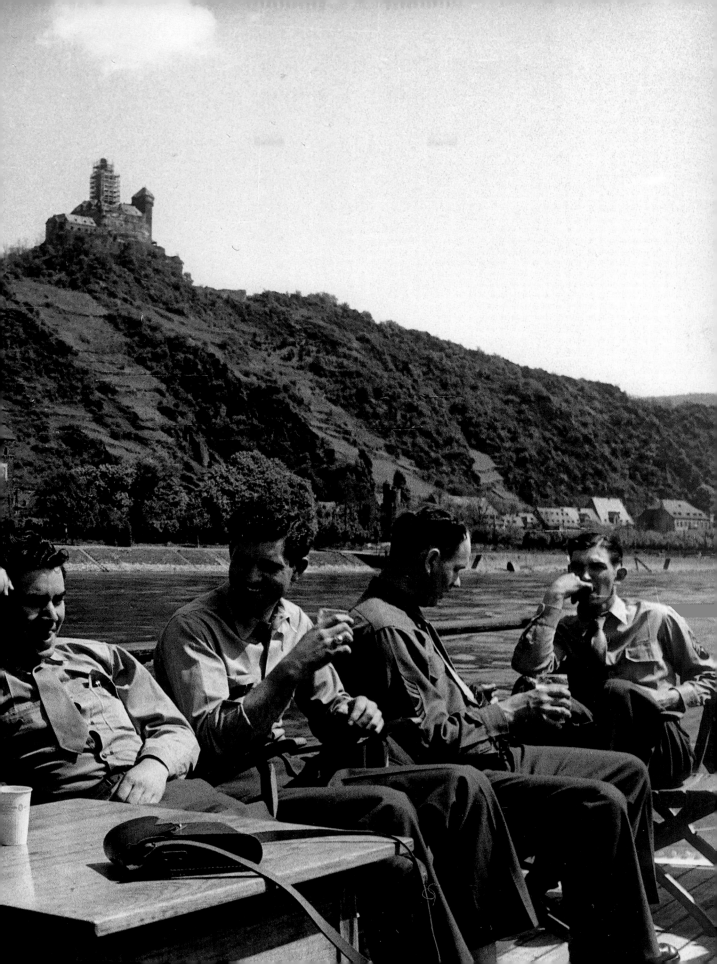

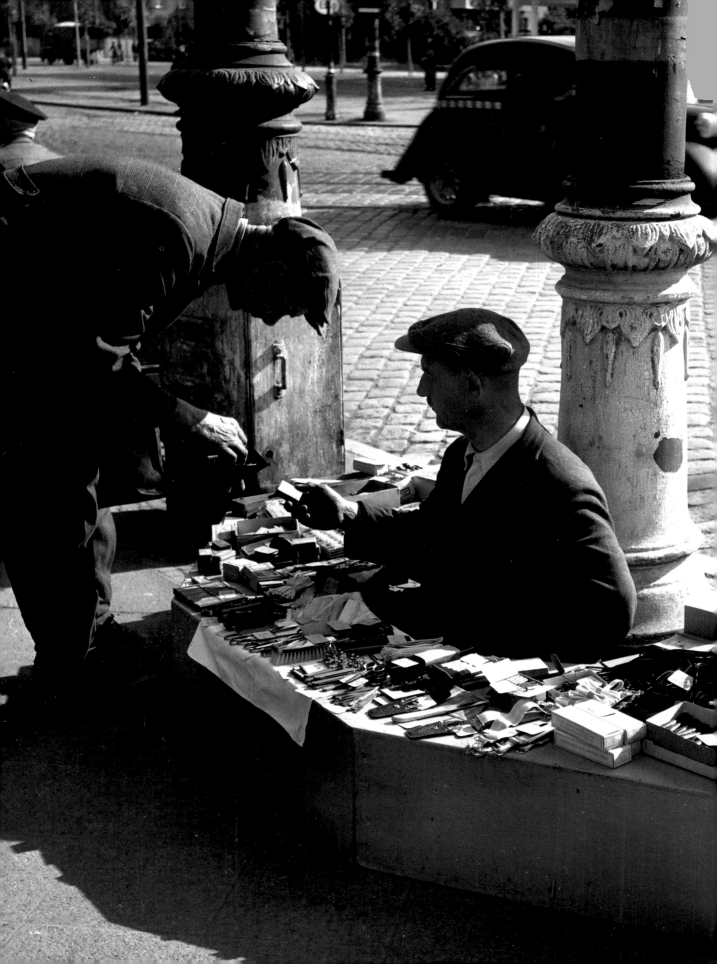

RECONSTRUCTION

Wiederaufbau

Reconstruction

A celebration in Walldorf

In March 1948 I drove to the town of Walldorf to cover an anniversary celebration of John Jacob Astor, and my story appeared in *Weekend* on April 10, 1948. That day I also discovered that the Germans had a long way to go in the process of reconstruction – both materially and culturally. From 1933 to 1945 they had been brainwashed by the Nazis and now they needed to start all over again among the free countries of the world. For over a century the people of Walldorf have shown their pride in their famous son who became one of America's richest industrialists.

In 1898 they had marked the 50th anniversary of his death by erecting a monument to him in the square near the house where he was born, but the bronze bust which topped it had been confiscated by the Nazis and melted down. On the 100th anniversary of Astor's death in March 28, 1948, a replacement bust was unveiled by its creator,

Eine Feier in Walldorf

Im März 1948 fuhr ich nach Walldorf, um über eine Jubiläumsfeier für John Jacob Astor zu schreiben. Die Story erschien am 10. April in *Weekend*. An jenem 28. März wurde mir klar, dass die Deutschen — nach 12 Jahren der Gehirnwäsche durch die Nazis — noch einen langen Weg vor sich hatten. Sowohl in wirtschaftlicher als auch in kultureller Hinsicht war ein Neuanfang nötig, um wieder Anschluß an die freie Welt zu gewinnen. Die Walldorfer waren stolz auf den berühmtesten Sohn der Stadt, der es in Amerika zu sagenhaftem Reichtum gebracht hatte.

1898, anlässlich seines 50. Todestages, hatte man auf dem Platz in der Nähe seines Geburtshauses ein Denkmal errichtet. Während des Krieges hatten die Nazis die bronzene Büste allerdings konfisziert und eingeschmolzen. Anlässlich des 100. Todestags enthüllte man eine neue, von dem damals 20jährigen Walldorfer Bildhauer

Une fête à Walldorf

En mars 1948, je me suis rendu en voiture à Walldorf. Je devais prendre des photos sur la célébration du centième anniversaire de la mort de John Jacob Astor qui était né à Walldorf et avait fait fortune en Amérique. Mon reportage fut publié le 10 avril dans *Weekend*. Ce jour-là, le 28 mars, j'ai découvert que le relèvement de l'Allemagne allait demander du temps car les Nazis avaient fait subir aux Allemands un véritable lavage de cerveau de 1933 à 1945. Il leur faudrait tout recommencer à zéro pour rejoindre les pays libres, et ce aussi bien sur le plan économique que culturel.

En 1898, cinquante ans après la mort de John Jacob Astor, les habitants de Walldorf lui avaient érigé un monument dans le square voisin de la maison où il est né. Mais le buste en bronze qui le surmontait avait été confisqué par les Nazis pour les besoins de l'armement. A l'occasion du centenaire de la mort de John Jacob Astor, on inaugura un

Previous double page: A legless Wehrmacht veteran street vendor
Vorhergehende Doppelseite: Der Straßenverkaufsstand eines beinamputierten Kriegsveteranen
Double page précédente : Un ancien combattant amputé des deux jambes devenu marchand ambulant
Frankfurt. October, 1948

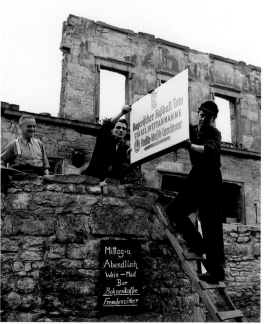

Signs of progress
Zeichen des Fortschritts
Les signes du progrès
Darmstadt. October, 1948

Monument to John Jacob Astor
Denkmal für John Jacob Astor
Le monument de John Jacob Astor
Walldorf, near Heidelberg.
March 28, 1948

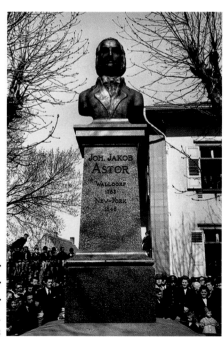

a twenty-year-old sculptor from Walldorf named Helmut Werner, and all of Walldorf's six thousand citizens turned out to mark the day.

Landrat Zimmermann congratulated all the Astors, and later told me that he had expected an American delegation to join them for the occasion. He had had five thousand programs printed in German and English and I was the only one there. At the banquet that evening, I was asked to say a few words, which I did. But then I discovered that they had not done any publicity at all and no one had notified the American authorities about the event. I suggested to the Bürgermeister that in the future he should hire a public relations person to do that kind of job. "Public relations?" He asked, "Was ist das?" "It's a kind of a modern town crier," I said.

Helmut Werner gefertigte Büste. Sämtliche 6 000 Einwohner der Stadt waren auf den Beinen, um das denkwürdige Ereignis zu feiern, und der Landrat sprach allen anwesenden deutschen Astors seine herzlichsten Glückwünsche aus.

Die Stadt Walldorf rechnete eigentlich mit einer amerikanischen Delegation. Dementsprechend waren 5 000 Programmhefte in deutscher und englischer Sprache gedruckt worden. Und nun war ich der einzige Amerikaner, der zur feierlichen Enthüllung der Büste erschienen war. Später am Abend, beim Bankett, bat man mich, ein paar Worte zu sprechen. Dabei stellte sich heraus, dass man weder für die Veranstaltung geworben, noch die amerikanischen Behörden informiert hatte. Ich riet dem Bürgermeister, für künftige Anlässe dieser Art einen Public-Relations-Fachmann zu engagieren. „Public-Relations?", fragte er, „was ist das?" „In etwa das, was früher ein städtischer Ausrufer gemacht hat", klärte ich ihn auf.

nouveau monument sculpté par Helmut Werner, un jeune homme de vingt ans originaire de Walldorf. Les six mille habitants de la ville célébrèrent l'événement. Pour tous ceux qui en ont été témoins, ce fut un moment inoubliable. Le sous-préfet félicita tous les Astor présents. Il me dit plus tard qu'il avait espéré la présence d'une délégation américaine pour l'occasion et fait imprimer cinq mille programmes en allemand et en anglais. Et voilà que j'étais le seul Américain... Au banquet, ce soir-là, on m'a demandé de dire quelques mots. Je me suis exécuté. Puis, j'ai découvert que personne n'avait fait la moindre publicité à l'événement et que les autorités américaines n'avaient pas été prévenues. J'ai informé le maire que dans le futur, il devrait songer à se faire assister d'un chargé de relations publiques. « Relations publiques, was ist das ? », m'a-t-il demandé. « C'est un peu le crieur public d'aujourd'hui », lui ai-je répondu.

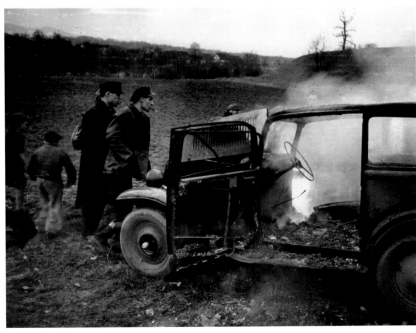

Burning car
Brennendes Auto
Voiture en flammes
Near Karlsruhe. November, 1947

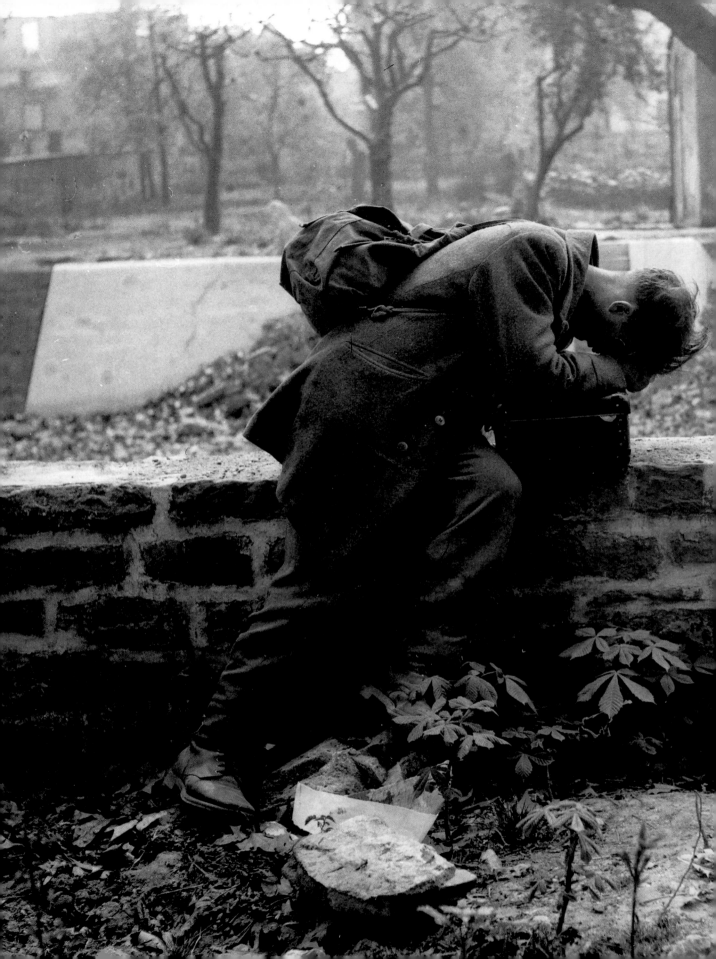

The return of the defeated soldier. A prisoner of war returns to a bombed-out home and family that is no longer there.

Die Heimkehr des besiegten Soldaten. Ein Kriegsgefangener kommt nach Hause, sein Haus ist ausgebombt, seine Familie nicht mehr da.

Le retour du soldat vaincu. Un prisonnier de guerre rentre chez lui, sa maison a été bombardée, sa famille a disparu.

Frankfurt. March 6, 1946

No "Welcome home!" for this returning German veteran

Für diesen Kriegsveteranen gibt es kein „Willkommen zu Hause".

Personne n'accueillera cet ancien combattant qui rentre chez lui.

Passau. July, 1945

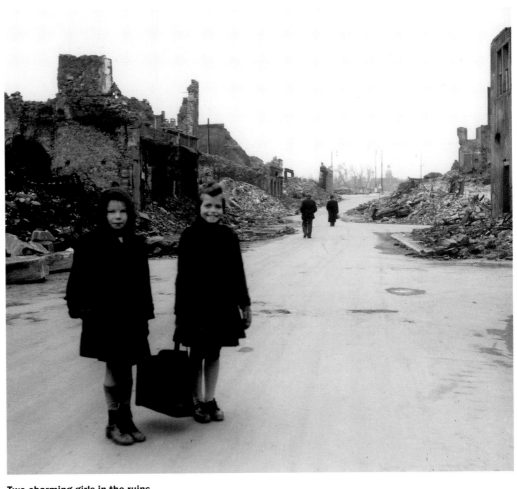

Two charming girls in the ruins

Zwei reizende Mädchen inmitten von Ruinen

Deux fillettes charmantes au milieu des ruines

Frankfurt. February, 1946

War veteran leaving a streetcar

Ein Kriegsveteran steigt aus der Straßenbahn.

Un invalide de guerre sortant du tramway

Frankfurt. April, 1946

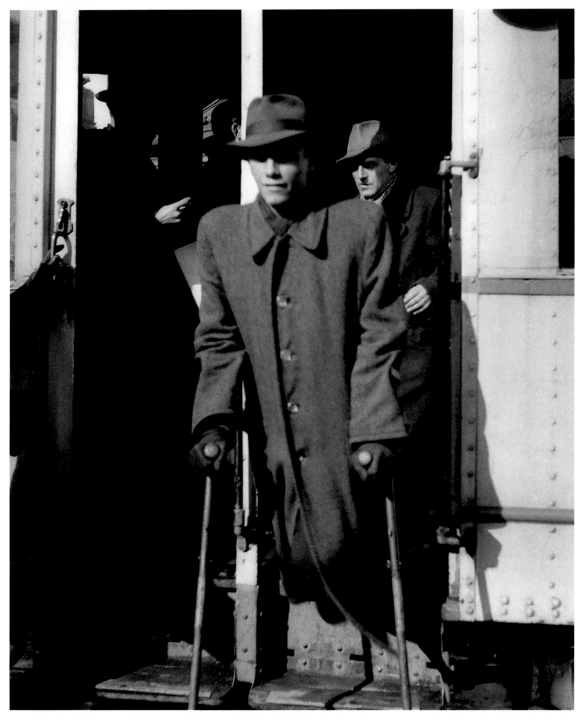

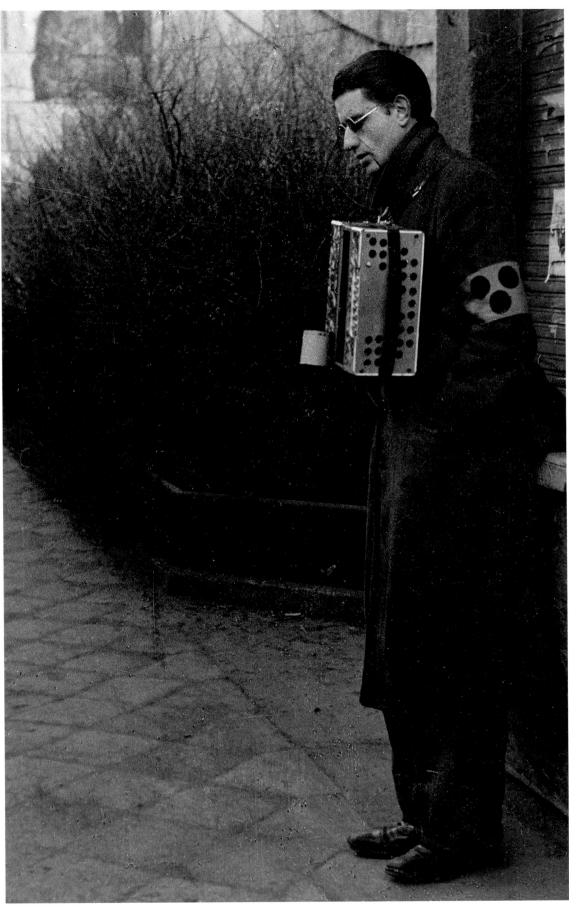

Blind veteran with accordion

Blinder Kriegsveteran mit Akkordeon

L'ancien combattant aveugle à l'accordéon

Frankfurt-Höchst.
January, 1946

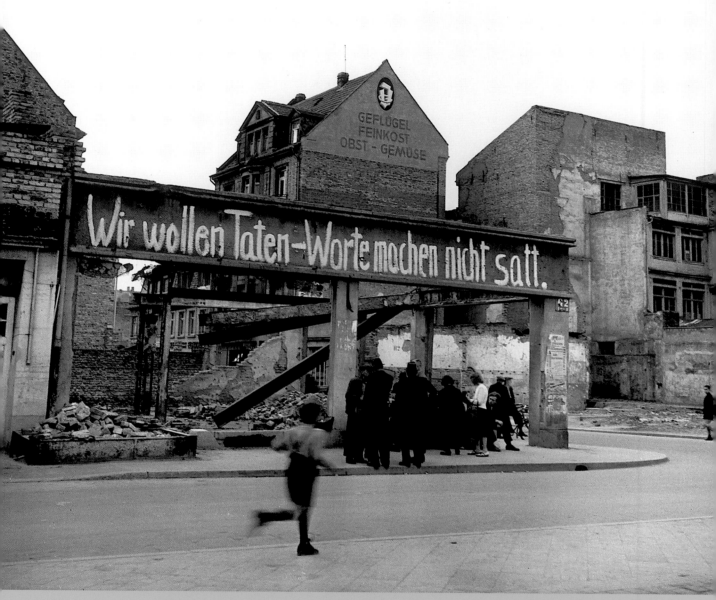

"We want action – words don't fill us up."

„Wir wollen Taten – Worte machen nicht satt."

« Nous voulons des actes – Les mots ne rassasient pas. »

Mannheim. October, 1948

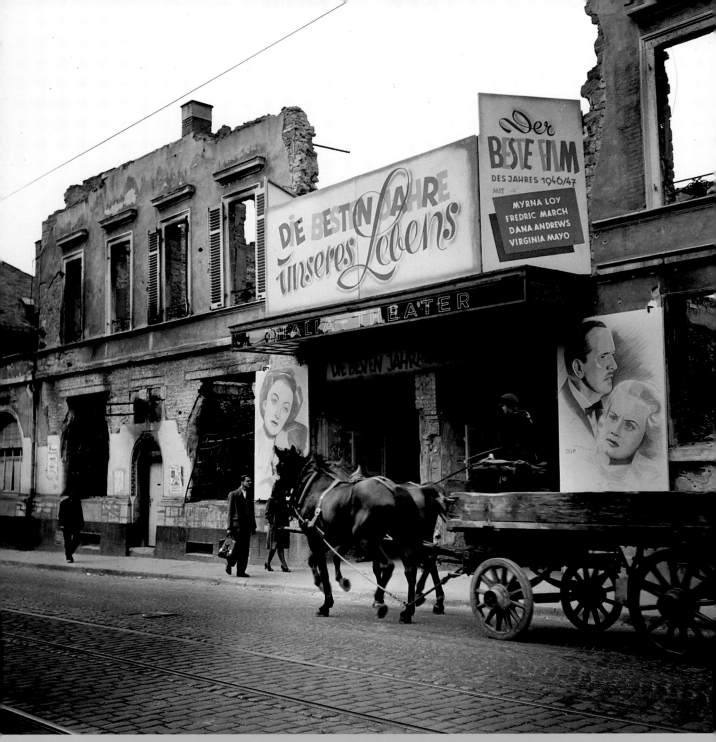

"The Best Years of our Lives". A Hollywood movie at the Thalia Theater
„Die besten Jahre unseres Lebens". Ein Hollywood-Film im Thalia Theater
« Les plus belles années de notre vie ». Un film d'Hollywood au cinéma Thalia
Darmstadt. October, 1948

**Woman who refused to leave her
bombed-out apartment**

**Die Frau, die sich weigerte, ihre ausgebombte
Wohnung zu verlassen**

**La femme qui n'avait jamais abandonné son
appartement bombardé**

Mannheim. November, 1948

People living in train cars

Menschen, die in Zügen leben

Personnes vivant dans des trains

Pocking, near Passau. June, 1945

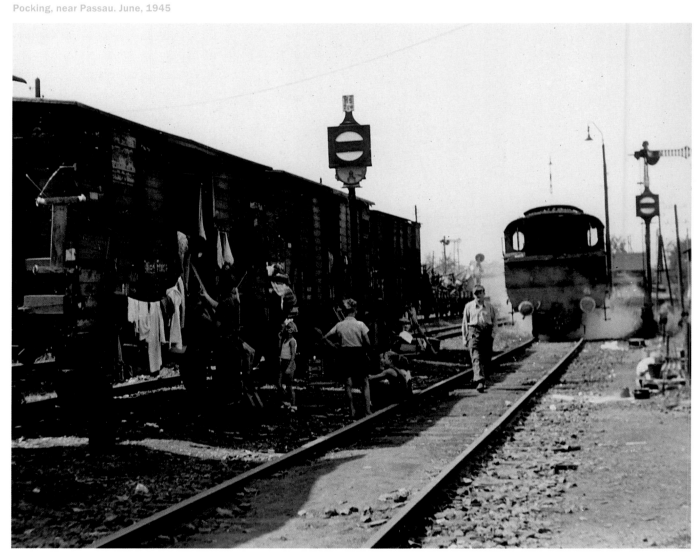

At first this boy was as serious as any other young man. However, as soon as he took the three loaves of bread he had purchased into his arms, he suddenly became one big smile.

Zunächst wirkte dieser Junge so ernst, wie jeder andere auch, doch als er die drei Brote endlich in seinen Armen hielt, strahlte er über das ganze Gesicht.

Ce gamin avait l'air aussi grave que les autres, mais quand il a serré dans ses bras les trois pains qu'il avait achetés, un grand sourire a éclairé son visage.

The Boy with the three loaves of bread
Der Junge mit den drei Broten
Le gamin aux trois pains
Ludwigshafen. October, 1948

Page 130: Child bricklayer rebuilding a house
Seite 130: Ein Maurerjunge baut ein Haus wieder auf.
Page 130: Un enfant-maçon reconstruisant une maison
Saarbrücken. November, 1948

Page 131: A locksmith's sign among the ruins
Seite 131: Das Schild eines Schlossers inmitten von Ruinen
Page 131: Une enseigne de serrurier au milieu des ruines
Kassel. December, 1946

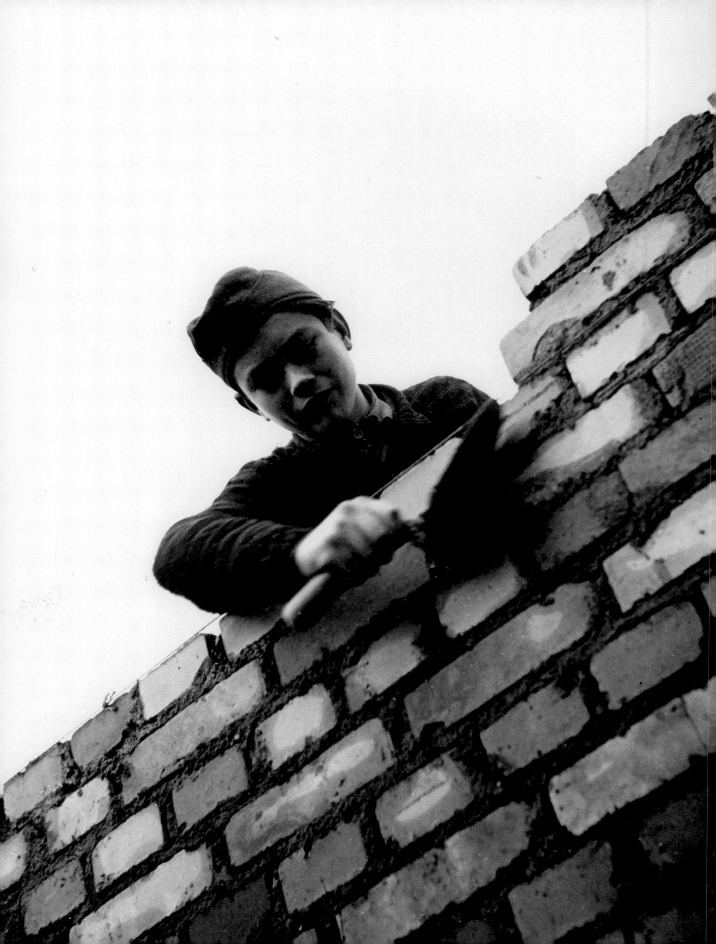

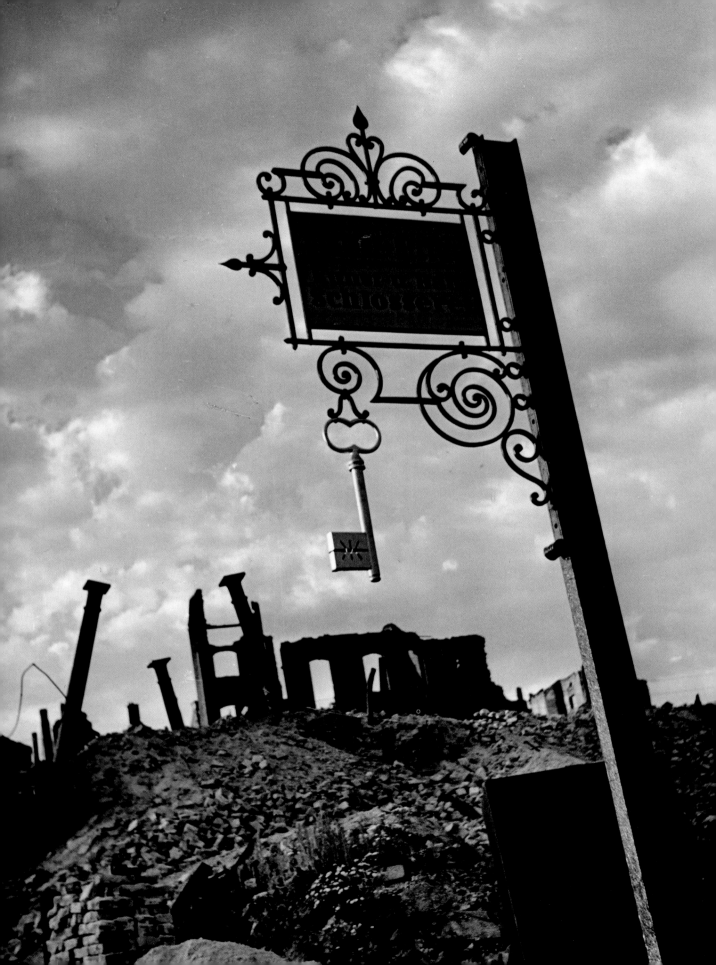

New beginning for a hardware store
Neuanfang eines Haushaltswarengeschäfts
Le nouveau départ d'une quincaillerie
Frankfurt. October, 1948

Following double page: Showcases in the ruins
Folgende Doppelseite: Schaufenster in den Ruinen
Double page suivante : Etalage dans les ruines
Frankfurt. October, 1948

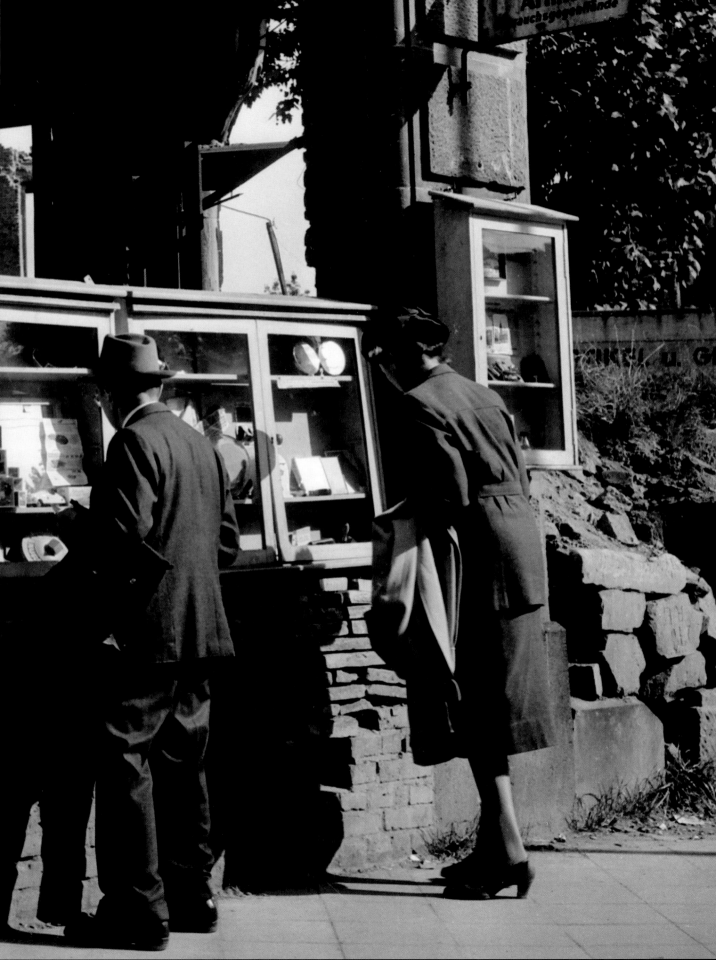

Early morning activity
Geschäftiges Treiben am frühen Morgen
Activités du petit matin
Wiesbaden. September, 1948

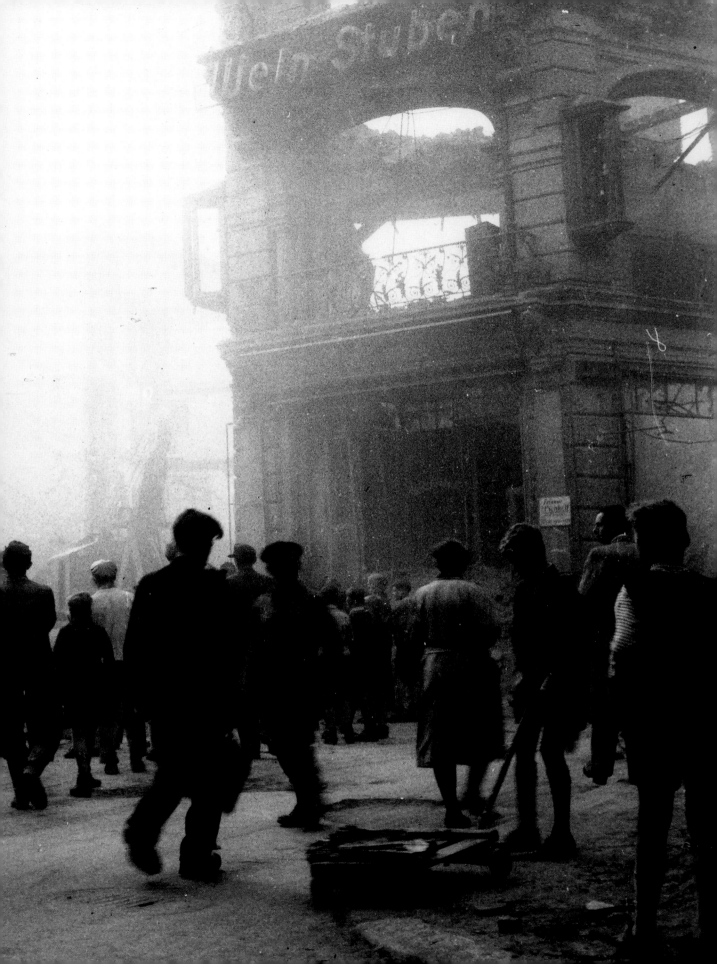

Young coal miners
Junge Bergleute
Jeunes mineurs
Saarbrücken. December, 1948

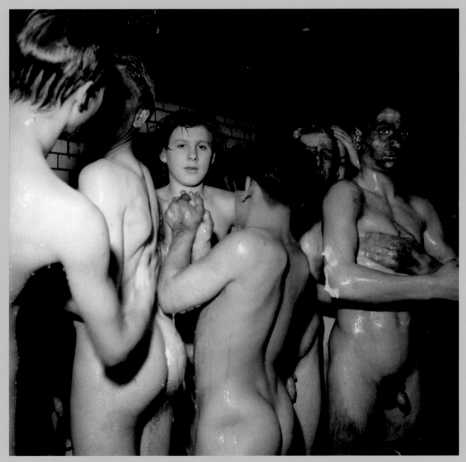

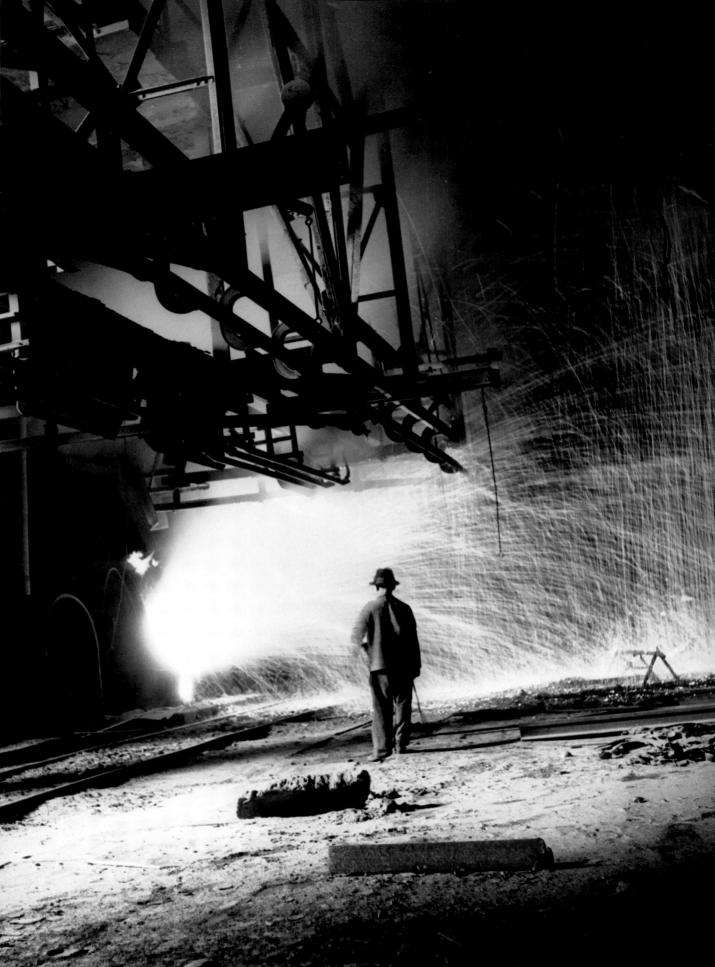

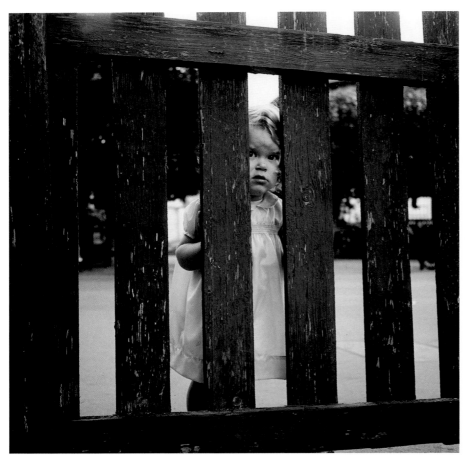

Little girl behind a fence

Kleines Mädchen hinter einem Zaun

Petite fille derrière une palissade

Baden-Baden. October, 1948

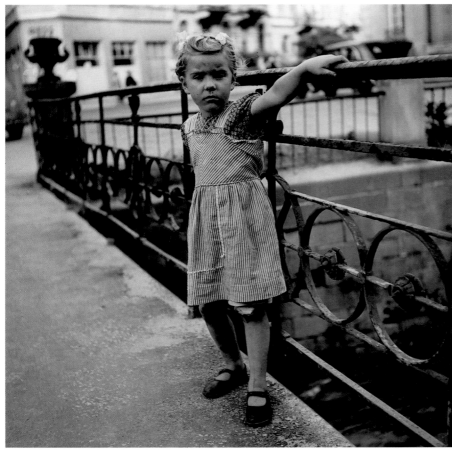

Child by a railing

Kind an einem Gitter

Enfant à côté d'un garde-fou

Baden-Baden. October, 1948

Boy on a monument
Junge auf einer Statue
Jeune garçon sur une statue
Baden-Baden. October, 1948

Germany's new generation
Deutschlands neue Generation
La nouvelle génération d'Allemagne
Frankfurt. October, 1948

A policeman's breakfast
Das Frühstück eines Polizisten
Le petit déjeuner d'un policier
Frankfurt. March, 1947

Watering a garden
Bewässerung eines Gartens
L'arrosage du jardin
Nuremberg. May, 1947

143

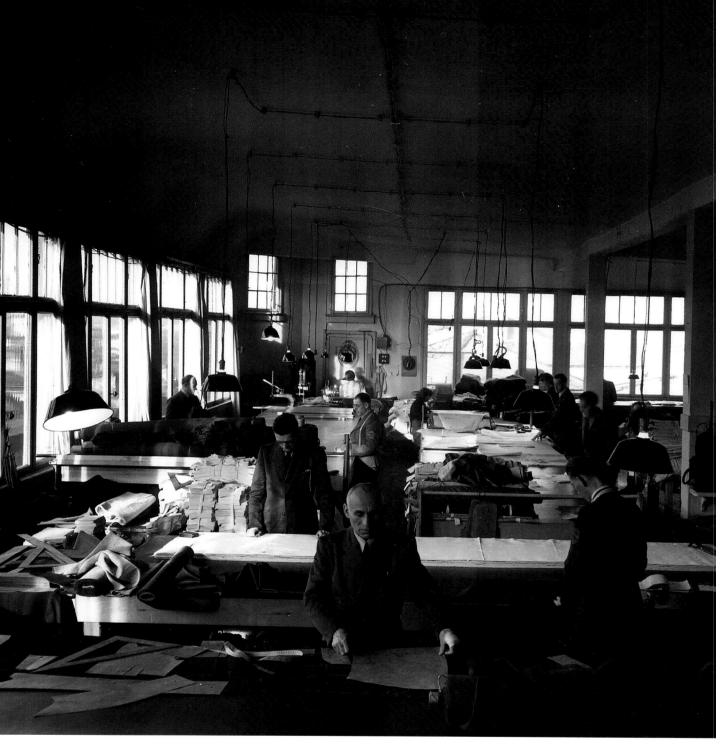

New beginning for a fashion house

Ein Neuanfang für ein Modegeschäft

La résurrection d'une maison de couture

Frankfurt. October, 1947

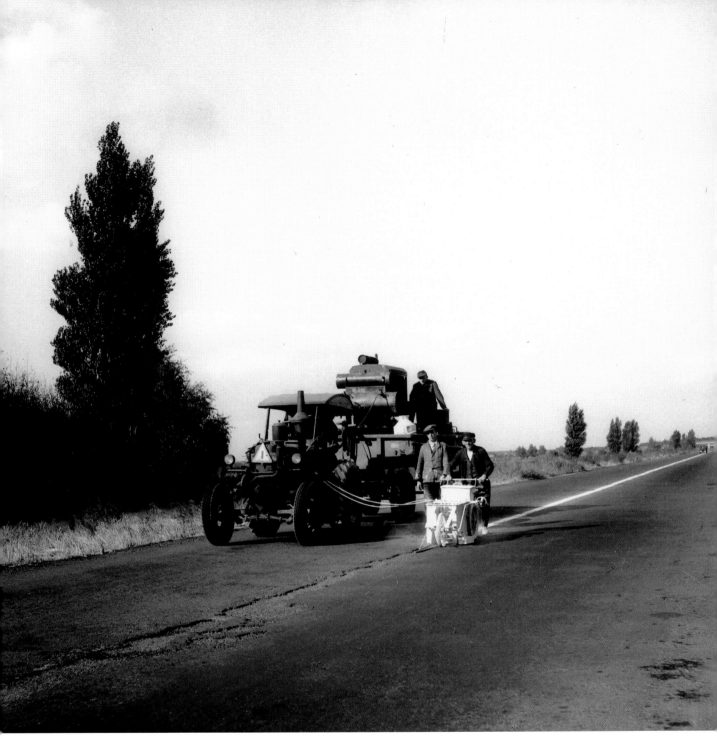

Painting the dividing line on the road

Eine Mittellinie wird gezogen

Marquage au sol

Appenweier, near Strasbourg. September, 1947

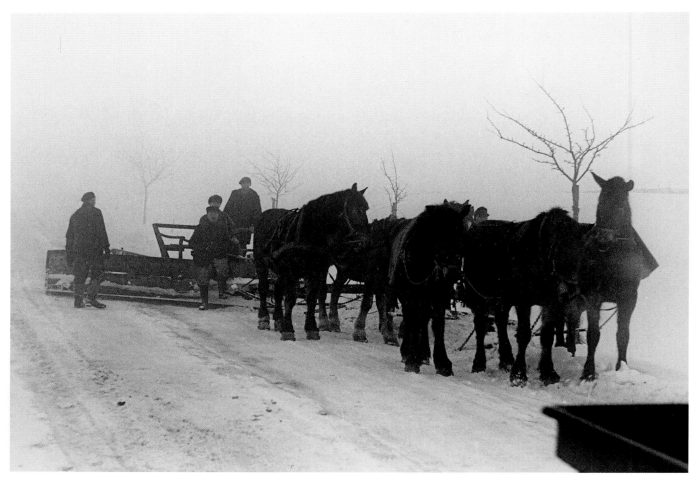

Horse-drawn snowplow

Von Pferden gezogener Schneepflug

Chevaux tirant un chasse-neige

Bremerhaven. December, 1947

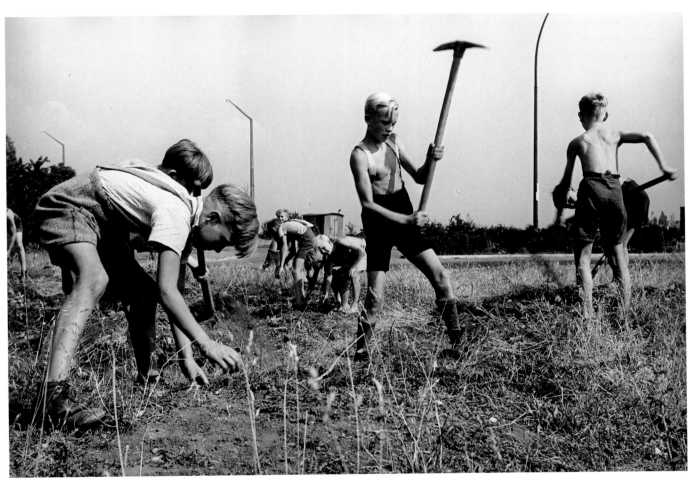

Children clearing the roadside

Kinder bei Aufräumarbeiten am Straßenrand

Enfants nettoyant le bas-côté de la route

Wiesbaden. June, 1947

The tireman gets a flat.
Der Reifenhändler hat einen Platten.
Le dépanneur à plat
Near Bruchsal. December, 1947

Train wreck
Wrack eines Zuges
Accident ferroviaire
Neuwied. December 26, 1947

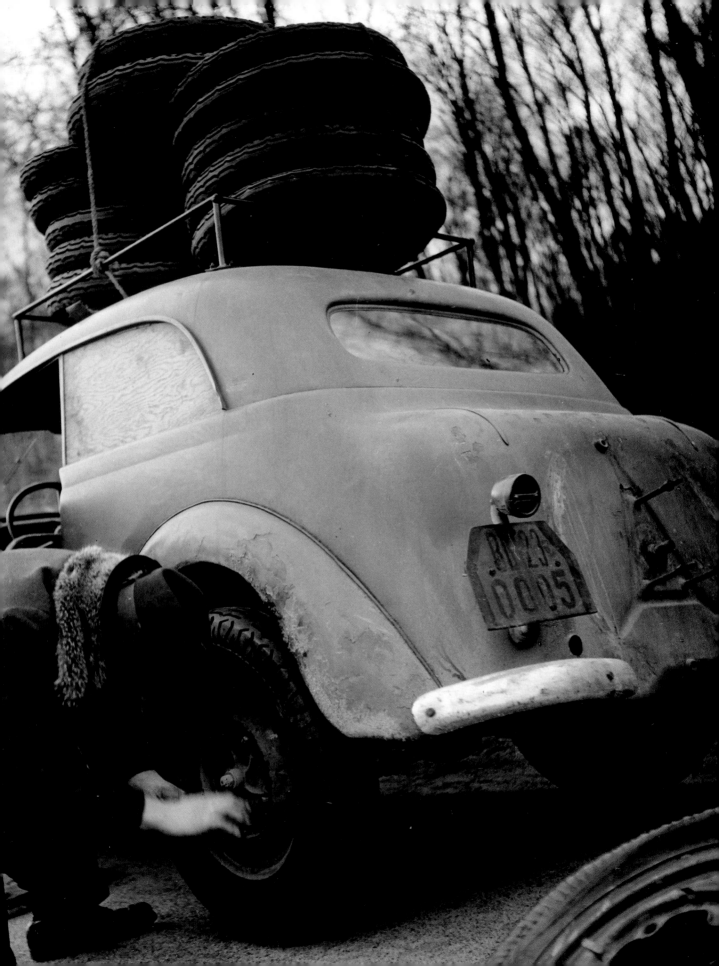

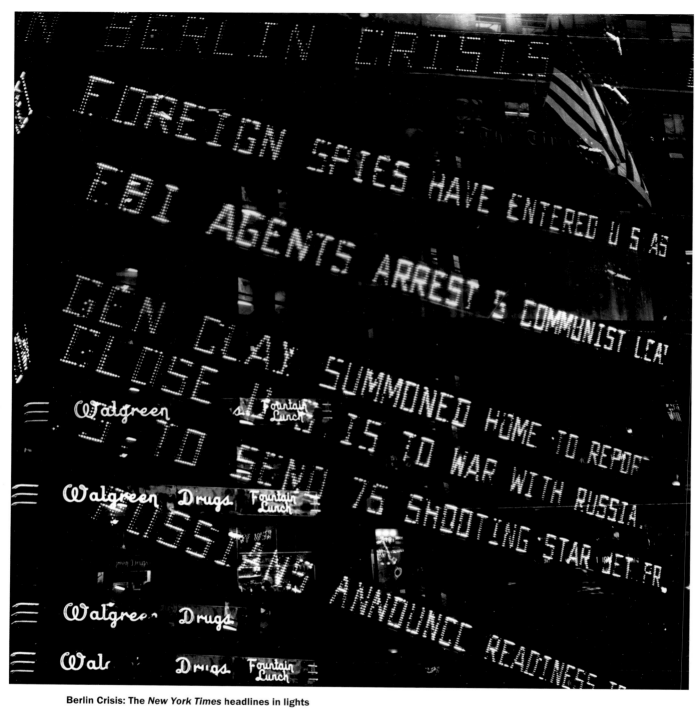

Berlin Crisis: The *New York Times* headlines in lights

Die Blockade Berlins: Schlagzeilen der *New York Times* in Leuchtschrift

Le blocus de Berlin : gros titres lumineux du *New York Times*

New York. June, 1948

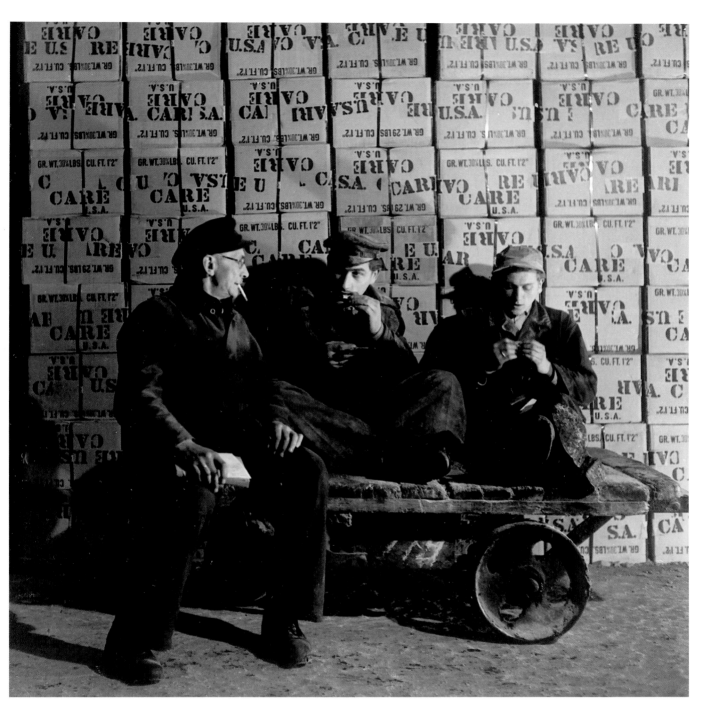

German workers with CARE packages

Deutsche Arbeiter mit CARE-Paketen

Travailleurs allemands et paquets CARE

Frankfurt. September, 1948

German workers loading a C-54, bound for Berlin

Deutsche Arbeiter warten auf eine C-54, um sie für Berlin zu beladen.

Travailleurs allemands en train de charger un C-54 à destination de Berlin

Celle. September, 1948

Irving Berlin, Jinx Falkenberg and Bob Hope at
the coal chute of a C-54

Irving Berlin, Jinx Falkenberg und Bob Hope
auf der Kohlenrutsche einer C-54

Irving Berlin, Jinx Falkenberg et Bob Hope sur
la glissière à charbon d'un C-54

Berlin. December 24, 1948

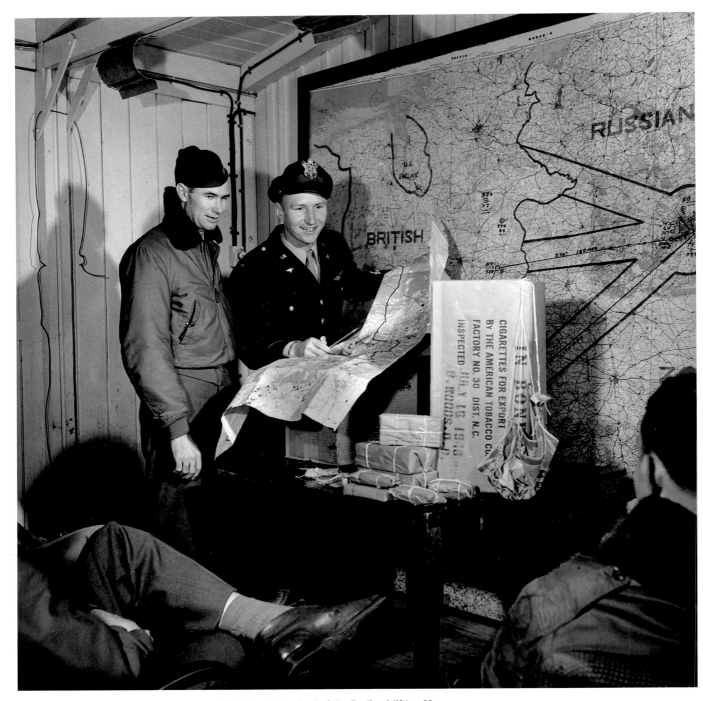

Lt. Gail S. Halvorsen (known as "The Candy Bomber" of the Berlin airlift), a Mormon from Provo, Utah, with a great sense of humor, instructing fellow pilots where to drop candies fitted out with tiny parachutes of colored bandanas, made by the women of Provo.

Leutnant Gail S. Halvorsen, auch der „Schokoladenflieger" genannt, ein Mormone aus Provo, Utah, hatte einen ausgeprägten Sinn für Humor; hier zeigt er anderen Piloten, wo sie die Süßigkeiten über Berlin abwerfen sollten. Diese hingen an kleinen bunten Fallschirmen, die von Frauen aus Provo genäht wurden.

Le lieutenant Gail S. Halvorsen, le « bombardier de bonbons » du pont aérien, un mormon doté d'un grand sens de l'humour et originaire de Provo, dans l'Utah, indique aux autres pilotes où ils doivent lancer les sucreries au-dessus de Berlin. Celles-ci sont le plus souvent suspendues à de petits foulards cousus par des femmes de Provo.

Celle. September. 1948

A C-54 arriving at Tempelhof

Eine C-54 im Landeanflug auf den Flughafen
Tempelhof

L'atterrissage d'un C-54 à l'aéroport de
Tempelhof

Berlin. December 24, 1948

Following double page: The Berlin airlift meant frenzied
round-the-clock activity. This photograph was taken at 1:30 AM.

Folgende Doppelseite: Die Berliner Luftbrücke bestand rund um
die Uhr. Diese Aufnahme wurde um 1:30 Uhr gemacht.

Double page suivante : Le pont aérien berlinois était actif
24 heures sur 24. La photo a été prise à 1 h 30 du matin.

Celle. September 19, 1948

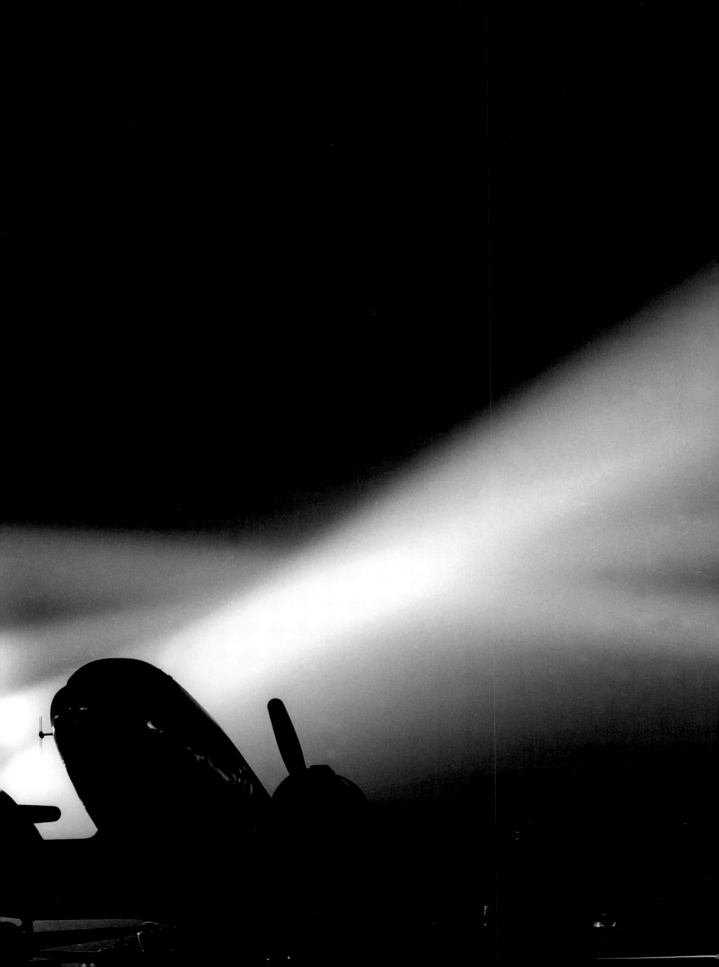

Leben im Frieden

La vie en temps de paix

LIFE IN PEACE

As a photographer in postwar Germany, my environment was similar to that of a traveling salesman. I was constantly on the road, driving at any time of day and night in every direction from my base in Pfungstadt. With the scarcity of public transportation at that time, it did not take long for Germans to learn the American way of "thumbing a ride." As a consequence, I gave rides to perhaps thousands of hitchhikers of every age and gender during my five years there. It was one way for me to meet many different people. They would tell about their problems and I could use the opportunity to learn more of the language. These talks often gave me ideas for photo essays.

The Cinderella of Bremen
One experience gave me a new appreciation of relations between the Americans and Germans and illustrated how far we had already progressed in the peace process. I had gone to Bremen with a colleague to visit Mabel, a friend from Hollywood, Florida, who had served in the Women's Army Corps and was now working as a civilian for the War Department there. One winter morning in 1947, we heard a

Mein Leben als Fotograf im Nachkriegsdeutschland glich mitunter dem eines Handlungsreisenden. Stationiert war ich in Pfungstadt, und von dort aus war ich ständig unterwegs und fuhr zu allen Tages- und Nachtzeiten mit meinem Jeep kreuz und quer durch das Land. Öffentliche Verkehrsmittel gab es kaum, und so dauerte es nicht lange, bis die Deutschen den Amerikanern das Reisen per Anhalter abgeschaut hatten: Ich nahm während meiner fünf Jahre in Deutschland an die 1 000 Anhalter beiderlei Geschlechts und jeden Alters mit. Auf diese Weise lernte ich die unterschiedlichsten Menschen kennen. Sie erzählten mir von ihren Problemen, während ich die Chance nutzte, meine Deutschkenntnisse zu vertiefen. Oft inspirierten mich diese Gespräche zu Fotoreportagen.

Das Aschenputtel aus Bremen
Zu einer für mich damals neuen Einschätzung des Verhältnisses zwischen Amerikanern und Deutschen gelangte ich durch ein Erlebnis, das mir anschaulich vor Augen führte, wie weit der Friedensprozess bereits gediehen war: Zusammen mit einem Kollegen besuchte ich Mabel, eine Freundin aus Hollywood, Flo-

En tant que photographe dans l'Allemagne de l'après-guerre, mon univers était grosso modo celui d'un commis-voyageur. J'étais continuellement en déplacement, sur la route à toute heure du jour ou de la nuit, sillonnant, depuis ma base de Pfungstadt, la région en tous sens. Etant donné la rareté des transports en commun à cette époque, il ne fallut pas longtemps aux Allemands pour apprendre la technique américaine de l'auto-stop. Pendant les cinq années passées en Allemagne, j'ai bien pris moi-même un millier d'auto-stoppeurs de tous âges et conditions. Ce fut pour moi l'occasion de rencontrer des Allemands et de découvrir ce qu'ils pensaient, les problèmes qu'ils connaissaient dans la vie de tous les jours, de pratiquer la langue et de dénicher des sujets de reportages photo.

La Cendrillon de Brême
Une expérience me permit de faire le point sur les relations entre Allemands et Américains et illustre les progrès du processus de paix : accompagné d'un collègue, je rendis visite à Mabel, une amie de Hollywood (Floride), ex-membre du corps d'armée des femmes et devenue fonctionnaire du minis-

Previous double page: Entertaining Americans at the Officer's Club

Vorhergehende Doppelseite: Im Offizierskasino, Unterhaltungsprogramm für Amerikaner

Double page précédente : Les Américains se distraient au Club des Officiers.

Darmstadt. April, 1948

faint knock at her door. On opening the door, we saw a shivering golden-haired, blue-eyed German girl about six years old dressed in rags and holding a puppy in her arms. Mabel, who knew German better than I, said that the little girl, Trautchen, wanted to exchange her pet for food. My friend gave her some food and we took her home with her puppy still in her arms. She was the only child of Mr and Mrs Sass who lived in a bombed-out dwelling nearby.

Mabel wrote of the child's plight, to her friend Helen, in Conshohocken, Pennsylvania. Helen sent a new wardrobe and doll. Mabel called Trautchen over and after shedding her tattered clothing and giving her a bath, dressed her in the new clothes. When the parents saw their daughter transformed into a Cinderella with a doll in her arms, they were overcome with gratitude.

rida, die im Armeekorps der Frauen gedient hatte und jetzt in Bremen als Zivilbeschäftigte für das Kriegsministerium arbeitete. An einem bitterkalten Wintermorgen des Jahres 1947 klopfte es leise an der Tür ihrer Wohnung. Mabel öffnete und vor uns stand Trautchen, ein etwa sechs Jahre altes, vor Kälte zitterndes Mädchen mit goldblondem Haar und blauen Augen, in Lumpen gekleidet, mit einem kleinen weißen Hund in den Armen. Mabel zufolge wollte sie ihren Hund gegen Lebensmittel eintauschen. Mabel gab der Kleinen etwas zu essen, dann brachten wir sie und das Hündchen nach Hause. Zusammen mit ihren Eltern, Herr und Frau Sass, hauste Trautchen ganz in der Nähe in einem ausgebombten Haus.

Voller Mitgefühl schilderte Mabel ihrer Freundin Helen aus Conshohocken, Pennsylvania, den Vorfall, worauf diese neue Kinderkleidung und eine Puppe nach Bremen schickte. Daraufhin wurde Trautchen zu Mabel gerufen, die dem Aschenputtel die Lumpen auszog, es von Kopf bis Fuß schrubbte und sodann völlig neu einkleidete. Als die Eltern ihr zur Prinzessin verwandeltes Töchterchen wiedersahen, waren sie vor lauter Dankbarkeit fast sprachlos.

tère de la Défense, en poste à Brême. Par une glaciale matinée de l'hiver 1947, nous avons entendu frapper à la porte de sa résidence. En ouvrant la porte, nous avons découvert une petite fille en haillons aux cheveux blonds et aux yeux bleus, toute tremblante. Agée d'environ six ans, elle tenait un petit chien blanc dans ses bras. Mabel qui parlait mieux l'allemand que moi, nous expliqua que la petite fille, Trautchen, voulait échanger son petit chien contre de la nourriture. Elle la fit manger, lui donna de la nourriture à emporter et nous la raccompagnâmes chez elle, son petit chien blanc toujours dans les bras. Elle habitait avec ses parents, M et Mme Sass, à proximité, dans la cave de leur immeuble en ruines.

Mabel écrivit à son amie Hélène, de Conshohocken (Pennsylvanie) pour lui exposer le cas de cette petite fille. Hélène répondit en envoyant une garde-robe complète et une poupée. Mabel invita Trautchen chez elle et après lui avoir ôté ses vieux vêtements et l'avoir décrassée des pieds à la tête, l'habilla de neuf. Quand les parents découvrirent leur fille transformée en Cendrillon avec une poupée dans les bras, ils furent submergée de gratitude.

A GI and his German fiancée at their engagement party

Ein GI und eine Kriegsbraut auf ihrer Verlobungsparty

Un GI et sa promise allemande fêtent leurs fiançailles.

Heidelberg. September, 1948

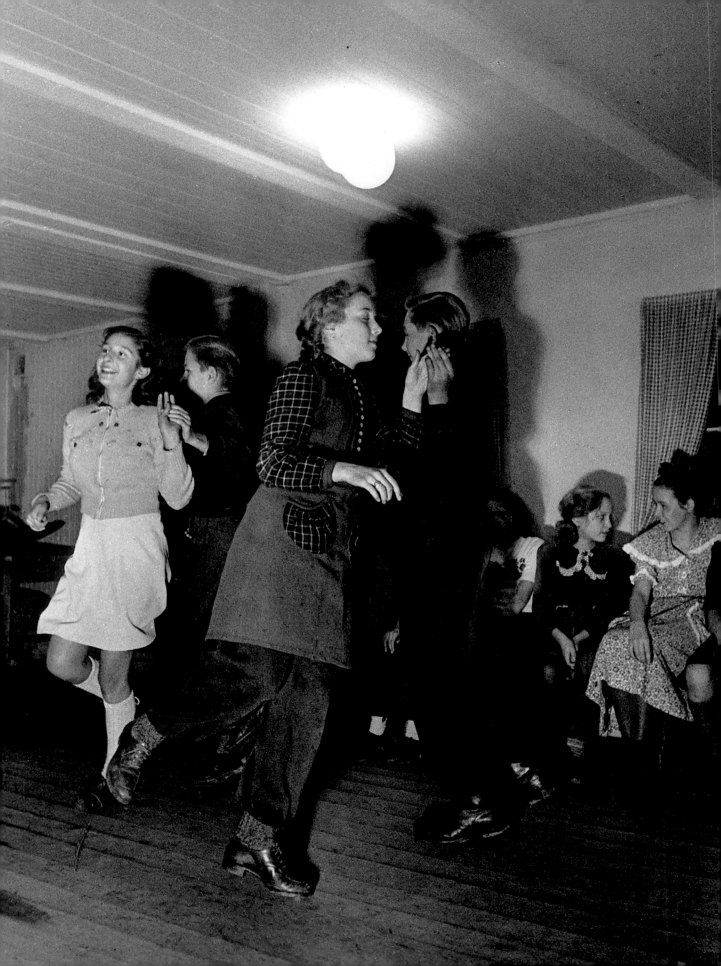

German youngsters taking dance lessons. During the Occupation, American representatives of many faiths came over to sponsor such activities. American Quakers initiated this event.

Junge Mädchen in der Tanzstunde. Während der Besatzungszeit wurden solche Veranstaltungen von amerikanischen Vertretern unterschiedlichster Glaubensrichtungen gefördert, diese beispielsweise von Quäkern.

Jeunes Allemandes prenant des cours de danse. Durant l'Occupation, des représentants américains de diverses confessions parrainaient ce genre d'activités. Celle-ci a été organisée par des quakers.

Frankfurt-Bockenheim. March, 1947

A U.S. WAC at the beauty parlor
Eine weibliche Angehörige der US-Army im Schönheitssalon
Un salon de beauté réservé au personnel féminin de l'armée américaine
Wiesbaden. May, 1947

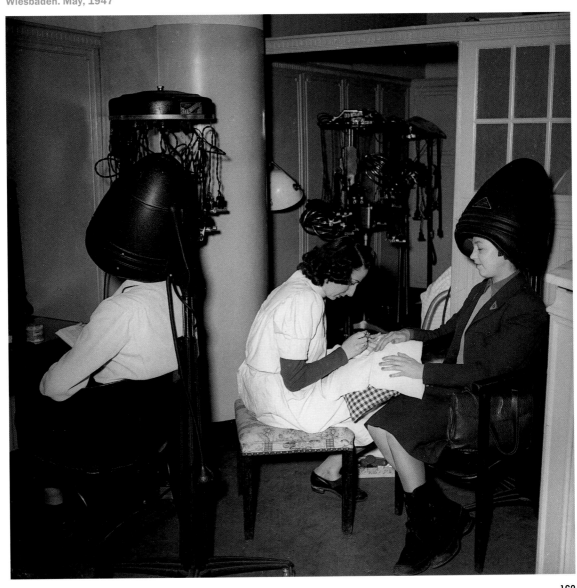

German haute couture

This was probably the first fashion show in postwar Germany. The model is wearing a black crepe with removable dickey and undersleeves, a copy of the Paris styles from 1947, designed by the fashion shop Zinnecker in Wiesbaden.

The Germans had virtually no cloth and even when they had it, the choice of colors was limited. Frau Emy Grassegger, director of the Frankfurt Art Institute Fashion School could not open the school for lack of good quality cloth. Most of the original haute couture products were sold directly to specialty shops catering to what Frau Grasseger called "questionable characters". These, she explained, would come to her, cross their legs, light cigarettes and say: 'I'll buy that'. They were quite obviously bad characters, Frau Grassegger explained. "There are no society women left; the upper classes do not exist in Germany anymore; they too are living from meal to meal".

Deutsche Haute Couture

Dies dürfte die erste Modenschau im Nachkriegsdeutschland gewesen sein. Das Mannequin trägt ein Kleid aus schwarzem Crêpe. Der Bluseneinsatz und die Unterärmel sind abnehmbar – ein an die Pariser Mode von 1947 angelehnter Entwurf des Modehauses Zinnecker in Wiesbaden.

Die Deutschen hatten praktisch keine Stoffe, und wenn sie welche hatten, dann nur in einer sehr begrenzten Auswahl an Farben. Frau Emy Grassegger, die Direktorin des Frankfurter Instituts für Modeschaffen, konnte die Schule nicht eröffnen, weil es an hochwertigen Stoffen fehlte. Fast alle deutschen Haute-Couture-Kreationen wurden direkt an spezielle Modegeschäfte verkauft, die, laut Frau Grassegger, „von fragwürdigen Frauen frequentiert werden, die ihre Beine übereinanderschlagen, eine Zigarette anzünden und ‚Das nehme ich' sagen. Damen der Gesellschaft gibt es nicht mehr. Die deutsche Oberschicht ist verschwunden. Alle leben jetzt von der Hand in den Mund."

Haute couture allemande

C'est sans doute le premier défilé de mode dans l'Allemagne de l'après-guerre. Le mannequin porte une robe de crêpe noir avec plastron et sous-manches amovibles, imitée des modèles parisiens de 1947 et confectionnée par la maison Zinnecker de Wiesbaden.

Les Allemands n'avaient pas de tissu et quand ils en avaient, le choix de coloris était limité. Frau Emy Grassegger, directrice de la section mode de l'Institut d'art de Francfort n'a pas pu ouvrir l'école à cause de la pénurie d'étoffes de bonne qualité. La plupart des véritables modèles de haute couture allemands étaient vendus dans des magasins réservés à des clientes qui étaient, selon la description de Frau Grassegger «des femmes douteuses qui s'asseyaient, croisaient les jambes, allumaient une cigarette et lançaient : ‹ Je l'achète ›, bref des femmes de mauvaise vie. Il n'y a plus de femmes du monde. Plus de classes supérieures en Allemagne. Tout le monde essaie de joindre les deux bouts. »

Fashion Show
Modenschau
Défilé de mode

Boy ice-skating in the street

Ein Junge läuft Schlittschuh auf der Straße.

Un gamin patinant dans la rue

Pfungstadt. January, 1947

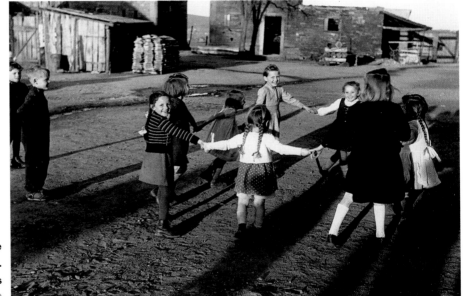

Children playing Ring-around-Rosie

Kinder spielen Ringelreigen.

Rondes et jeux enfantins

Bremerhaven. February, 1949

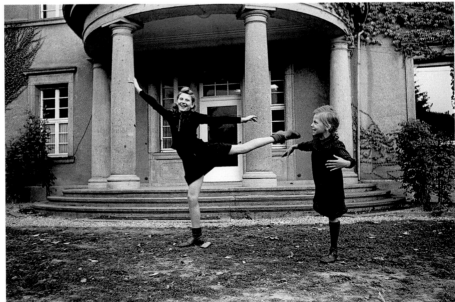

Girls' impromptu ballet

Balletimprovisationen junger Mädchen

Ballet improvisé de deux fillettes

Heidelberg. March, 1948

Children reading "The Story of Babar, the Little Elephant"
Kinder lesen „Die Geschichte von Babar, dem kleinen Elefanten".
Des enfants lisant « L'Histoire de Babar, le petit éléphant ».
Amerika Haus. Frankfurt. April, 1948

Taking a nap in a handcart
Ein Nickerchen im Handwagen
La sieste dans la charrette à bras
Baden-Baden. November, 1948

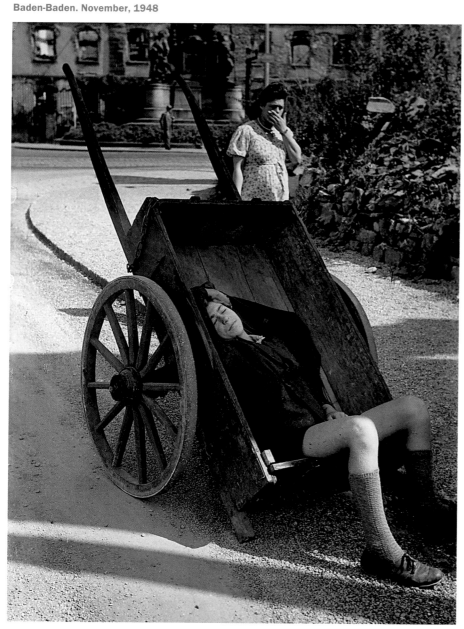

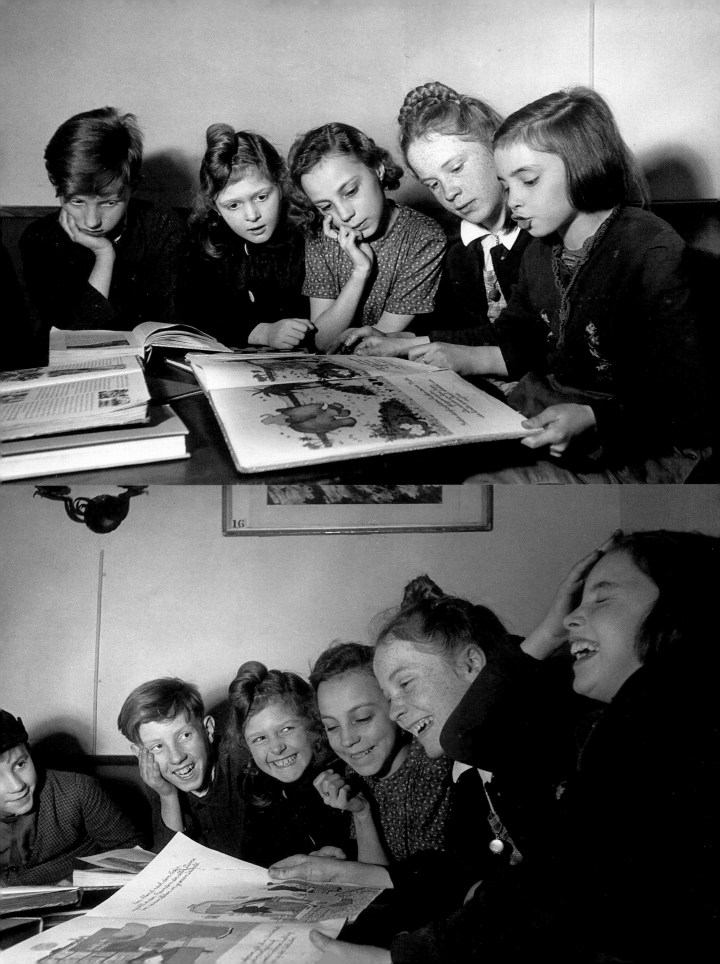

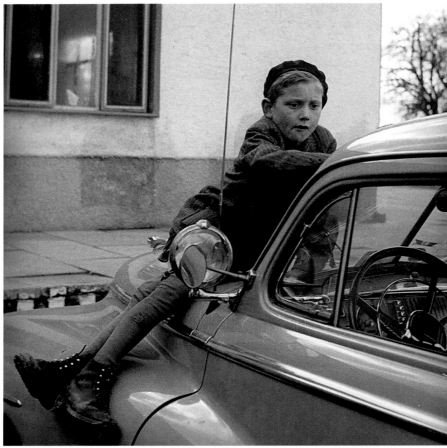

Boy cleaning the car of a
U.S. officer

**Ein Junge wäscht das Auto eines
amerikanischen Offiziers.**

**Jeune garçon lavant la voiture
d'un officier américain**

Berlin. December, 1948

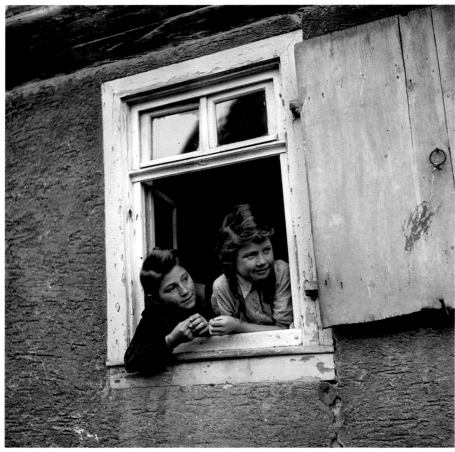

Two girls at a window

Zwei Mädchen am Fenster

Deux fillettes à une fenêtre

Near Darmstadt. December, 1948

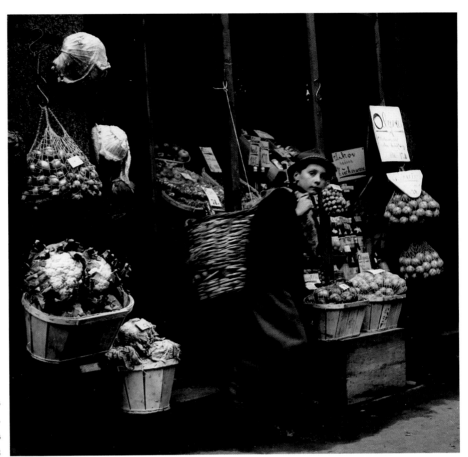

Boy delivering fruits and vegetables
Ein Junge trägt Obst und Gemüse aus.
Jeune garçon livrant des fruits et légumes
Saarbrücken. December, 1948

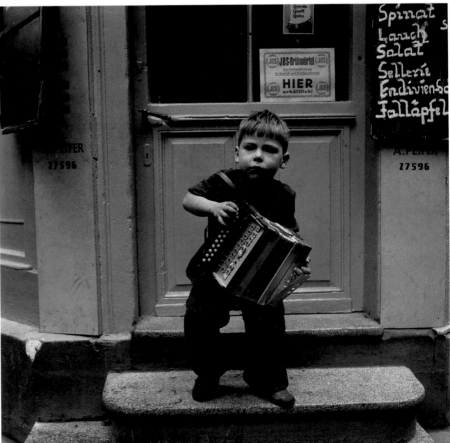

Boy with accordion
Junge mit Akkordeon
Gamin à l'accordéon
Pfungstadt. May, 1947

Spring in Heidelberg

On Sunday morning, March 7, 1948, approximately 12,000 Heidelberg children, joined by many Americans, marched through the city streets to welcome spring. They were following a custom which originated in the 17th century when Countess Lieselotte von der Pfalz (1652–1722) chose the fourth Sunday in Lent to distribute new shoes and sweets to the children of the town. The day has come to mark the arrival of spring in the Neckar Valley. On this day, children parade through the city singing the traditional song about their new shoes and brandishing long sticks decorated with paper streamers, pretzels, colored eggs, and apples. The parade begins in Karlsplatz with the burning of winter in effigy. Two weeks before the official beginning of spring, two boys, costumed as winter (in a tepee of straw) and spring (in a tepee of green leaves), fight for supremacy, with spring, of course, emerging victorious.

Frühling in Heidelberg

Diese Aufnahmen entstanden am 7. März 1947, einem Sonntag. Etwa 12 000 Kinder zogen, begleitet von vielen Amerikanern, durch die Straßen Heidelbergs, um den Frühling zu begrüßen. Dieser Brauch geht auf das 17. Jahrhundert zurück, als Liselotte von der Pfalz (1652–1722) alljährlich zum vierten Sonntag der Fastenzeit an die Kinder der Stadt neue Schuhe und Leckereien verteilen ließ. Bis heute feiert man hier im Neckartal an diesem Tag den Frühlingsbeginn. Während des Zugs durch die Stadt singen die Kinder begeistert von ihren neuen Schuhen und schwingen dabei mit bunten Papierschlangen, Brezeln, gefärbten Eiern und Äpfeln geschmückte Stöcke. Traditionellerweise beginnt der Umzug auf dem Karlsplatz mit der symbolischen Verbrennung des Winters. Winter und Frühling, dargestellt von zwei Jungen, kämpfen um die Vorherrschaft – der eine in einem Umhang aus Stroh, der andere in einem Kostüm aus grünen Blättern. Und selbstverständlich siegt der Frühling.

Printemps à Heidelberg

Le dimanche 7 mars au matin, environ 12 000 enfants de Heidelberg auxquels s'étaient joints de nombreux enfants américains ont formé une procession qui a traversé les rues de la ville pour célébrer le printemps. Ils reprenaient une coutume remontant au dix-septième siècle et instituée par la comtesse Liselotte von der Pfalz (1652–1722) qui, chaque année, le quatrième dimanche du printemps, distribuait chaussures neuves et friandises aux enfants de la ville. Depuis, cette fête marque le retour des beaux jours dans la vallée du Neckar. Les enfants défilent à travers la ville en chantant des chansons traditionnelles sur leurs nouvelles chaussures et en brandissant de longs bâtons gaiement ornés de banderoles en papier, de bretzels, d'œufs peints et de pommes. On a brûlé l'hiver en effigie sur la Karlsplatz pour donner le coup d'envoi du défilé. Ensuite deux adolescents harnachés l'un de paille et l'autre de feuillages verts (l'hiver et le printemps) se sont affrontés jusqu'à la victoire du printemps.

Right page: A child representing winter
Rechte Seite: Ein Kind verkörpert den Winter.
Page de droite: Un enfant représentant l'hiver
Heidelberg, March 7, 1948

Mother and child at the feast of welcome to spring
Eine Mutter mit ihrem Kind beim Frühlingsfest
Une mère et son enfant à une fête du printemps
Heidelberg, March 7, 1948

A girl contemplates the symbols of spring.
Ein Kind betrachtet die Symbole des Frühlings.
Une enfant contemplant les symboles du printemps
Heidelberg, March 7, 1948

A musician taking a swig of beer

Ein Musiker gönnt sich einen Schluck Bier.

Une gorgée de bière pour le musicien

Munich. Oktoberfest, 1948

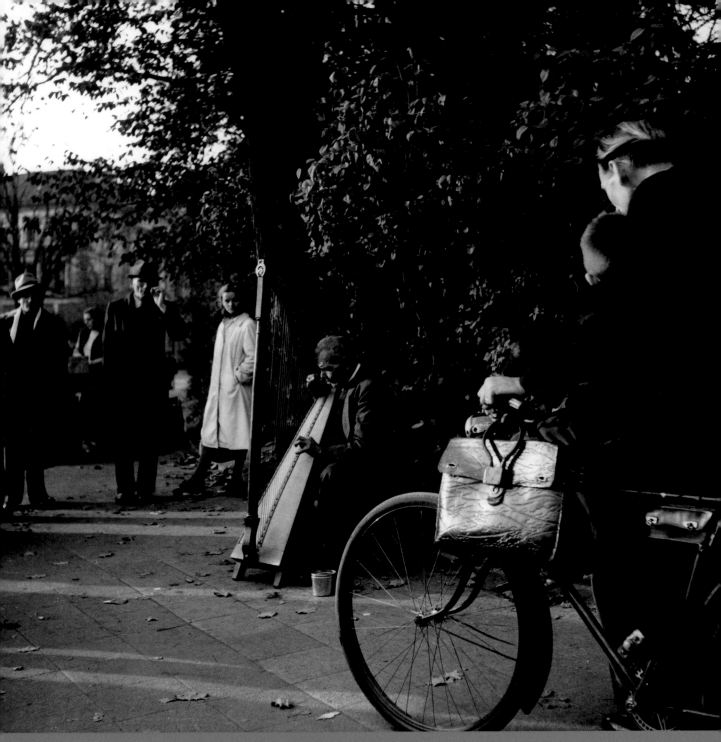

Street harp player
Der Harfenspieler auf der Straße
Le harpiste dans la rue
Frankfurt. October, 1948

Page/Seite/Page 176:
Nazi anti-spy propaganda
Nazi-Propaganda, Warnung vor Spionen
Propagande nazie contre les espions
Celle. September, 1948

Page/Seite/Page 177:
Lady in bikini
Frau im Bikini
Jeune femme en bikini
Baden-Baden, 1948

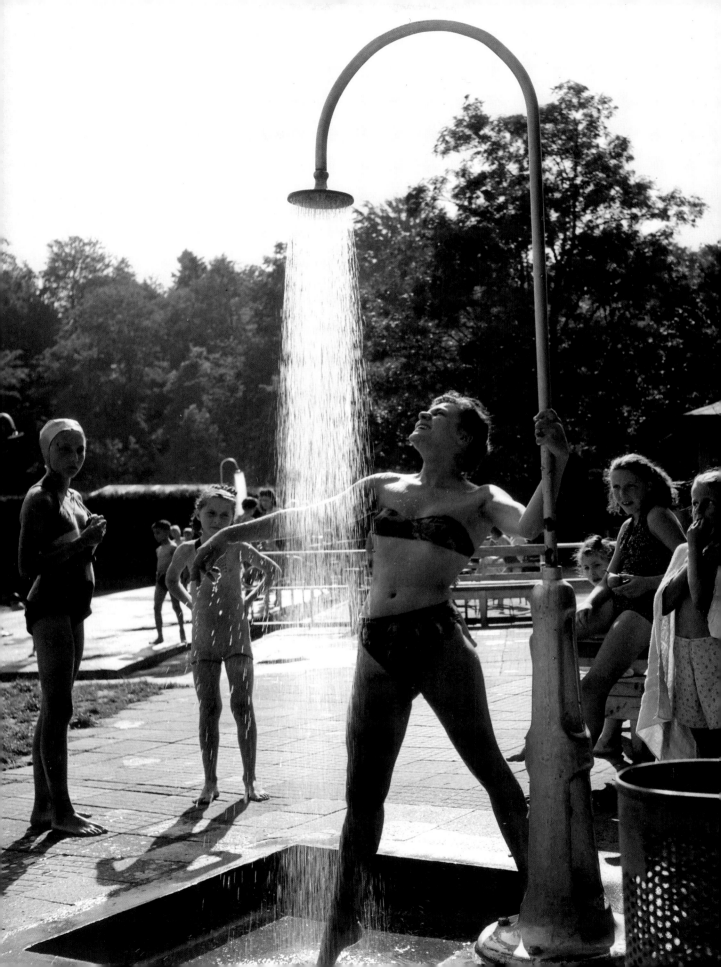

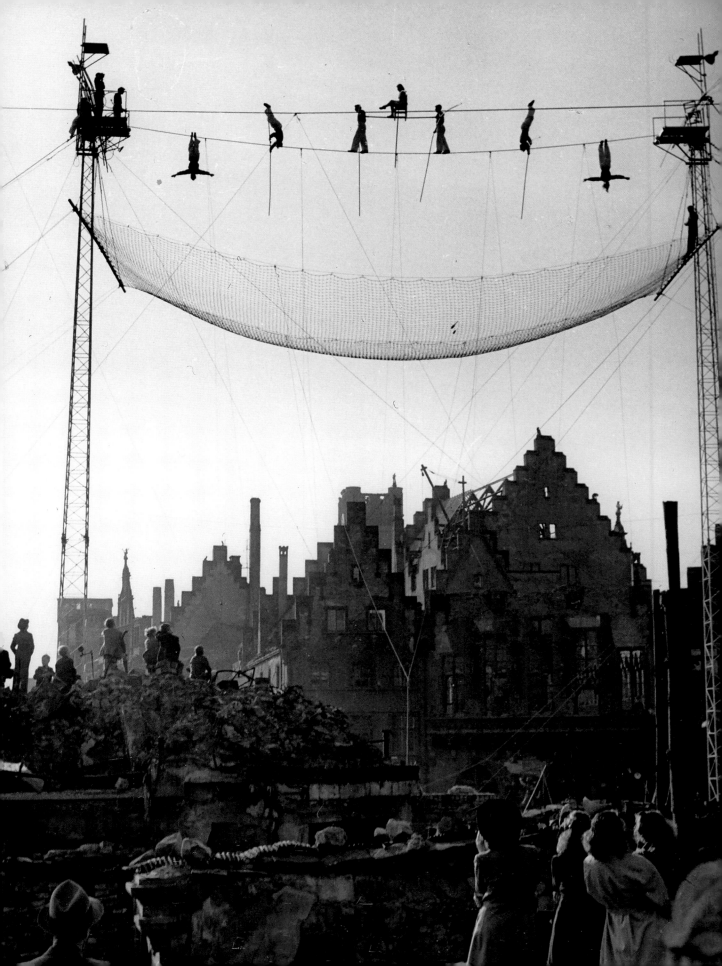

Trapeze artists of the Camilla Mayer troupe performing a death-defying feat

Die Trapezkünstler der Camilla-Mayer-Truppe präsentieren den „Todeslauf".

Les trapézistes de la troupe Camilla Mayer dans leur numéro de « défi à la mort »

Frankfurt. March, 1948

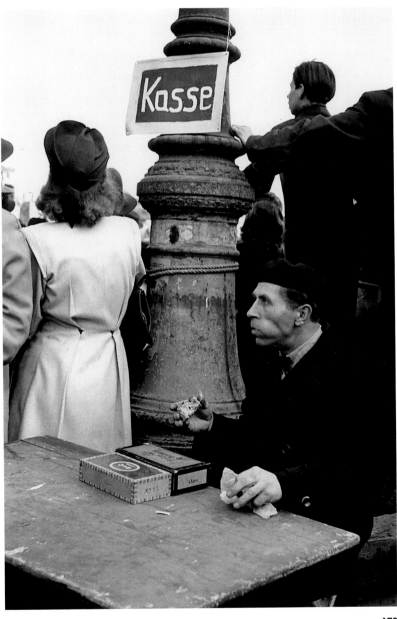

Cashier at lunch
Der Kassierer beim Mittagessen
Le caissier casse la croûte.
Frankfurt. March, 1948

"Unus," the acrobat. After the war, he became famous in America.
Der Akrobat „Unus". Nach dem Krieg wurde er in den USA berühmt.
L'acrobate « Unus ». Après la guerre, il deviendra célèbre aux Etats-Unis.
Heidelberg. March, 1948

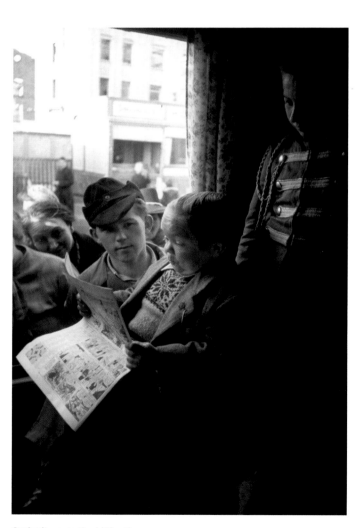

Curiosity over the Lilliputians
Neugierige Blicke auf einen Liliputaner
De la curiosité pour les Lilliputiens
Bremen. March, 1948

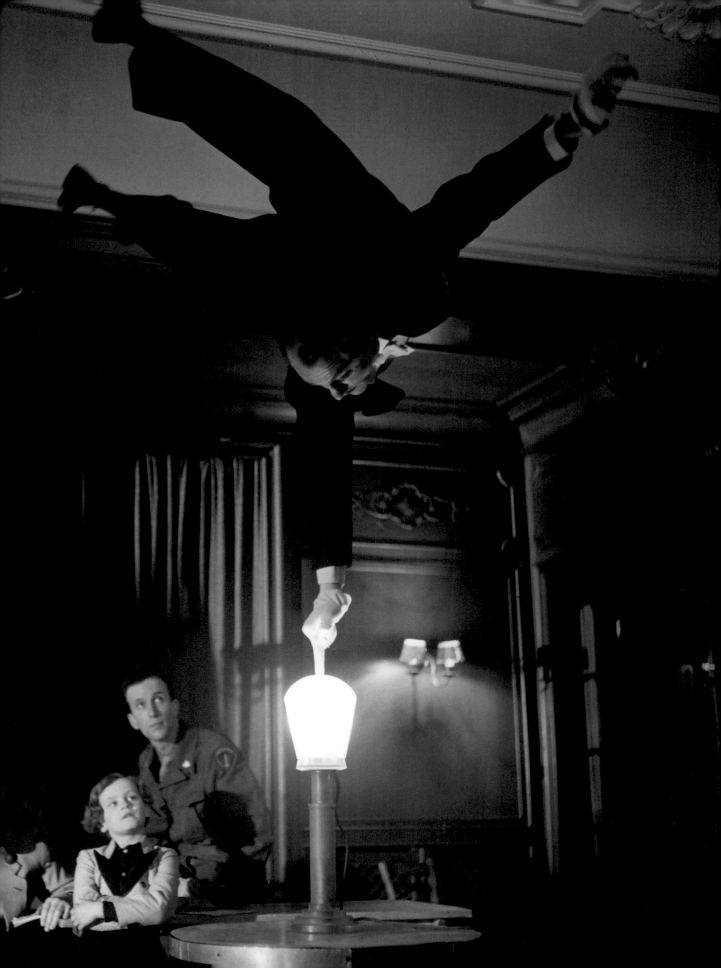

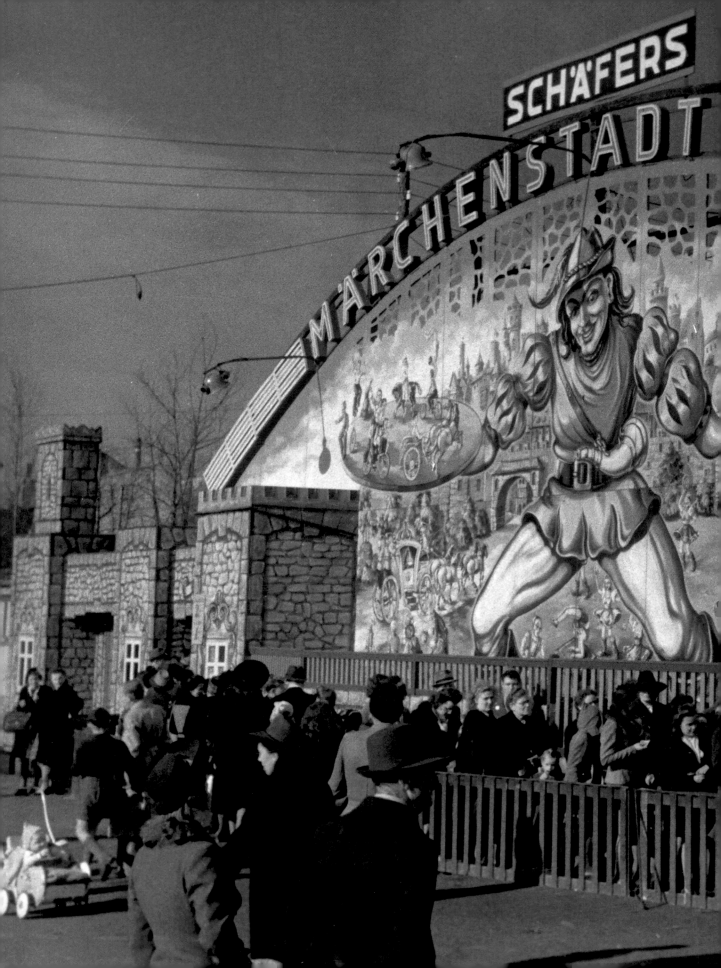

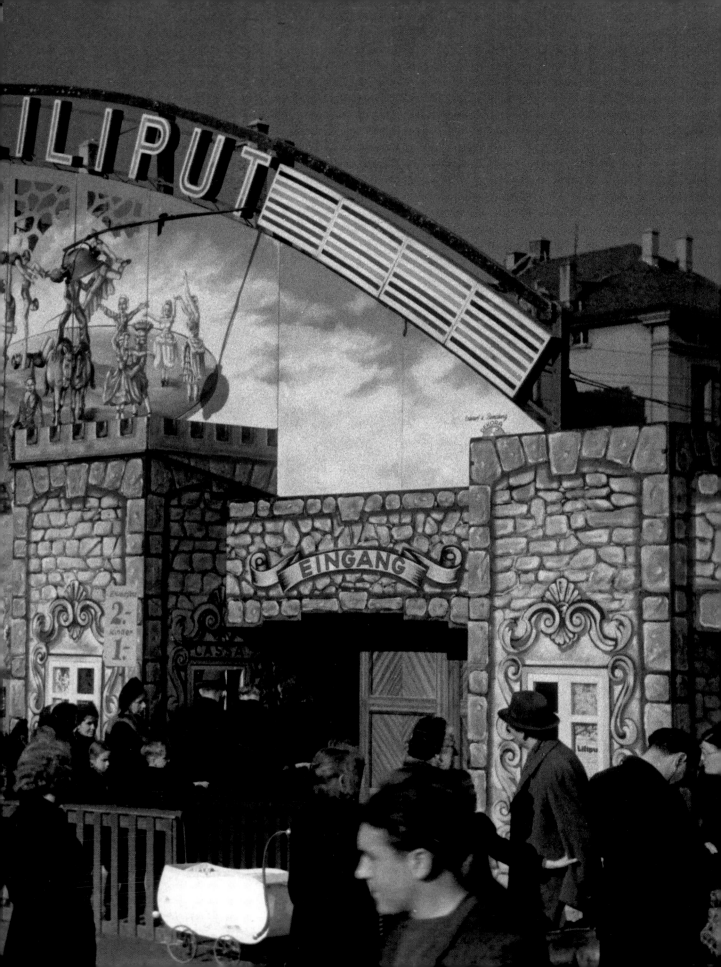

Previous double page: Lilliputians' dream town
Vorhergehende Doppelseite: Die Märchenstadt der Liliputaner
Double page précédente : La ville enchantée de Lilliput
Bremen. March, 1948

Striptease on Hitler's yacht
Striptease auf Hitlers Yacht
Strip-tease sur le yacht d'Hitler
On the Rhine. May, 1947

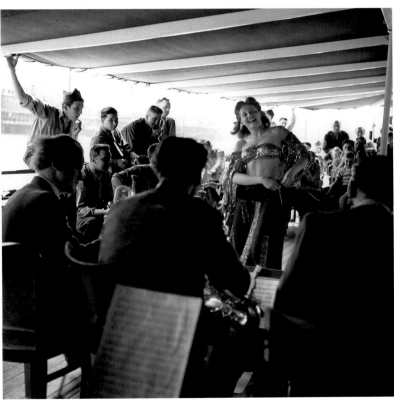

Mardi Gras clientele at the "Bugi Wugi" club
Karneval im „Bugi Wugi"-Club
Le Mardi-Gras au club « Bugi-Wugi »
Frankfurt. March, 1948

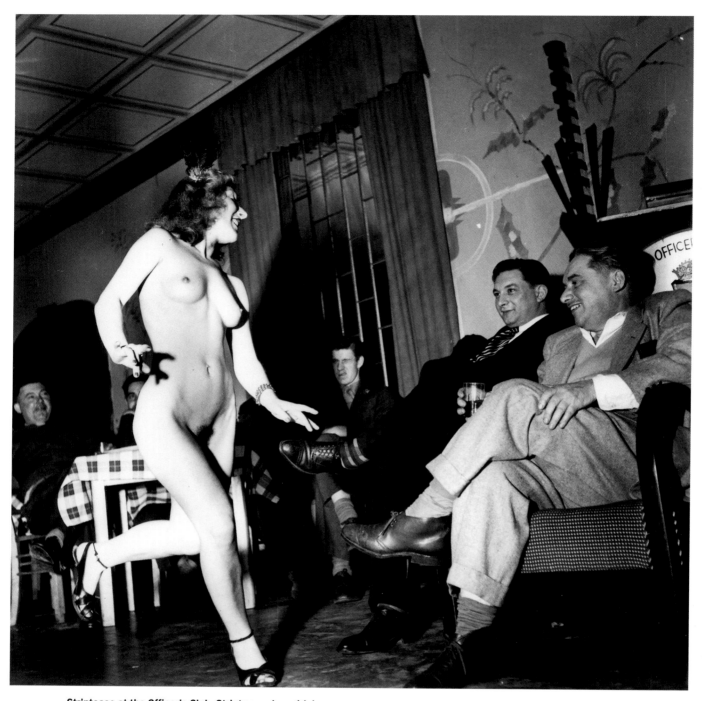

Striptease at the Officer's Club. Striptease showgirl dances for the Americans.

Striptease im Offizierskasino. Eine Stripperin tanzt für Amerikaner.

Strip-tease au Club des Officiers. Une strip-teaseuse dance pour les Américains.

Darmstadt. April, 1948

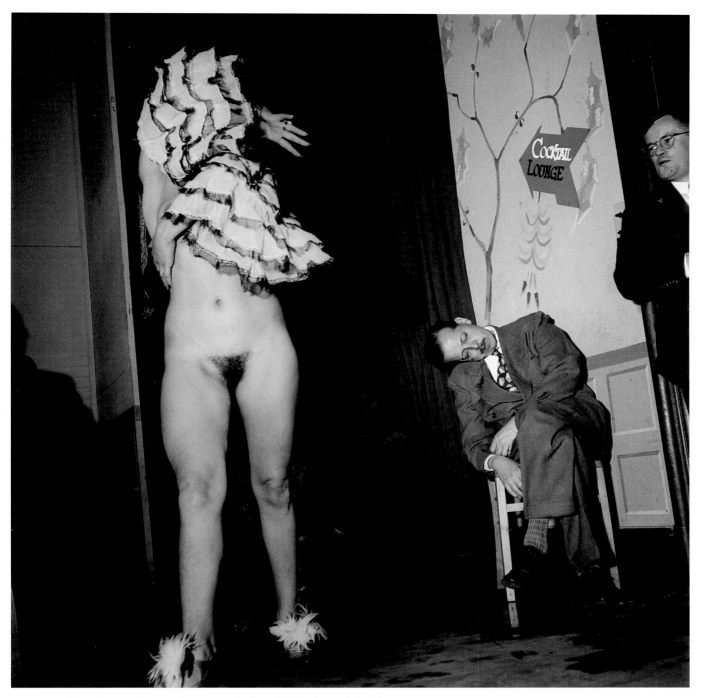

When the gentleman woke up, he asked me: "Did I miss anything?"

Als der Mann aufwachte, fragte er mich: „Habe ich etwas verpasst?"

Lorsque cet homme se réveilla, il me demanda : « J'ai manqué quelque chose ? »

Darmstadt. April, 1948

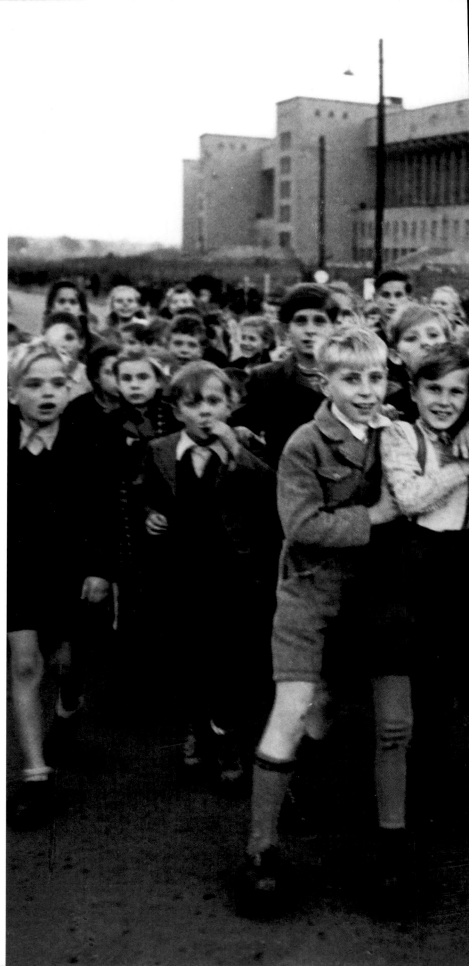

On July 4, 1949, I sold my car, said goodbye to my friends, and was driven to Frankfurt's main station to catch a train to Cherbourg to board the Queen Elizabeth, bound for New York on the 8th. At the Gare de l'Est, in Paris, I found that my trunk with all my possessions, including negatives was missing. I was reassured by the authorities that everything would be taken care of. I trusted them. Nearly a year later, I received a postcard informing me that my footlocker was in a warehouse in Bremen. A month later it arrived intact (though with a lot of green mold in it). I opened my 1949 notebook and read my last entry. "The Occupation is a success; the Berlin airlift is a success; the Germans are friendly—plenty of war brides are going to the States—it's time you too, Tony, got back there. *Auf Wiedersehen, Deutschland*"

Am 4. Juli 1949 verkaufte ich mein Auto, verabschiedete mich von meinen Freunden und machte mich auf den Heimweg nach New York. Von Frankfurt aus fuhr ich nach Cherbourg, wo ich am 8. Juli an Bord der „Queen Elizabeth" ging. Leider ging meine Feldkiste mit meiner ganzen Habe, einschließlich der Negative, auf der Zugfahrt verloren. Fast ein Jahr später teilte man mir auf einer Postkarte mit, dass sie sich in einem Lagerhaus in Bremen befinde, und nach einem weiteren Monat traf sie bei mir ein – zwar war alles übersät von grünem Schimmel, aber unbeschädigt. Ich schlug mein klammes Notizbuch von 1949 auf. Der letzte Eintrag lautete: „Die Besatzung ist ein Erfolg, die Berliner Luftbrücke ist ein Erfolg, die Deutschen sind unsere Freunde geworden, viele Kriegsbräute gehen in die Staaten, Tony, auch für dich ist es an der Zeit, nach Hause zurückzukehren. *Auf Wiedersehen, Deutschland*"

Le 4 juillet 1949, j'ai vendu ma voiture, fait mes adieux à mes amis et repris le chemin de New York. Parti de Francfort, j'ai rejoint Cherbourg où je suis monté à bord du « Queen Elizabeth » le 8 juillet. Malheureusement, la cantine qui contenait tout mes biens, négatifs compris, avait été perdue dans le train. Près d'un an plus tard, je reçus une carte postale m'informant qu'elle se trouvait dans un hangar à Brême, et un mois plus tard, elle était chez moi – couverte de moisissures vertes mais intacte. J'ouvris mon carnet de 1949, tout imprégné d'humidité. La dernière inscription (du 1er juillet) disait : « L'occupation est une réussite, le pont aérien de Berlin est une réussite, les Allemands sont devenus nos amis l'heure est venue de rentrer. *Auf Wiedersehen, Deutschland* »

Children and a GI at Tempelhof Airport
Kinder und GI am Flughafen Tempelhof
Enfants et GI à l'aéroport de Tempelhof
Berlin. October, 1948

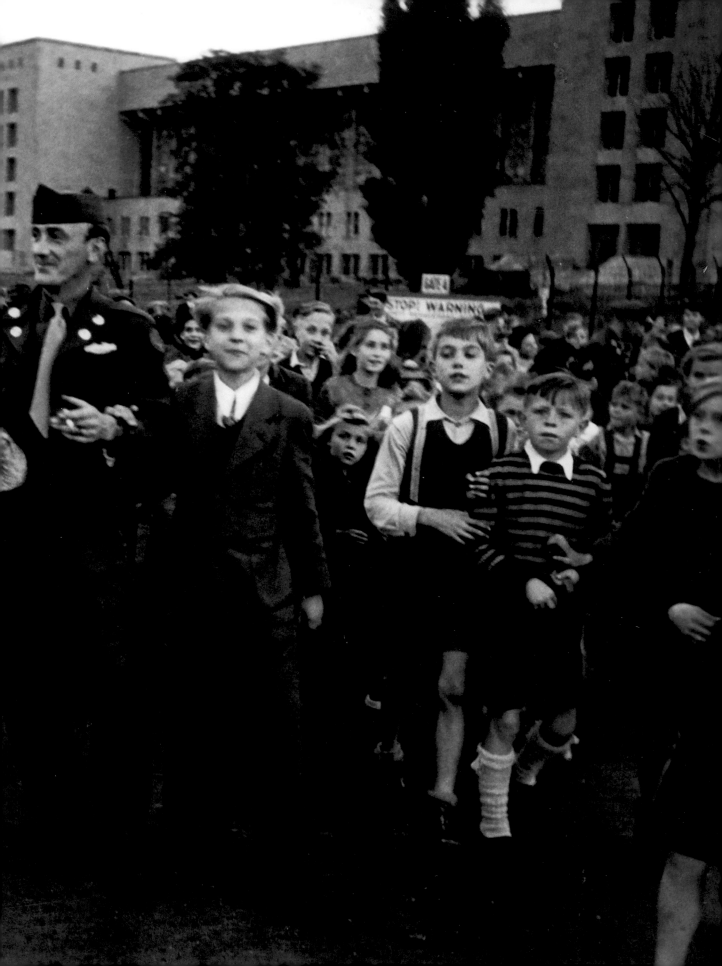

Biography

Born in **1922** in Greensburg PA to immigrant Italian parents, Tony Vaccaro was brought up in Bonefro, Italy, and returned to the U.S. upon the outbreak of WW II. His love of photography was born in Bonefro where, at the age of 10, he began using a box camera to take snapshots of his friends. At high school in New Rochelle, NY, his teacher and mentor Bertram L. Lewis guided him through a year of concentrated apprenticeship in photography. In August **1942** he bought an Argus C-3 35mm camera and was drafted into the U.S. Army, and by the time he landed in Normandy in June **1944**, with the U.S. 83rd Infantry Division, he was expert in both the rifle and the camera. By the end of WW II he had taken nearly 8,000 photographs of war and war-related scenes.

Vaccaro remained in Germany during the allied Occupation as a civilian photographer, working for *Weekend* magazine, the Sunday supplement of the Army newspaper *The Stars and Stripes*, whose editor, Dick Jones, Vaccaro credits with the launching of his photographic career. His assignments for Weekend took him all over Germany and to other countries and continents. By the summer of **1949**, when he returned to the U.S., he had taken over 9,000 images of Germany, and almost as many in postwar France, Spain, Italy.

In September **1950**, the legendary Fleur Cowles, founder and editor of *Flair*, hired Vaccaro as the magazine's head photographer after viewing his portfolio of combat photographs. "I do not need a combat photographer," she said, "but can you do fashion photography for me with the same force and power?" He apparently satisfied the Fleur Cowles formula, because in the next few years he went on to do original ground-breaking fashion and related arts photography for both *Flair* and the parent Cowles publication *Look*. During that period, he met and became friends with such luminaries as Maria Callas, Duchamp, Willem de Kooning, Max Ernst, Georgia O'Keeffe, Picasso, Jackson Pollock, Bertrand Russell and Frank Lloyd Wright.

In **1953**, Vaccaro moved to *LIFE* magazine and

Biografie

Tony Vaccaro wurde **1922** in Greensburg (PA) als Sohn italienischer Einwanderer geboren. Als Dreijähriger kam er nach Bonefro, Italien, dem Heimatort seiner Eltern und wuchs dort bei Verwandten auf. Hier entstand auch seine Liebe zur Fotografie: Im Alter von zehn Jahren machte er mit einer Boxkamera die ersten Schnappschüsse von Freunden. **1939**, bei Ausbruch des Zweiten Weltkriegs, kehrte er in die USA zurück. Auf der High School in New Rochelle (NY) machte ihn sein Lehrer und Mentor Bertram L. Lewis mit den Grundlagen der Fotografie vertraut. Im August **1942** kaufte er sich eine Argus C-3, eine 35mm-Kamera. Er wurde in die US-Army eingezogen und landete im Juni **1944** mit der 83. Infanteriedivision in der Normandie. Bald war er mit dem Gewehr genauso vertraut wie mit der Kamera, und bei Kriegsende hatte er seine Erlebnisse in fast 8 000 Aufnahmen dokumentiert. Während der Besatzungszeit blieb er als Zivilist in Deutschland und arbeitete als Fotoreporter für das Magazin *Weekend*, die Sonntagsbeilage der Armeezeitung *The Stars and Stripes*. Dick Jones, dem Chefredakteur dieses Magazins, verdankt Vaccaro den Einstieg in seine Karriere. Für seine Reportagen reiste er um die halbe Welt, und als er im Sommer **1949** in die USA zurückkehrte, hatte er allein im Nachkriegsdeutschland fast 9 000 Fotos gemacht, annähernd genauso viele in Frankreich, Spanien und Italien.

Im September **1950** engagierte ihn Fleur Cowles, die legendäre Gründerin und Herausgeberin der Zeitschrift *Flair*, als Cheffotografen. Nachdem sie eine Mappe seiner Kriegsfotografien durchgesehen hatte, sagte sie: „Ich brauche zwar keinen Kriegsfotografen, aber können Sie die Kraft und Vitalität dieser Bilder in die Modefotografie übertragen?" Offenbar erfüllte er ihre Erwartungen, und in den folgenden Jahren entstanden – für *Flair* und die etablierte, ebenfalls von Cowles herausgegebene Zeitschrift *Look* – bahnbrechende Mode- und Porträtaufnahmen. In dieser Zeit begegnete er Persönlichkeiten wie Maria Callas, Duchamp, Willem de Kooning, Max Ernst, Georgia O'Keeffe, Picasso, Jackson Pollock, Bertrand Russell und F. L. Wright.

Biographie

Né en **1922** à Greensburg (Pennsylvanie) de parents italiens immigrés, Tony Vaccaro a été élevé à Bonefro (Italie) avant de rentrer aux Etats-Unis, peu avant la Seconde Guerre mondiale. C'est à Bonefro qu'il commence à se passionner pour la photographie à l'âge de dix ans. Il prend des clichés de ses amis avec un appareil photo rudimentaire. Au lycée de New Rochelle (NY), son professeur et mentor, Bertram L. Lewis, le guide dans son apprentissage intensif de la photographie qui dure un an. En août **1942**, il achète un Argus C-3 35 mm et est incorporé dans l'armée américaine. En juin **1944**, à l'époque où il débarque en Normandie avec la 83e division d'infanterie, il est aussi expert à manier un fusil qu'un appareil photo. A la fin de la guerre, il a pris près de 8 000 photos de la guerre. Vaccaro reste en Allemagne à l'époque de l'occupation alliée comme photographe civil et il travaille pour *Weekend*, le supplément du dimanche de *The Stars and Stripes*, le journal de l'armée. C'est Dick Jones, son rédacteur en chef et mentor qui, selon Vaccaro, le lance dans la photo magazine. Il est envoyé en reportage dans toute l'Allemagne, dans d'autres pays européens voire sur d'autres continents. A la fin de l'été **1949**, quand il rentre aux Etats-Unis, il a recueilli plus de 9 000 images de l'Allemagne. En septembre **1950**, Vaccaro est embauché comme chef du service photo de *Flair* par Fleur Cowles, sa fondatrice et rédactrice en chef légendaire. Impressionnée par les photos de guerre qu'il lui montre elle lui lance : « Je n'ai pas besoin d'un photographe de guerre, mais pouvez-vous faire des photos de mode pour moi avec la même force et la même puissance ? » Il satisfait apparemment l'attente de Fleur Cowles puisque dans les années qui suivent, il multiplie les sujets photo originaux pour le magazine (mode, art de vivre…) tout en collaborant avec *Look*, une autre publication de Mme Cowles. C'est à cette époque qu'il rencontre et devient l'ami d'artistes et d'écrivains marquants : Maria Callas, Duchamp, Willem de Kooning, Max Ernst, Georgia O'Keeffe, Picasso, Jackson Pollock, Bertrand Russell et Frank Lloyd Wright.

With Anita Ekberg, photograph by
Tony Vaccaro, New York, 1951

With Anna Magnani, photograph by Jack Hamilton,
New York, 1953

On a *LIFE* assignment in Italy,
photograph by Alberto Burri, 1954

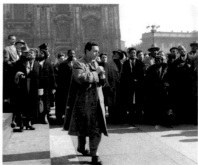

On a *LIFE* assignment in Milan, photograph by
Vincenzo Carrese, 1955

was sent to its Rome bureau. There, his assignments varied from coverage of time-honored rituals of the Vatican to the achievements of personalities in the nascent postwar Italian film industry. De Sica, Fellini, Anna Magnani, Sophia Loren, Alberto Burri and Karel Appel all looked into Vaccaro's lens.

With the confidence born of such experience, Vaccaro "went freelance" and worked steadily over the next two decades on special assignments for *LIFE* and *Look*, the twin peaks of a magazine photographer's journey in the mid-20th century.

It was *LIFE* that sent Vaccaro to Finland in **1965** to do a story on Helsinki's great Marimekko fashion house. On that assignment he met and married Anja Lehto, Marimekko's star model. They settled in Rome for the next five years, where their sons Frank and David were born and from where he now covered all of Europe, the Mediterranean nations and Africa.

Since childhood Vaccaro has been driven to search for images across the gamut of life, from the ugly to the aesthetic. The demise of *Look* and *LIFE* in the early **1970**s brought this adventure and the profession of magazine photographers to an end. It brought Vaccaro to a penthouse on Central Park, New York, from where he has worked for American corporations and taught photography at Cooper Union University in New York for many years.

Recognition of quality of the Vaccaro photographic corpus is growing. In June **1994**, France mounted an exhibition of his battlefield images to commemorate the 50th anniversary of the Normandy invasion. He has received the "Prix Bayeux des Correspondants de Guerre" and other decorations from France and Luxembourg. There are now 12 exhibitions of his work traveling through Europe, one of which caught the eye of the publisher Benedikt Taschen and led to this book.

Vaccaro has never forgotten his childhood, box camera in hand, on the streets of Bonefro, and life will have come full circle for him if his hopes for a "World Museum of the Magazine Photographer" are realized there in his palazzo.

1953 ging Vaccaro als Bildjournalist für *LIFE* nach Rom. Dort war er im altehrwürdigen Vatikan genauso zu Hause wie in der Cinecittà. Federico Fellini, Anna Magnani und Sophia Loren, sie alle standen in der frühen Glanzzeit des italienischen Nachkriegsfilms vor seiner Kamera, aber auch Künstler wie Alberto Burri und Karel Appel. Vaccaro wagte den Sprung in die Selbstständigkeit, und in den folgenden zwei Jahrzehnten war er regelmäßig als freier Fotograf für *LIFE* und für *Look* tätig, die beiden bedeutendsten amerikanischen Zeitschriften der 50er und 60er Jahre. **1965** reiste er nach Finnland, um für *LIFE* eine Fotoreportage über Marimekko, das große Modehaus in Helsinki, zu machen. Dort lernte er das Star-Mannequin Anja Lehto kennen und heiratete sie. Für die folgenden fünf Jahre ließen sie sich in Rom nieder, wo ihre Söhne Frank und David geboren wurden. Von dort aus bereiste Vaccaro für seine Reportagen ganz Europa, die Mittelmeerländer und Afrika.

In seinen Fotografien war es ihm seit jeher ein Anliegen, die gesamte Bandbreite menschlichen Lebens zu erfassen, das Schöne ebenso wie das Hässliche. Als *Look* und *LIFE* in den frühen 70er Jahren eingestellt wurden, gelangte diese Suche an ein Ende. Vaccaro zog in ein Penthouse am Central Park, arbeitete für amerikanische Unternehmen und lehrte viele Jahre lang Fotografie an der Cooper Union University in New York.

In den letzten Jahren hat sein Werk eine ständig wachsende Anerkennung gefunden. Anlässlich des 50. Jahrestags der Landung der Alliierten in der Normandie wurden im April **1994** in Bayeaux und Caen zwei Ausstellungen seiner Kriegsfotografien eröffnet. Vaccaro erhielt u. a. den „Prix Bayeux des Correspondants de Guerre". Zur Zeit sind in Europa zwölf Wanderausstellungen mit seinen Fotografien zu sehen; durch eine von ihnen wurde der Verleger Benedikt Taschen auf Vaccaros Fotos aufmerksam – die Idee zu diesem Buch war geboren.

Als Kind durchstreifte Vaccaro mit seiner Boxkamera die Straßen von Bonefro – der Kreis seines Lebens schlösse sich, wenn sich seine Hoffnung auf ein „World Museum of the Magazine Photographer" in seinem dortigen Palazzo erfüllte.

En **1953**, Vaccaro est engagé par le magazine *LIFE* et envoyé en poste à Rome. Il y photographie aussi bien les grandes cérémonies religieuses du Vatican que les stars du cinéma italien d'après-guerre. Federico Fellini, Anna Magnani, Sophia Loren, Alberto Burri et Karel Appel ont tous regardé l'objectif de Vaccaro.

Avec la confiance que procure une telle expérience, le photographe s'installe à son compte et, durant une vingtaine d'années, il enchaîne les sujets pour *LIFE* et *Look*, les deux grands titres de la photo magazine du milieu du XXe siècle.

En **1965**, *LIFE* envoie Vaccaro en Finlande pour un reportage sur la grande maison de couture Marimekko. Lors de ce séjour, il rencontre et épouse Anja Lehto, mannequin vedette de Marimekko. Le couple s'installe à Rome où il passe les cinq années suivantes et c'est dans la capitale italienne que naissent leurs fils Frank et David. Basé à Rome, Vaccaro couvre toute l'Europe, les pays du pourtour méditerranéen et l'Afrique.

Depuis l'enfance, Vaccaro n'a cessé de chercher des images, belles ou laides, dans le kaléidoscope de la vie. La mort de *LIFE* et *Look*, au début des années **1970**, met un terme à cette aventure et à la profession de photographe de magazine. Vaccaro s'installe alors dans un penthouse du quartier de Central Park (New York) où il travaille pour des grandes sociétés américaines et enseigne la photo à la Cooper Union University de New York pendant de longues années.

On commence depuis peu à reconnaître l'importance de l'œuvre de Vaccaro. En avril **1994**, la France organise à Bayeux et à Caen deux expositions de ses photos pour commémorer le Cinquantenaire du débarquement de Normandie. Il reçoit entre autres le « Prix Bayeux des Correspondants de Guerre ». Douze expositions des travaux de Vaccaro tournent à l'heure actuelle en Europe. L'une d'elles a attiré l'attention de Benedikt Taschen et lui a donné l'idée de ce livre.

Vaccaro n'a jamais oublié son enfance, appareil photo en main, dans les rues de Bonefro. La boucle serait donc bouclée pour lui, si son espoir de la création d'un « World Museum of the Magazine Photographer » voyait le jour dans le palais qu'il possède là-bas.

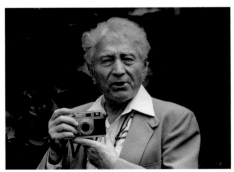

With his beloved Saint-Bernard, photograph by Francesca Naldoni, New York, 1993

With his Leica M 3, photograph by Maria Vaccaro, New York, 1996

With Yevgeny Khaldei, photograph by Andreas Labes, Berlin, 1997

Cover and page 8/9
Love in the ruins. The GI and the German lady,
hand in hand into the future
Liebe in Ruinen. Der GI und die deutsche Frau,
Hand in Hand der Zukunft entgegen
L'amour dans les ruines. Le GI et la dame allemande,
mains dans la main vers le futur
Frankfurt. December, 1945

Back cover
Children and a GI at Tempelhof Airport
Kinder und GI am Flughafen Tempelhof
Enfants et GI à l'aéroport de Tempelhof
Berlin. October, 1948

Page 2/3
German V-2 rocket
Deutsche V-2-Rakete
Bombe volante V-2 allemande
Reims, France. October, 1945

Page 4/5
White Death—Requiem for a dead soldier
Der weisse Tod – Requiem für einen toten Soldaten
La mort blanche – Requiem pour un soldat mort
Bihain, Belgium. January 12, 1945

Page 6/7
Germany's best means of towing
Deutschlands beste „Zugpferde"
Les meilleurs moyens de traction d'Allemagne
Near Munich. June, 1945

Page 10/11
The main office of Coca-Cola
Die Hauptverwaltung von Coca-Cola
Le bureau principal de Coca-Cola
Darmstadt. October, 1948

Page 12
Tony Vaccaro
New York. September, 1951
Photograph by Anita Ekberg

© 2001 TASCHEN GmbH
Hohenzollernring 53, D–50672 Köln
www.taschen.com

© for the photographs: Tony Vaccaro, New York City, and AKG, Berlin
Editing and coordination: Michael Konze, Cologne
Design: Claudia Frey, Cologne
Cover design: Angelika Taschen, Cologne
Production: Ute Wachendorf, Cologne
German translation: Wolfgang Himmelberg, Düsseldorf
French translation: Daniel Roche, Paris

Printed in Germany
ISBN 3–8228–5908–7

TO MY SISTERS GLORIA AND SUE

Acknowledgements
Many friends have helped me with this book and I am grateful to all of them, beginning with my high school teacher and mentor Bertram L. Lewis who taught me the physics and chemistry of photography. I am greatly indebted to the following members of the 83rd Infantry Division, who gave me permission to take photographs during WW II and greatly assisted and encouraged me in my work: Lt. Jesse Adams, Lt. Joseph Storey, Capt. James Patterson, Capt. Harry C. "Bud" Flemming (of the 908 FA Bn, attached to the 83rd), Lt. Col. Leniel E. MacDonald, Colonel Robert H. York, Major General Robert C. Macon, and Pfc. James Nichols who convinced Franke & Heidecke of the Rolleiflex factory to give me a brand new Rolleiflex that took most of the pictures in this book. I also wish to thank Evan "Dick" Jones, editor of *Weekend* magazine and my mentor in the field of magazine photography; Ken Zumwatt, editor of *The Stars and Stripes*, who introduced me to the field of journalism; photographer Hans Hubman, a German colleague, who opened doors in his country for me; Dominique Monsingeon, a friend who, with the aid of the staff of the newspaper Ouest-France, launched the rebirth of my WW II photographs in France; Kathrin Göpel of AKG and Reinhard Schultz of Galerie Bilderwelt, who continue to distribute and exhibit my photographs throughout Europe, and Arthur Bacon for spotting the photographs. Warm thanks also go to Maria Höchst; writer and editor Walter K. Wilson, who helped me to find the right words to go with the photographs in the final text. Many thanks to the staff of TASCHEN for the personal assistance they have given me: Claudia Frey, who made the superb layouts, and my exacting editor, Michael Konze, who directed the theme of the book like a symphony conductor. Finally, I am grateful to the person most responsible for the making of this book, who, after seeing my exhibiton in Bonn, patiently sought out my studio in Long Island City N.Y.–a true friend and individualist, publisher Benedikt Taschen.